THE LOU

THE
LOUVRE

GERMAIN BAZIN
DE L'INSTITUT
CONSERVATEUR-EN-CHEF HONORAIRE
DU MUSÉE DU LOUVRE

THAMES AND HUDSON

Translated from the French by M. I. Martin

This book is sold subject to the condition that it shall not, by way of trade or otherwise, be lent, re-sold, hired out or otherwise circulated, without the publisher's prior consent, in any form of binding or cover other than that in which it is published, and without a similar condition including these words being imposed on a subsequent purchaser.

© *Editions Aimery Somogy S.A., Paris 1979*

English language edition © *1971 and 1979 Thames and Hudson Ltd, London*

First published in Great Britain in 1957
Revised in 1962, 1966 and 1971
This new revised edition 1979

All Rights Reserved. No part of this publication may be reproduced or transmitted in any form or by any means, electronic or mechanical, including photocopy, recording or any information storage and retrieval system, without permission in writing from the publisher.

Printed in West Germany

CONTENTS

FOREWORD

This book, an anthology of the most famous paintings in the Louvre, is intended as a work of reference. Also, the notes which accompany the colour reproductions provide information on the history of the work concerned, the circumstances of its creation, and its life prior to its acquisition by the Louvre, rather than a subjective appreciation of the painting. The introductory essay briefly retraces the history of the collections of paintings assembled in the Louvre, in relation to that of the palace which now houses them. This history has never been written — at least, in its present form; the booklet published by the Musées Nationaux in 1930 (*Histoire des collections de peinture du Musée du Louvre*, with texts by Gaston Brière, Louis Hautecœur, Gabriel Rouchès and Madame Clotilde Brière-Misme) was divided up according to schools. The present work is an attempt to give a brief general history of the formation of the Louvre collection of paintings, from its origins to the present time; the impressionist collections have been omitted, however, since these have been dealt with in a separate work.

No effort has been spared to ensure that all the information in this book is accurate, to the best of the author's belief, though it would be presumptuous to claim that this has been achieved. The history of French art collections in general, of those of the Louvre in particular, has only been studied in a fragmentary fashion; most writings on the subject rely on the works of eminent cataloguers or historians such as Villot, Reiset, Engerand, or Bonnaffé. These men did a great deal to clear the ground, and were indeed remarkable for their time, but closer investigations have now revealed the gaps in their knowledge; and subsequent writings and catalogues have all too often repeated and even amplified their inaccuracies and errors of interpretation, their uncritical acceptance of legends and traditions. I have myself, in previous writings, sometimes been too ready to accept unquestioningly

the authority of the written word. For this short introduction, however, I have consulted with caution the published material, and in particular have benefited from the recent researches of Madame Christiane Aulanier, Mademoiselle Adeline Hulftegger, MM. Claude Ferraton and Jean Adhémar, and notes collected by the Service de Documentation of the Département des Peintures under the direction of Madame Jean Adhémar and of her successor, Madame Béguin.

Scholars who may pick up this book will find that the usual historical apparatus of notes and references is missing; but it was felt that this would have discouraged the general reader, for whom the work is intended.

Now that the virgin soil of history has become buried beneath such an accumulation of exegeses, the seeker after truth has no option but to return to the sources. The history of the paintings in the Louvre can only be fully revealed if a team of research workers, freed from the constraints of routine museum work, can devote themselves to a methodical examination of the archives, setting aside everything that has hitherto been written on the subject, pending its verification. Meanwhile, perhaps those familiar with the galleries of the Louvre may learn from this brief and provisional synthesis something of the continuous effort which has built up this incomparable collection, in spite of changing tastes and fashions and the vicissitudes of peace and war; for more than four hundred years the various systems of government which France has experienced have all contributed to this effort, and have helped to bring about the creation of the most complete collection of works from all the great European schools, from primitives to moderns, ever to be assembled under one roof.

GERMAIN BAZIN

THE COLLECTIONS OF THE FRENCH CROWN

It is to Francis I and to Louis XIV that the Louvre owes its collection of the most splendid paintings of the French and Italian schools. Both these rulers held the view that the monarch was not only a political power, responsible for keeping at bay the enemies of the kingdom, for extending its frontiers, and for ensuring order and prosperity within it; it was his duty to be first in all things, a true *princeps*, the perfect example of the hero on which all his courtiers should try to model themselves, without ever hoping to equal him. A favoured lover, a victorious general, a protector of Arts and Letters — the king must be a man of universal attainments; Francis I was such a man; so, later, was Louis XIV. But this ideal was even more completely realized in Francis than in Louis; the latter belonged to that baroque world in which men organized their lives according to a conception which they formed of themselves, and he played the part of royalty as an actor of genius might have done. The men of the Renaissance, however, were still swayed by the vehement instincts of the preceding age; for all their refinement, they obeyed the impulses of the vital spark, and lived their life, not acted it. It is this conviction which gave its conquering drive to the civilizing process. Federigo da Montefeltro, the most cultivated man of the Quattrocento, was a *condottiere*. His most redoubtable enemy, Francis I, was not to be content with merely vanquishing him in painting, as Louis XIV did later on the ceiling of his gallery at Versailles. The King's armour was no mere parade costume; he fought heroically at Marignan and Pavia, sword or lance in hand, rallying his men, scattering his enemies, always in the thick of the fighting and pursuing victory or death.

The 'modernism' of Francis I, and his Renaissance spirit, shows itself in his high regard for painting. As the culmination of Florence's patient efforts, painting had become, by 1510, the major form of artistic

expression – surpassing even sculpture, which at one time had given it its direction, and which, apart from Michelangelo, was to produce no more men of genius. Perhaps this was because of its power to 'simulate', which is greater than that of any of the other arts, and for which Leonardo gave it the highest place in the order of human activities. For the adornment of his various residences, Francis I wished to acquire masterpieces of this Italian style of painting which so powerfully affirmed the coming of liberation from the old medieval servitudes.

Francis was the first, in the whole of northern Europe as well as in France, who fully appreciated the value of the new aesthetics. Earlier kings had indeed owned collections of works of art, but these were simply a part of the royal treasure, the 'garde-robe'. At the beginning of the fifteenth century, however, France had possessed a most liberal patron of the arts in the person of the Duc de Berry. Entirely for the sake of the pleasure they gave him, he accumulated paintings, tapestries, illuminated manuscripts, Persian miniatures and antique intaglios, Oriental fabrics, coins and medals, in the various châteaux whose appearance has been recorded in the *Très Riches Heures* by the Limbourg brothers. He was indeed the type of person that Robert Estienne was to call a century later, in his Latin-French dictionary (1538), a 'curieux' – a word used to translate 'antiquarius' – defining it as 'one interested in possessing or knowing about relics of classical antiquity'. But the Duc de Berry was also a true Maecenas, commissioning artists to produce illuminated manuscripts – those masterpieces of combined genius and patience. His brother Charles V also loved books, but more as a scholar than as a bibliophile. Charles VI, Charles VII and the austere Louis XI enjoyed far less luxurious surroundings than the Dukes of Burgundy, who were, in their own fashion, Renaissance princes; the Kings of France at this period still lived in a medieval setting. There was indeed a *cabinet* of some kind at Amboise in the sixteenth century, but it contained a collection of arms and historical relics such as were popular with feudal overlords – and with well-to-do *bourgeois* as well, if we are to believe the description of Jacques Duché's Paris house written in the early fifteenth century by Guillebert de Metz.

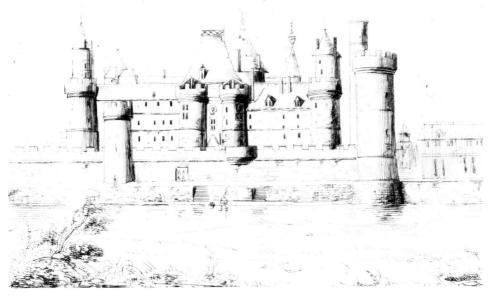

The Louvre at the time of Philippe Auguste

Amboise witnessed the first manifestations of the new ultramontanism, after the return from the Naples expedition. But the famous statement of the wages paid to Italian workmen in 1497 and 1498 shows that Italy had influenced customs even more than taste; everything Italian was considered the height of fashion. Travellers' tales, exaggerated as usual, increased the general admiration for anything coming from the other side of the Alps. Anne of Beaujeu, the Regent, would have been overjoyed if Lorenzo de Medici could have been persuaded to give her his giraffe. The barons who took part in the first Italian expedition did not on the whole go further than this naïve delight; any Renaissance masterpiece entering France at this time usually did so through some noble Italian family. Mantegna's *Saint Sebastian*, for example (bought by the Louvre from the municipality of Aigueperse in 1910), must have been brought into the country in 1481, when the Comte de Montpensier married Clara di Gonzaga. A

little later Fra Bartolommeo's *Mystical Marriage of Saint Catherine* (painted in 1511 — acquired by the Louvre in 1800) was given by the Signoria of Florence to Louis XII's ambassador Jacques Hurault, who presented it to the cathedral of Autun.

Louis XII displayed a more cultivated taste than his cousin. At Milan, so great was his enthusiasm for Leonardo's *Last Supper*, recently painted in Santa Maria delle Grazie, that he wanted to have it detached from the wall and transported to France. There is ample evidence to show the admiration which this painting aroused amongst the French; Cardinal d'Amboise had a copy of it made for his château of Gaillon; the Louvre owns another fine replica which Henry II's favourite, the Constable Anne de Montmorency, had in his chapel in the château of Ecouen. In 1948 a huge ruined fresco inspired by the famous *Cenacolo* was discovered on the wall of the refectory in the monastery of the Franciscan friars at Blois, who had also owned Solario's *Virgin with the Cushion*, now in the Louvre. Francis I had a version of the picture woven in tapestry at Fontainebleau, and presented Pope Clement VII with a copy which is still in the Vatican.

The first work by Leonardo to be seen in France was a *Virgin with a Spindle*, bought by the Secretary of State, Florimond Robertet, and now lost. This picture created a sensation when it arrived at court, and may have prompted Louis XII's determination to bring Leonardo to France. He expressed this desire in the most pressing terms to the Florence Signoria in 1507. In that same year he made his triumphal entry into Milan, and it was Leonardo who organized the celebrations in his honour at the Castello Sforzesco. Louis XII continued to patronize the artist, and granted him a royal pension; Leonardo was even his military engineer on the expedition to Venice in 1509. It has sometimes been thought that the *Virgin of the Rocks*, which is not mentioned by the Cardinal of Aragon's secretary as being in the artist's studio in 1517, could have been brought back from Milan by Louis XII.

Francis I was more successful than Louis XII, and managed to persuade Leonardo to come to France. After the victory of Marignan (14 September 1515) the King of France was once more a power to be reckoned with in Italy; Leonardo was discouraged by the lack of

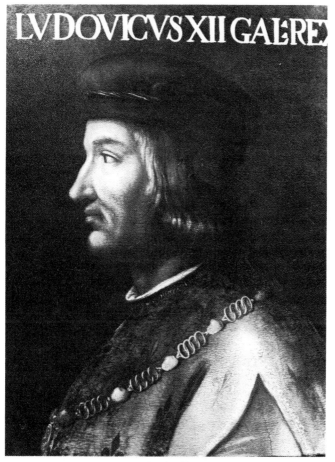

Louis XII

appreciation shown to him in his own country, and was glad to accept the protection of His Most Christian Majesty. In 1516 Francis I provided him with a pension, and installed him in a pleasant house at Cloux, near Amboise. Leonardo's hand was paralyzed, and he could no longer do much painting; but he advised the king on questions of engineering and architecture, and devised festivals for his amusement. He had brought with him a few of his favourite works; on 10 October 1517 he showed three pictures to the Cardinal of Aragon, who came to visit

13

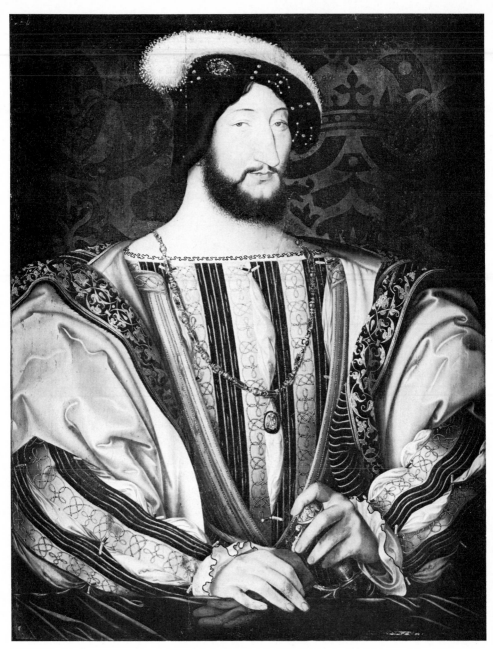

Jean Clouet *Francis I*

him. The Cardinal's secretary, Antonio de Beatis, has left an account of the occasion; the pictures were a *Saint John the Baptist*, the *Saint Anne*, and a portrait of a woman — which must certainly be *La Gioconda*. Perhaps Francis I bought these pictures (and possibly others, including the *Bacchus* and the *Belle Ferronière*) after Leonardo's death, on 2 May 1519, from his executor Francisco Melzi; in spite of all efforts, it has not yet been discovered how these pictures entered the royal collection. According to Père Dan, writing in 1642, *La Giaconda* was bought by the King for 4,000 gold crowns; perhaps it was purchased from Leonardo himself. In any case, Vasari mentions it as being at Fontainebleau in 1550, and Paolo Giovio, writing in 1529, describes the *Saint Anne* as belonging to the King of France. The Crown also owned another work by Leonardo — a *Leda*; some seventeenth-century prince must have objected to what he considered its indecency, and it was destroyed. A number of early copies, and particularly a drawing by Raphael at Windsor, give some idea of the masterpiece so regrettably lost.

Leonardo's paintings are the most valuable in the Louvre; they are also the *incunabula* of the gallery. However, in 1518, before Leonardo's death, Francis I summoned to France Andrea del Sarto, who was later to behave so badly to him. The King already owned a *Madonna* by this Florentine artist, and later acquired from him a *Holy Family* and the well known *Charity*. The French crown received various works of art from Italy as diplomatic gifts, including antiques presented by the Venetian Republic and, above all, two paintings by Raphael — the large *Holy Family* and the large *Saint Michael*. These two pictures, painted in 1517 and 1518, were presented by Lorenzo de Medici, Duke of Urbino, acting on behalf of Pope Leo X; so the attractive legend of the King and the artist trying to outdo each other in generosity over these two works is without foundation.

The portrait of Joan of Aragon was probably given to the King by Cardinal Bibiena. This painting was long believed to be the result of collaboration between Raphael and Giulio Romano, but a recent cleaning under my direction has revealed it as a work by the master of Urbino himself. Other Italian paintings also crossed the Alps into

France — works by Perugino, Sebastiano del Piombo (the *Visitation*), Fra Bartolommeo (the *Annunciation*), and even by Michelangelo, if we are to believe that he painted the *Leda* at Fontainebleau which has so often been ascribed to him. However, this picture might possibly be an adaptation of the painting by Rosso in the National Gallery, London. The King was particularly attracted by Rome and Florence, with which he had diplomatic relations; he seems to have disregarded Venice, whose situation linked her with the Holy Roman Empire. Charles V owned a number of works by Titian, whom he created a Count Palatine; Francis I only possessed a single portrait of himself by that artist, done from a medal.

The early Renaissance had made its appearance in France in the Loire valley; the royal châteaux of Blois and Chambord had been the first to adapt Italianate features, broadly interpreted, to the traditional French style of architecture. Moving nearer to his capital, Francis I decided in 1528 to build himself a residence which would remind him of the beauties of Italy. He chose Fontainebleau, near the forest of Bière, which was well stocked with game. The building itself was carried out by a French mason, Gilles Lebreton, and there was nothing particularly novel about it; indeed, it was of a somewhat rustic character, and less advanced in style than Blois and Chambord. But there was nothing, even in Italy, to match its sumptuous interiors, decorated by Rosso and Primaticcio; the stucco work was in advance of what was being done in Rome, Parma, Mantua or Florence. Works of art continued to arrive from Italy; since the King could not obtain possession of the famous antique sculptures which had been discovered in Rome, he sent Primaticcio to have casts taken of them, and from these he had bronze replicas made to decorate his gardens. As for the Italian pictures brought by the King to this 'new Rome', they were not displayed in the galleries or the state apartments, or even in the private apartments, but oddly enough in the Chambres des Bains, installed between 1541 and 1542 beneath the Galerie des Réformés and only destroyed in the eighteenth century. There were baths there, and six retiring rooms where the pictures were arranged in decorative frames. When the King gave himself over to physical relaxation, therefore, he also sought

16

The Cour Carrée (16th-18th centuries)

refreshment of the mind, in looking at works by the great masters. Some pictures, however, were placed in the chapels; the *Visitation*, by Sebastiano del Piombo, in the lower chapel of Saint Saturnin, and Raphael's large *Holy Family* in the upper chapel.

The third stage of the Renaissance in France is marked by the reconstruction of the Louvre. On 2 August 1546 Francis I commissioned Pierre Lescot to erect a new building on the site of the old fortress built by Philippe Auguste, which Charles V had tried to embellish. Lescot's new wing was a correct and elegant application of Vitruvian principles – the first example of French classical architecture. The development of a French classicism out of antique basic principles was to take place under Henry II; to this monarch must go the credit for having carried out the project of Francis I, who died on 14 August

17

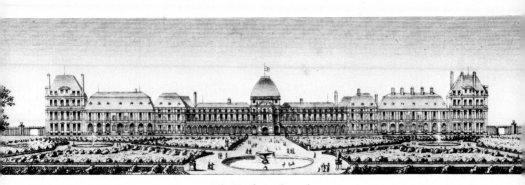

The Tuileries from the parterres

1547. The handsome façade which replaced the west wing of the old château was built in 1548. It was originally intended that this should be flanked by two simple galleries, but there was a change of plan, and a square château was envisaged, with four corner pavilions, exactly following the plan of the medieval fortress. French and Italian artists decorated the king's apartments in the Pavillon du Roi with fine wood-work, the remains of which were unfortunately removed to the Colonnade wing by Duban in 1850.

In 1564, however, Queen Catherine de Medici bought some land a little to the west of the Louvre on the spot known as the Tuileries, outside Charles V's city wall, and commissioned her favourite architect Philibert Delorme to build her a country residence there. It is still uncertain when the decision was taken to link the Louvre and the Tuileries by means of a gallery which for part of its length followed the line of Charles V's walls along the river, and was joined by a small gallery to the Pavillon du Roi. Catherine began with the building of the small gallery, at first as a single-storey building with a terrace above it; later, with the addition of another floor, it was to house the Galerie d'Apollon. According to T. Sanvel, the idea of using it as a starting-point for carrying out the junction of the Louvre and the Tuileries came from the Queen herself, and dated from before 1574. In the first edition of this book, I suggested that Catherine might have been inspired by the gallery across the Arno, linking the Pitti Palace with the Uffizi, which Vasari built in 1564 for the marriage of Francesco de Medici. This is still a valid hypothesis; but the idea of the junction does not seem to have been contemporary with that of the Tuileries itself. In any case,

it fell to Henry IV to put the plan into execution; it was carried out in several stages between 1595 and 1603. As for the idea of building another gallery parallel to the Grande Galerie and to the north of the latter, along the line of the present Rue de Rivoli, mention of this occurs as early as 1605. An essential element of this project (which was known as the 'grand dessein') was the quadrupling of the Cour Carrée, an idea which probably originated with Henry II himself. Charles IX and Henry III carried on with the building of the Louvre in accordance with this new plan.

The plan of the Louvre and the Tuileries—together with the Vatican and the Hermitage, the largest palace in the world—was already laid down, therefore, in the sixteenth century; three hundred years were needed to bring the colossus to completion. The slow progress of the work, constantly interrupted but always taken up afresh, is due to the fact that the Louvre was competing with the building of other royal palaces. Throughout its history it has been a dynastic work, to which each reign has brought its own contribution.

Did Henry II inherit his father's artistic tastes? It seems that in his day the naïve admiration for Italian masterpieces, presupposing a feeling of inferiority, was less exclusive than during the preceding reign. Assimilation of Renaissance principles brought about an awareness of a valid national art; the influence of Flemish and German artists, who had themselves profited by the example of Fontainebleau, came to counter-balance that of Italy. During this period, few foreign works of art seem to have been acquired by the royal collections. The new spirit of individualism, the problems of conscience set by protestantism and humanism, introduced a fashion for portraiture into France. Little pictures drawn or painted by Jean Clouet or his son François, by Corneille de Lyon or by other artists whose names have not survived, accumulated in small rooms specially designed to contain them. Queen Catherine, who could herself 'sketch and draw a likeness', had several of these rooms in the private house she had built for her own use in Paris (later known as the Hôtel de Soissons), where the pictures were set in to the woodwork. It is this kind of presentation which I have tried to recreate in one of the rooms fitted up in the Louvre in

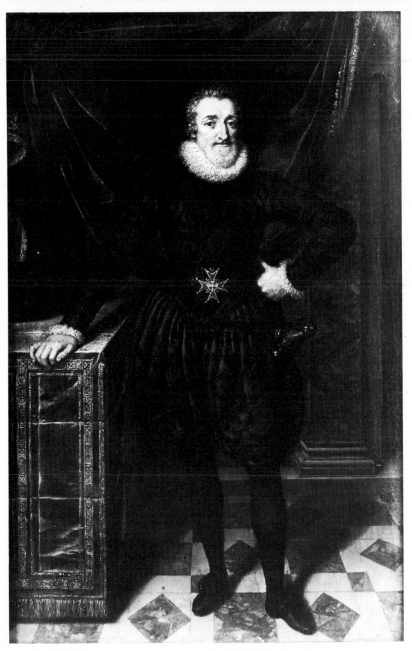

Pourbus *Henry IV*

1953. In the Cabinet des Émaux in the Queen's house, there were thirty-two portraits displayed in company with thirty-nine Limoges enamels; the Cabinet des Miroirs contained eighty-three portraits and one hundred and nineteen Venetian mirrors.

It would probably be a mistake to imagine that Henry II left the masterpieces acquired by Francis at Fontainebleau because he was not interested in them. Henry was very fond of Fontainebleau; no doubt he wished to respect his father's work in its entirety, and set himself to round it off architecturally. With its paintings by the great masters, its frescoes and stucco work, its tapestries after Giulio Romano (some of the cartoons for these came into the possession of the Crown under Louis XVI), the casts from the antiques which adorned its gardens, and Benvenuto Cellini's famous nymph, Fontainebleau formed a kind of sanctuary of Italian art in the northern lands; indeed, it was described by Vasari as 'the Rome of the North'.

Under Henry IV, a measure of order was restored to the kingdom, after a shocking period of anarchy and civil war. This monarch followed an artistic policy which tended to renew the vitality of the French school, calling on foreign help where needed. What he chiefly required for his châteaux of Saint-Germain-en-Laye, Fontainebleau and the Louvre was not great works of art but good masons and decorators. He carried out a great deal of work on the Louvre; he completed the south wing of the Cour Carrée (begun by Henry II and Charles IX), finished the Petite Galerie, and made a definite advance in the progress of the 'grand dessein' by uniting the Louvre and Tuileries, as Catherine de Medici had planned. In 1595 the Grande Galerie was begun by Jacques Audrouet du Cerceau and Clément Métezeau; the building, running alongside the Seine for more than 480 yards, made rapid progress, and in 1606 the Dauphin was able to traverse the whole gallery from the Louvre to the Tuileries. In erecting this building, Henry IV was co-operating in the scheme to provide lodgings beneath the Grande Galerie for 'numbers of the best craftsmen and most competent masters in painting, sculpture, goldsmith's work, clock-making and many other excellent arts'. In these letters patent of 22 December 1602 lies the origin of the artists' lodgings and studios which continued to exist in the Louvre till

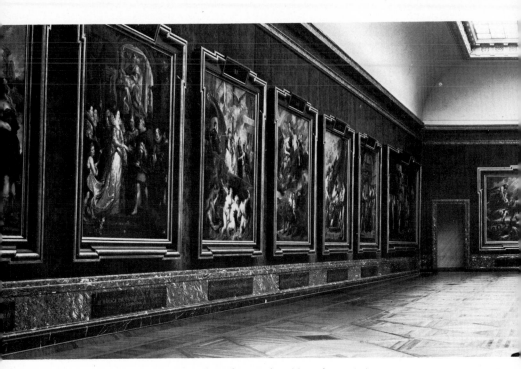

The Galerie Médicis (the Rubens series)

the time of the First Empire. The King's intention, said Sauval, was to create 'a kind of nursery of craftsmen, trained by good masters, some of whom would later be dispersed throughout the kingdom, and who would be able to render great services to the country'. According to the same author, Henry IV also wanted to accommodate in the Louvre the greatest nobles in the kingdom, as well as the best artists, in order to establish an alliance between the aristocracy and the fine arts.

The Grande Galerie was simply a vast empty hall; the Petite Galerie, however, was full of portraits of past and present worthies, and formed a kind of historical museum, known as the Galerie des Rois. The kings were ranged along one side of it and the queens on the other, in between the windows; of this series, we still possess the solemn full-length portrait of Marie de Medici, by François Pourbus the younger; the others were destroyed in the fire of 6 February 1661. Each pier of the gallery had borne the effigy of a king or queen of France; the kings

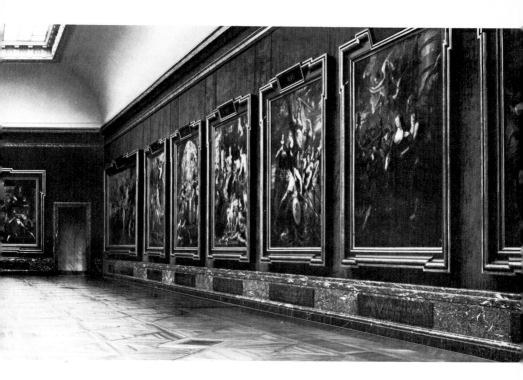

had been painted by Bunel and the queens by his wife. With its Latin mottoes, inscriptions, allegorical and mythological allusions and coats of arms, the gallery formed a humanistic *ensemble* of the kind so much enjoyed by contemporary men of letters.

On the third floor of the Pavillon du Roi was the Grand Cabinet, where Henry IV gave audience; in it were kept all the various precious and rare objects and the souvenirs which the kings handed on to their successors. These formed a miscellaneous assembly of bronzes, goldsmiths' work, and curios, together with curiosities of natural history – the kind of collection which the Germans call a 'Wunderkammer'. Later, Louis XIII used to take refuge in this room during the hours of solitude which he loved; he was also fond of the Cabinet des Armes on the second floor of the same building.

As for the famous Italian masterpieces at Fontainebleau, it was observed that they were beginning to deteriorate because of the humidity

in the Appartement des Bains on the ground floor, and so they were removed to the first floor in the Pavillon du Fer à Cheval, which thus became known as the Pavillon des Peintures. But in order to preserve the décor of the Chambres des Bains as Francis I had created it, the original paintings were replaced by copies, of which some still exist at Fontainebleau — Michelin's copy of Raphael's large *Holy Family*, for example. It was decided to appoint a keeper to look after these great paintings; and in 1608 Jean de Hoey of Utrecht, a painter of Dutch origin (a grandson on his mother's side of Lucas van Leyden) was put in charge of 'the paintings at His Majesty's Castle of Fontainebleau, in order to have restored those pictures in oils, whether on wood or canvas, that are damaged, and to have cleaned the surrounds of the frescoes in the bedrooms, reception rooms, galleries and cabinets of this castle'. When he died in 1615 he was succeeded by his son Claude, and Claude's son in his turn inherited the position from his father in 1660, and accompanied the collections when they were transferred to the Louvre. We are fairly well informed on the pictures which were at Fontainebleau in the seventeenth century, from two sources; in 1625 an Italian visitor to the château, Cassiano del Pozzo, left us an account of his visit, and in 1642 Père Dan described the Cabinet des Tableaux in his valuable work *Trésors et merveilles de Fontainebleau*.

Queen Marie de Medici carried out various works in the interior of the Louvre, none of which has survived; she did not concern herself with the architectural progress of the building, being more interested in the erection of the Luxembourg palace for her own personal use. She summoned Rubens to decorate the latter palace for her; he may have been recommended by her sister, the Duchess of Mantua, as he had worked as official painter at that court, and possibly also by the Baron de Vicq, the Paris ambassador from the Low Countries, whose portrait by Rubens is in the Louvre. The Queen commissioned this artist to paint two galleries, one in honour of the late King, and one in her own honour. The latter was inaugurated on 11 May 1625, on the occasion of the marriage of Louis XIII's sister, Henrietta of France, and Charles I of England. In the last years of the *ancien régime*, when the palace became an appanage of the Comte de Provence, the twenty-one pic-

tures were taken down and rolled up; they were exhibited there again in 1802, and in 1815 they were brought to the Louvre. They are one of the Museum's most splendid possessions. Unfortunately, the projected gallery in honour of Henry IV's exploits was never carried out, because of the Queen Mother's fall from favour; only sketches for it survive, and two unfinished paintings now in the Uffizi, Florence.

When Louis XIII began to reign in person, in 1624, he solemnly announced that he was going to resume work on the Louvre, which had been abandoned on the death of his father. The first stone of this new period of building activity was laid in the summer of 1624, and a medal was struck to mark the occasion. The architect was Pierre Lemercier. The quadrupling of the Cour Carrée, as planned in the time of Henry II, was now begun by extending Lescot's building for an equal distance beyond a pavilion with caryatids (the Pavillon de l'Horloge) which separated the old block from the new. Work continued on it throughout the reign, and Lemercier laid the foundations for the north-west corner pavilion of the north wing (bordering the Rue de Rivoli).

The Louvre at the time of Louis XIII

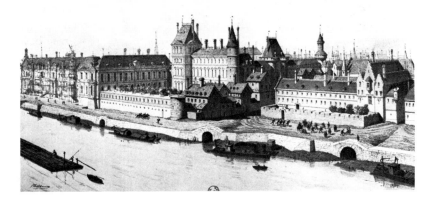

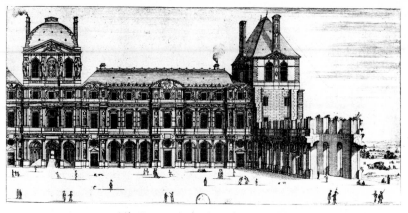

The Louvre at the time of Louis XIII

Louis XIII wanted to provide a worthy décor for the Grande Galerie, left undecorated during the preceding reign. Acting, no doubt, on the advice of Sublet des Noyers, the Surintendant des Bâtiments, he resolved to entrust this task to Poussin, who was then living in Rome, and whose reputation had crossed the frontiers into France. Monsieur de Chanteloup, who went to Rome for the special purpose of bringing Poussin back, managed to persuade him after much hesitation to accede to the royal request, and the artist arrived in Paris early in 1641. Gratified by the offer of a salary of 3,000 livres, received with honour and made director of all works carried out in the royal residences, Poussin prepared cartoons for paintings and stucco work for a great decorative scheme representing the life of Hercules, who was accepted as a symbol of Louis XIII.[1] But in November 1642, driven to exasperation by Simon Vouet's scheming, and the airs of the Baron de Fouquière 'who only paints with his sword at his side', disgusted by court intrigues and at loggerheads with Lemercier over the décor, Poussin fled to Rome, pleading anxiety over the health of 'his dearly-loved wife'. He left the work unfinished, promising to return; all that now remains of it are the drawings for the scheme, in the Cabinet des Dessins in the Louvre.

Louis XIII made a considerable contribution to the great work of building the Louvre, but he added little to the royal collections. The Queen, Anne of Austria, failed to take advantage of her connections with the Spanish court, and acquired no masterpieces by Velasquez – an

[1]From the sixteenth century, Hercules had been the symbol of royalty, before his place was taken in France by Apollo; the Hapsburgs continued to regard him as such until the eighteenth century.

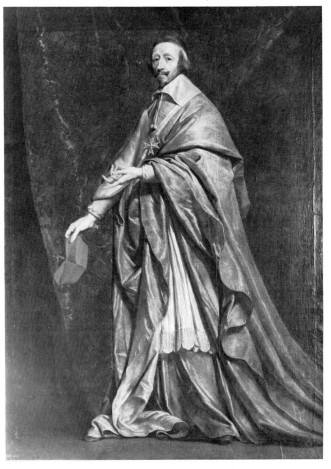

Philippe de Champaigne *Richelieu*

artist unknown in France at that time, and not appreciated in that country till the eighteenth century. Among the portraits of her relations which the Queen kept in her Chambre des Bains, the best is that of the *Infanta Margarita*, now in the Grande Galerie; but this is only a studio work and not by Velasquez himself.

In the reign of Louis XIII it fell to Cardinal Richelieu to exercise the kingly privilege of patronage; and, with State funds, he amassed for his own benefit a collection which should have been assembled by the

King. These works of art filled his Paris residence, the Palais Cardinal (now the Palais Royal), his château at Rueil, and the enormous château he built for himself in Poitou, near the town which bears his name. Before 1627, in which year most of the Gonzaga collection was sold to King Charles I of England, he secured for himself the fine series of paintings from Isabella d'Este's *Studiolo*, by Perugino, Mantegna and Lorenzo Costa. These were the gems of his collection in the château in Poitou; the Louvre acquired them when they were confiscated during the Revolution. It is not impossible that Richelieu arranged for this magnificent group of paintings to be offered to him by Vincenzo Gonzaga in 1624, when the latter was scheming with the French court to obtain the title of 'Altesse'. It emerges from the correspondence of the Duke's ambassador in Paris with his master that the Cardinal, 'great *curieux* of rare paintings who hunted for them everywhere', would be favourably influenced in the negotiations by the gift of a picture. Since the *Studiolo* was specifically excluded from the deal transacted with Charles I's representative in 1627, it may well be that by then Richelieu was already in possession of the pictures it had contained. In 1629 the Cardinal was in Piedmont, at Casal, to which he had just laid siege; there he bought Leonardo's *Saint Anne*, which must have ceased to belong to the Crown at some unknown date, probably as the result of a gift. In 1636 Richelieu bequeathed to the King the Palais Cardinal and all the treasures it contained – its pictures, its bronzes, and the famous chapel of goldsmiths' work. The King thus obtained a few additional master-pieces, notably a ceiling by Poussin (*Time Rescuing Truth from Discord and Envy*), later installed in the Grand Cabinet du Roi in the Louvre, Veronese's *Pilgrims at Emmaus*, and Leonardo's *Saint Anne*; also some works by contemporary Italian masters, particularly the Carracci.

During the second half of the seventeenth century in France, the passion for collecting and for dealing in curios was intensified; there was keen competition to obtain masterpieces, and speculation played its part. The most ardent 'curieux' of all was undoubtedly Mazarin. Lo-ménie de Brienne, who was the Cardinal's secretary, relates how, just before his death in 1661, he wandered about like a ghost amongst his

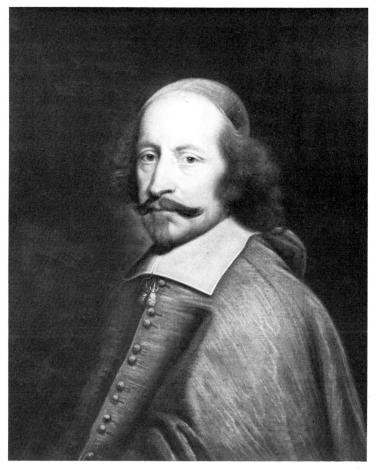

Mignard *Mazarin*

collection, grieving: 'All must be left — how I have struggled to possess these things!...Where I am going, I will never see them again!' He trafficked unceasingly in works of art, buying and, after selecting what he wanted out of the material reaching him from Italy, selling it again — even organizing public sales in a house specially rented for the purpose: the Hôtel d'Estrées. His collections included countless numbers of curios, as well as masterpieces of painting and sculpture; they were housed in his apartments in the Louvre and in the two fine galleries,

upper and lower, which formed the famous Galerie Mazarine. These are now part of the Bibliothèque Nationale; they were built round the Hôtel Tubeuf, which Mazarin had bought and which he commissioned Mansart to alter. When the Cardinal fled, driven away by the Fronde, his collections and library were sold by auction; and a decree of the Parlement in December 1651 even arranged that the sum promised as a reward to whoever handed over Mazarin, alive or dead, should be provided out of the proceeds of his sales.

However, the interests of the Cardinal (who lived in style, even during his exile) were secretly safeguarded in Paris by his secretary Colbert; a certain number of items from his collection were saved and restored to him.

In 1650 Mazarin, having got wind of the breaking-up of Charles I's collection in England, commissioned Everhard Jabach (who was travelling to that country) to buy some works for him. Cromwell's government did indeed commit the great error of selling the King's collection – the finest to have been assembled in the first half of the seventeenth century. Charles' first acquisition had been the purchase in 1627 of most of the masterpieces in the Gonzaga collection at Mantua. This group of paintings and sculpture must have been the richest Renaissance collection in existence; it had been amassed by the uninterrupted efforts of a family who had patronized the arts and letters for more than a hundred years, from the end of the fifteenth century. Luigi and his wife Barbara of Brandenburg employed Mantegna, who also worked for Francesco, husband of Isabella d'Este, a princess always anxious to possess fine paintings. Guglielmo, the protector of Palestrina, had added to the collection; finally Vincenzo I (1587–1612), patron of Rubens and of Monteverdi (and who had *Orfeo* staged on 24 February 1617 in the Accademia dei Invaghiti) had a gallery built to house these works, and added a number of treasures such as Caravaggio's *Death of the Virgin*. But their love of festivities, horses and works of art finally brought ruin to this extravagant family. The last duke of the Italian branch, Vincenzo II, whose biographer describes him as 'a worm of a man, rather than a prince', only reigned a few months – but long enough to sell this collection, the finest in Italy, to

Charles I of England, through the intermediary of the merchant Daniel Nys.

All Europe benefited from Charles I's sale, but the best part of his collection came to France, thanks to the financier Everhard Jabach and to Cardinal Mazarin who shared the spoils when it was dispersed between 1649 and 1653. The sales were carried on in a friendly fashion, by negotiation; Jabach bought without counting the cost; the more parsimonious Mazarin bargained at great length in order to obtain a reduced price and often saw the coveted object removed from his grasp, sometimes by Jabach himself. But the Cardinal lost nothing by waiting, because he was able to acquire a part of Jabach's collection later, on advantageous terms, when the latter was short of money.

Everhard Jabach was a native of Cologne, and belonged to a well-to-do bourgeois family whose name is connected with a famous work by Albrecht Dürer. He was naturalized in 1647. He was a banker, and director of the Compagnie des Indes Orientales; in 1667 he received in addition a contract for providing leather equipment for the royal army. His good fortune deserted him at one point, and he had to sell his pictures – a proceeding which benefited Mazarin, the Duc de Richelieu and the King. However, matters subsequently improved and he was able to form a second collection. Le Brun painted a portrait of him, showing him with his family; it was in the Museum at Berlin, and was burnt in 1945. In opposition to the aristocratic collectors such as Loménie de Brienne, the Marquis de Hauterive, or the Duc de Richelieu, Jabach represents the type of financier-collector frequently encountered in the eighteenth century.

When Mazarin died, for the first time since Henry IV the King refused to be satisfied with reigning; he decided to govern. Henceforth, he was to lead both in politics and as art patron; after the lapse of a century, he took up the tradition of Francis I, who had made patronage a kingly right and duty. Assisted by Colbert, who had learnt a great deal from his apprenticeship with the Cardinal, Louis established this principle as an institution of the monarchy.

The King began with a master-stroke, and acquired some of Mazarin's pictures. He had refused the Cardinal's offer, made a few days before

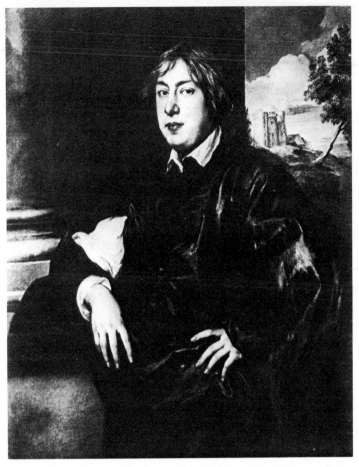

Rigaud *Everhard Jabach*

his death, of his complete fortune; but he accepted a legacy of some
pictures and eighteen large diamonds. Furthermore, he bought from
Mazarin's heirs the most famous paintings and statues. In this way the
Louvre acquired some of its greatest treasures: *Balthasar Castiglione*
(Charles I), *Saint George* and *Saint Michael*, by Raphael, Titian's *Venus
of the Pardo*, which had been given by Philip IV to Charles I when the
latter visited Madrid in 1623, Correggio's *Allegory of the Vices* and
Antiope (Charles I), and the *Marriage of Saint Catherine* by the same

artist (Cardinal Barberini), the *Deluge* by Antonio Carracci (Charles I), and a curious picture of the German Renaissance—a *History of David* in the form of a table top by Hans Sebald Beham.

Not much is known of the transactions which took place with Jabach. We only know that on 31 March 1671 Colbert obtained from him 5,542 drawings and 101 pictures for 220,000 livres—which prompted Loménie de Brienne to remark that Colbert had behaved to Jabach 'not like a Christian, but like a Moor'. The inventory of the drawings bought by Jabach still exists, but not that of the paintings. Recent researches carried out by Mademoiselle Adeline Hulftegger seem to indicate that, except for a few items, they were not of great importance, and that the most celebrated canvases had already become the King's property by 1671, either by donation or by transfer. In any case, the Crown obtained possession by these means of some magnificent works: the *Man with the Glove*, the *Entombment* (Charles I), the *Pilgrims at Emmaus*, the so-called *Allegory of Alfonso of Avalos*, the *Woman at her Toilet* by Titian, Giorgione's *Concert Champêtre*, Gentileschi's *Holy Family* (Charles I), Caravaggio's *Death of the Virgin* (Charles I), Claude's *Capture of the Pass at Susa* and *Siege of La Rochelle* (from Brienne), Domenichino's *Saint Cecilia*, several works by Veronese including *Susanna Bathing* and *Esther*, Correggio's *Allegory of the Vices*, thus reunited with its companion piece the *Allegory of the Virtues*, acquired through Mazarin, Leonardo's *Saint John the Baptist* which, according to a tradition no longer accepted, Louis XIII had exchanged for Holbein's *Erasmus* (in fact, this exchange was made with the Duc de Liancourt); the surviving documents incline Mademoiselle Hulftegger to the belief that the *Erasmus* came into Louis XIV's possession through Jabach with all the other Louvre Holbeins, bought in England and originally in the Arundel collection— *Archbishop Warham, Nicolas Kratzer, Sir Henry Wyatt* and *Anne of Cleves*.

Since the Renaissance, the gift of works of art was considered one of the best diplomatic means of acquiring a sovereign's good graces. The most splendid present Louis XIV ever received was Veronese's *Feast in the House of Simon*, given to him in 1665, together with a Titian, by the Republic of Venice. Courtiers also availed themselves of this elegant method of paying their respects—a method, only naturally,

dear to the King. In 1693, Le Nôtre offered him three Poussins, two Claudes and his Albanis; Louis XIV did not wish to be indebted to his landscape gardener, and granted him a pension of 6,000 livres. Knowing the King's taste for contemporary Italian paintings, the princes of the Roman families sent him some of these. In 1665 Prince Pamfili gave Bernini (summoned to Paris to work on the Louvre) eight pictures to take to the King, including some Albanis, *Hunting Scene* and *Fishing Scene* by Annibale Carracci, a magnificent Titian, the *Virgin with SS. Maurice, Stephen and Ambrose*, and the *Fortune Teller* by Caravaggio. From Monsignor Orsini the King received the superb *Battle Scene* by Salvator Rosa, and various Italian prelates gave him other less important Seicento works.

An important event in the history of the collections of the Crown under Louis XIV took place in 1665 – the purchase from the Duc de Richelieu (the Cardinal's nephew) of thirteen Poussins, two Claudes (one of them the very fine *Ulysses restoring Chryseis to her Father*), and various Italian pictures, including the beautiful *Virgin with a Rabbit*, one of Titian's best-preserved paintings. According to Loménie de Brienne, this last painting was the stake in a game of tennis, in which the King defeated the Duke; recent researches by M. Claude Ferraton, who has discovered the receipt for the sale, neither prove nor disprove the legend. Among the Poussins acquired on this occasion were the *Diogenes*, the *Four Seasons*, the flamboyant *Bacchante and Lute Player, Eliezer and Rebecca*, which so exercised the Académie, the *Ecstasy of Saint Paul*, and the *Philistines Struck by the Plague*, a brilliant Mantegnesque work.

A great number of paintings by contemporary French artists were bought at this time. Louis XIV had thirty-two Poussins, eleven Claudes, twenty-six Le Bruns, seventeen Mignards, without taking into account the decorative work of the last two painters. French taste was 'classic' in character and definitely preferred French and Italian painting; the Hapsburgs, on the other hand, as a result of their position in Europe, were equally in favour of the Northern and of the Italian schools. Being in possession of Spain, they naturally owned works by Spanish masters, so that at the end of the seventeenth century the collections

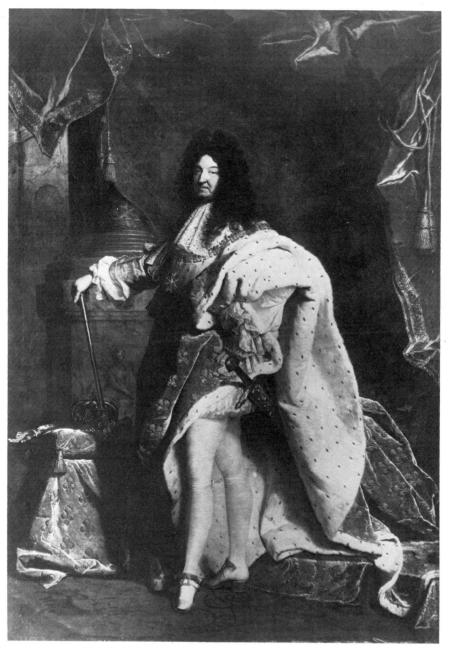

Rigaud *Louis XIV*

of Vienna and Madrid were much more representative than that of Versailles of all the great European schools of painting. The situation changed during the eighteenth and nineteenth centuries, but the Louvre has always preserved something of this spirit of exclusiveness which presided over the formation of the royal collections.

During the reign of Louis XIV, however, the Crown acquired a certain number of Northern pictures. We have already mentioned the Holbeins purchased from Jabach. At that time the Flemish artist most appreciated in France was Van Dyck, much esteemed as a court painter; the *Mercure galant* mentions no less than fourteen of his works in the collection stored in the Louvre which the King visited in 1681. The conviction that drawing was more important than colour, and noble subjects superior to *genre* (a prejudice imposed by the 'Poussinist' spirit of the Académie) led to a belief that Rubens' work was vulgar, with its 'fat, well-fed, pot-bellied gods', its brilliant presentation of 'beauty out-of-doors', its pigment applied like cosmetics, and its 'licentious' character. During the second half of the reign, however, under the influence of Mignard, Jouvenet, Largillière and Roger de Piles, Rubens came back into favour, with the result that Poussins were less sought after. The Duc de Richelieu, who had sold his Poussins to the King, later bought Rubens' work instead. In spite of the remark attributed to Louis XIV by Voltaire (no doubt apocryphal),[1] the royal collections began to acquire Flemish works. The *Mercure galant* of 1681 mentions Rubens' *Virgin of the Holy Innocents*, which Mademoiselle Hulftegger thinks may have been bought as early as 1671 from M. de la Feuille, together with *Queen Thomirys and Cyrus*; and in 1685 the King did not hesitate to buy the *Kermesse* — one of the artist's most 'popular' works — from the Marquis de Hauterive. Finally, the 1683 inventory mentions the *Portrait of Rembrandt as an old Man*, possibly bought in 1671 from M. de la Feuille.

By now, a special organization and administration had become necessary to look after the very extensive collections. Le Brun was put in charge of it, and thus added the title Garde des Tableaux et Dessins du Roi to those he already held — Premier Peintre and Directeur de la Manufacture des Meubles de la Couronne (the Gobelins). He took up

[1]'Get these monstrosities out of my sight', Louis is supposed to have exclaimed, on seeing some Teniers which had been hung in his apartments (Voltaire, *Mélange d'histoires anecdotiques sur Louis XIV*).

his new duties in 1671, and held the post till his death in 1690. In 1683 he drew up a detailed inventory of the royal collections, which mentioned 426 pictures. The inventory compiled in 1709–10 by Bailly, Garde des tableaux de Versailles et des Maisons royales, listed 2,376 items, of which 369 were Italian, 179 by Northern artists and 930 French, the balance being made up of copies, decorative works and sketches.

In the time of Le Brun, the King's paintings were housed in the Louvre, in the wing built by Le Vau after the fire of 1661 round the present court which contains the antiquities of Assos and Maeander. The surplus was in the neighbouring Hôtel de Gramont. An article in the *Mercure galant*, December 1681, gives an account of a visit 'which His Majesty paid on 5 December 1681 to the Louvre, to see his collection of painting'. The writer, full of admiration, announced that 'there is no longer any need to travel to see the rarest treasures'. The pictures covered the entire walls, reaching to above the cornice; there were even three layers of them, one behind the other, which could be inspected by a system of hinged screens (the picture stores in modern museums employ the same principle). In the Hôtel de Gramont, for safety's sake, 'the oldest and most precious are kept shut up in flat gilded cupboards'. The chronicler relates that on that occasion the King chose fifteen new pictures to be transferred to Versailles; he now no longer lived in the Louvre, which was simply a storehouse.

In 1690, after Le Brun's death, the position of Garde des Tableaux was given to Mignard. When the latter died in 1695, the duties were divided between two officials, one responsible for the Louvre, the other for Versailles and the royal residences (Marly, Fontainebleau, and the Luxembourg). The painter Houasse, Garde des Tableaux of the Louvre, only admitted to ninety paintings in the inventory made when he took up his duties; during the eighteenth century, the collection in the Louvre became a collection of drawings only.

At Versailles, the most valuable paintings were earmarked for the Cabinet des Raretés, which had the best light for their display; but the majority were used to adorn the palace. A mixture of schools was evidently found pleasing, contemporary French paintings being shown in

the company of works by Italian artists. In the Salon de Mars, for example, Veronese's *Pilgrims at Emmaus* was hung as a pendant to Le Brun's *Alexander in the Tent of Darius*; Voltaire, comparing them, preferred the French picture to the Venetian one. The Surintendance had magnificent frames made for the King's pictures; the finest examples are perhaps those which still surround two pictures by Annibale Carracci — *Hunting Scene* and *Fishing Scene*.

When the King visited the Louvre in 1685, it was already seven years since he had abandoned it for Versailles. From that time, all his efforts were directed to the creation of his own personal legend; but he had already contributed more than any other monarch to the task of rebuilding the Louvre, and it had witnessed the fifteen best years of his reign — its most brilliant and most carefree period.

When Louis XIV had returned to Paris in 1652, he carried out a considerable amount of redecoration in the royal apartments; some of the woodwork still survives, but was removed to the Colonnade wing in the nineteenth century. The Queen Mother, Anne of Austria, had an apartment fitted up for herself in 1655, on the ground floor of the Petite Galerie, with a 'modern' décor consisting of stuccoes by Michel Anguier and paintings by the Italian Romanelli. In 1659 Mazarin put his favourite architect Le Vau to work on the north wing of the Cour Carrée; so that nothing might be allowed to interrupt the building programme, a royal ordinance was actually issued forbidding private persons to 'undertake the construction of any new building'. On 6 February 1661, however, fire broke out in the Petite Galerie, and though the Queen Mother's summer apartment was saved, the first floor was gutted.

In the course of my years as Conservateur, several fires have broken out in the Louvre, but they have always been extinguished even before the arrival of the fire brigade. They have invariably been caused by negligence on the part of workmen; the Museum seems doomed to be permanently in the hands of builders. Things were no different in the past. On this particular occasion, work had been going on till midnight preparing a stage for a performance of the ballet *L'Impatience*. A workman left to keep watch fell asleep beside a torch which set fire to some

nearby planks. Smoke reaching the King's apartments gave the alarm, but it was impossible to quench the outbreak with the inadequate means then available—buckets of water passed from hand to hand. The flames were only prevented from reaching the Grande Galerie by cutting a breach at the beginning of it, and thus forming a fire-break. In the presence of the King, the Queen and the court, the Blessed Sacrament was finally brought with great pomp and ceremony from the church of Saint-Germain-l'Auxerrois; divine aid succeeded where men had failed, and the fire did not reach the Pavillon du Roi. The gallery was rebuilt by Le Vau, who added a wing on the left side to house the library; Le Brun undertook its decoration, planning a painted schema in honour of Apollo (Louis XIV's symbol) which was never finished.

Colbert, Surintendant des Bâtiments in 1663, wanted to give a new impetus to the building of the Louvre; he had the Tuileries completed and enlarged by Le Vau, and wished to provide the palace with a triumphal entry on the east, the side nearest the city. Le Vau, Premier Architecte des Bâtiments, produced a design, and the foundations were laid. The scheme aroused much criticism; Colbert had a large-scale model made in wood and plaster, the better to judge the effect. A competition was announced, and plans were submitted by French and Italian architects. In 1665, the King even invited Bernini, regarded as the greatest living Roman architect, to come to Paris. He was received with great honours, and produced a number of grandiose schemes more suitable for Rome than for Paris; however, there was a symbolic laying of the first stone of the final project on 17 October 1665, after which Bernini returned to Rome and building operations were suspended.

The task of producing a definitive design was entrusted to a commission of three—Le Brun (the Premier Peintre), Le Vau, and Claude Perrault, a doctor. The latter was the son of Charles Perrault, the author of the fairy tales, who was chief clerk of the Surintendance des Bâtiments. Building went ahead from 1667 to 1674, after which the sculpture was put in hand.

Some designs which still survive show a moat in front of the façade; this idea was abandoned in the course of construction. The feudal and military significance of such a feature was already out of date by this

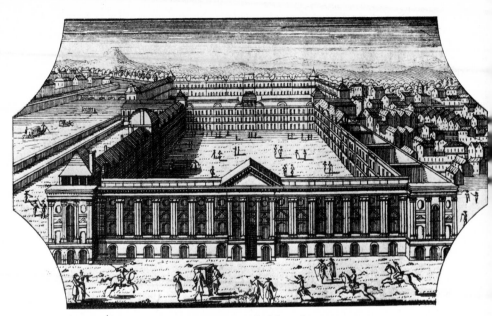

The Louvre at the end of the 17th century

time, as Jean-François Blondel makes clear in his *Architecture Française*. Perhaps the idea can be attributed to Le Vau, who belonged to an earlier generation, and was a leftover of his project; the fortress-like aspect which it would have given to the entrance to the Louvre must have been unacceptable to a monarch whom it would have reminded of the shameful days of the Fronde, and who wished to be as accessible as possible to his subjects. Nevertheless in recent years the Service des Monuments Historiques, acting on orders from above, has opened up a ditch in front of the façade; this was completed in 1968. The result is a fundamental change in the appearance of the building; the predominantly horizontal character aimed at by Louis XIV's architects has been diminished by it. The Colonnade now appears to be resting on a basement, which brings it close to one of Bernini's schemes. Seen from the front, the façade seems to have lost its lower moulding, which is hidden by the counterscarp. Paradoxically, it appears to rest on the openwork tracery of the new balustrade. The most perfect example of French classicism has thus been given a 'baroque' flavour.

During the years 1967, 1968 and 1969, this ditch has been the subject of much criticism. One of the simplest proofs that the project for it was voluntarily abandoned has not been sufficiently brought out: the architects did not give up the idea of digging a ditch, since this actually existed for almost the whole length of Le Vau's basement of 1663, preserved intact and revealed by the excavations. It must therefore have been filled in, although it could easily have been converted into a dry moat if the intention had been to carry out exactly the project which included it. True, this would have involved demolishing Le Vau's basement; but this would have provided materials for the foundation of the new building, or for the construction of the counterscarp (the latter was in fact done during the carrying out of the recent project). It cannot have been a question of economy, since demolition is not costly and useful materials can thus be salvaged (indeed, it was suggested to Cardinal Fleury in the eighteenth century that the Louvre should be pulled down in order to sell the stones!). However, no doubt in order to hasten the completion of this interminable building, the ditch was filled in without bothering to demolish Le Vau's basement.

Perhaps we should re-echo the words of Grimm, referring to a proposed modification of the Colonnade in the eighteenth century: 'Is it credible that in a century as enlightened as this we are capable of spoiling the finest monument in the whole of France?'

Once built, the Colonnade was considerably longer than the building to which it was attached. In order to join it up to the *corps-de-logis* which Le Vau had completed in 1664 on the side nearest the river, the latter building had to be doubled in size.

However, Louis XIV grew weary of all this building work and the constant changes of plan. Increasing interest in Versailles meant that work on the Louvre slowed down, and in 1678 finally came to a halt. The Louvre ceased to be the residence of the King of France. Louis XV lived at the Tuileries during his minority; and it was the Tuileries that received Louis XVI when he was brought back from Versailles by the people.

THE BEGINNINGS OF THE MUSEUM

At the beginning of the eighteenth century, a small number of noble-men and financiers continued in the tradition of the great collectors of the previous century. The Regent had no less than 478 pictures on show in his Palais Royal gallery, including works by the great Renaissance masters; in 1704 Baron Crozat de Thiers installed his collection of 19,000 drawings and 400 pictures in his house in the Rue de Richelieu. However, collectors had lost the taste for the grand manner in art; the great 'machines' of earlier centuries, darkened during the passage of years, did not suit the small apartments, with their light-coloured wood-work and cheerful mirrors, which were now the homes of a society grown weary of the uncomfortable ostentation of the 'grand siècle'. Pier-glasses were needed now instead, and door-panel designs by living artists in fresh clear colours, representing 'sujets galants' which required no mental effort on the part of the beholder. The bourgeois influence brought into favour the work of the minor Dutch and Flemish artists, the size and subjects of whose paintings were more in keeping with the spirit of the time. Rembrandt was admired, but Gerard Dou was wor-shipped, and became one of the most popular masters of the century. Finally, the mania for objects — knick-knacks and curios, pieces of furniture, *chinoiseries* — dealt a severe blow to painting.

The Dutch were, at a stage, far better organized than the French on the commercial side of collecting; Gersaint, Watteau's dealer, had been to Holland and studied the Dutch method of auctioning works of art, which he then introduced into France. There were a number of experts in Paris during the eighteenth century — Gersaint, Mariette, Rémy, Glomy, Lebrun (the husband of Marie-Antoinette's portrait painter, Madame Louise Vigée). Printed catalogues were carefully prepared by experts for the important sales. Towards the end of the *ancien régime* sales became more frequent; works of art constantly changed hands, and at this period Paris collectors sold more than they bought. It seems

strange to find Rémy, in his preface to the catalogue of the Tallard sale (1756), deploring the fact that so many masterpieces were leaving France. Later, Bachaumont, in his *Mémoires secrets*, voices his regrets that a foreigner should have been the only one to benefit from the sale of a famous collection: 'The Empress of Russia,' he said, 'has carried off all the pictures formerly belonging to the Comte de Thiers, the well-known connoisseur, who had a fine collection of this kind of work. Monsieur de Marigny [the Directeur des Bâtiments] has had to suffer the disappointment of seeing these treasures go abroad, for want of funds with which to acquire them on the King's behalf.' The countries which had produced all the great modern schools of painting — Italy, France, Belgium and the Netherlands — were emptied of their master-pieces for the benefit of England, Germany, Austria and Russia. Frederick the Great, the Electors of Saxony, Augustus the Strong and Augustus II, Catherine the Great (whose Paris agent was Diderot) and Baron Stroganoff all became the owners of paintings by the great masters sold by French collectors; across the Channel, the English aristocracy became enamoured of French classical painting, and bought all the finest works of Poussin, Claude and Gaspard Dughet both in Italy and in France.

The Crown did not derive as much benefit as it might have done from the ample products of French talent during that period. The regimentation of the fine arts introduced under Louis XIV had resulted in the formation of an official art, which always lagged behind the innovators. From this there developed a rift between the State and the most vital manifestations of contemporary art, which went on widening until the nineteenth century, when the gulf became unbridgeable. In the eighteenth century, the royal administration gave its commissions to the most facile, not to the most gifted. Watteau and his disciples were left out, and, later, Fragonard; Chardin had better success amongst the citizens that he had at court. Up to 1869, the date of the La Caze gift, the Louvre only owned one Watteau — *The Embarkation for Cythera*, his Académie diploma piece. The collections where French art of this period was best represented, therefore, were not those of the King of France, but those formed by the foreign princes and sovereigns already

mentioned – with the addition of Queen Louise of Sweden, sister of Frederick the Great, whose adviser was her Ambassador in Paris, Charles Gustave Tessin.

The only important acquisition of earlier works during the reign of Louix XV was from the estate of Amédée de Savoie, Prince de Carignan, in 1742. The painter Hyacinthe Rigaud, who usually advised Augustus of Saxony, King of Poland, bought approximately twenty pictures for the King of France on this occasion, including masterpieces by Northern artists: Rubens' *Tournament* and his *Lot Fleeing from Sodom* and *The Angel Leaving Tobias*, by Rembrandt. He also rescued a Raphael, the *Madonna with the Veil*, and Solario's *Virgin with the Cushion*, bought by Marie de Medici in 1619 from the Franciscans at Blois, and at one time owned by Mazarin. Finally, somewhat surprisingly in view of their lack of popularity at court, Rigaud also bought some Seicento pictures, by Annibale Carracci, Castiglione, Guido Reni and Carlo Maratta. However, the sale of the magnificent Crozat collection was allowed to pass without anything being saved from it, thus provoking the lamentations of Bachaumont already mentioned above.

The eighteenth century witnessed the growth of historical studies in France. Research work was methodically carried out by the Benedictines on the history of France, and in 1729-33 was published the *Monuments de la Monarchie française*, by Dom Bernard de Montfaucon. This movement had been initiated in the seventeenth century, however, by a few 'curieux'. One of these, François Roger de Gaignières, had travelled round Europe visiting a vast number of monasteries and castles, and had assembled an extraordinary collection 'of nearly 27,000 prints of all kinds by famous engravers, maps or plans of towns, battles, carrousels, burials, autographs of several kings, queens, princes, princesses, portraits in miniature, all kinds of coloured glass such as is found here and there in old churches; *item* all sorts of ancient fashions of dress worn in France since the reign of Saint Louis till our own day, together with a great quantity of odds and ends, maps, pictures and other things'.[1] Gaignières was one of the tutors of the Duke of Burgundy, and had formed this historical museum to assist in the education of the prince, with the aid of money from the latter and from Madame

[1]*Séjour de Paris, c'est-à-dire Instructions fidèles pour les Voyageurs de Condition*, by S. J. C. Nemeitz, Leyden, 1727. Revised edition by Alfred Franklin, *La Vie de Paris sous la Régence*, Paris, 1897.

de Maintenon. In 1711 he made it over to the King, at the same time requesting various payments for himself and his heirs. In 1716, a year after his death, all the documents were transferred to the Bibliothèque Royale;[1] but in the following year the various objects were sold, and all the pictures except one – the portrait of *King John the Good of France*, which was also handed over to the Bibliothèque Royale. This was inherited by the Bibliothèque Nationale, and was exchanged with the Louvre for some miniatures in 1925. Very fortunately, the genealogist Clérambault saved a great many of the little portraits, inserting them in the bundles of documents in the archives of the Cabinet des Titres Nobiliaries. They now form the main part of the collection of Renaissance portraits in Versailles and the Louvre.

Louis XVI's reign, on the other hand, was one of the greatest periods in the history of the Louvre. No age was ever more fertile in the desire to carry out various schemes, in projects for reform of different kinds, than this feverish period. In the development of museums, as well as in many other fields, revolutionary France made use of principles laid down during the *ancien régime*.

Under Louis XV, much indignation was expressed at the situation in which the change of taste at court had left the King's collection of paintings. Louis XIV had lived a public life, and access to the royal apartments was easily obtainable in his day. The life of Louis XV, however, was more intimate, more secret, and it was not possible to admire the works of the great European masters in His Majesty's collection. Courtiers borrowed pictures from the King; between 1715 and 1736 the Duc d'Antin exhibited in the gallery of his Paris house some of the finest gems from the royal collection – Raphael's *Balthasar Castiglione*, Annibale Carracci's *Hunting Scene* and *Fishing Scene*, and three works by Titian: the *Venus of the Pardo*, the *Virgin with the Rabbit*, and a *Portrait of a Man*. As early as 1744, an anonymous note to the Directeur des Bâtiments[2] deplored this dispersal, and demanded that these masterpieces be exhibited in the Galerie des Ambassadeurs, in the Tuileries. A new attack was launched in 1747, this time in a printed pamphlet by Lafont de Saint Yenne: *Réflexions sur quelques causes de l'état de la peinture en France*. In his view, masterpieces of painting had

[1]In 1784 some of the documents were stolen from the Bibliothèque du Roi, and eventually found their way into the Bodleian Library, Oxford.

[2]Paul Lacroix attributed it to Bachaumont.

an exemplary value; by studying them, artists should rescue story paint-
ing from the decadence into which it had fallen (it was coming back into
favour with the newly developing neo-classical taste). Lafont de Saint
Yenne recommended the building of a special gallery. Two years later,
in 1749, he again took up the idea in a new pamphlet, in which he re-
ported an imaginary conversation between '*l'Ombre du grand Colbert,
le Louvre et la Ville de Paris*', in the manner of Lucian's *Dialogues*.

At that time, the Grande Galerie was in no condition to receive the
pictures. It was in a very dilapidated state, and, ever since 1754, its
whole length had been filled with the extraordinary collection of plans
of the fortresses of the kingdom, of which the first elements had been
installed there in 1697. However, public opinion was not disregarded.
In 1750 Jacques Bailly, who had succeeded his father Nicolas Bailly
as Garde des Tableaux at Versailles, was ordered by the Marquis de
Marigny, Directeur de Bâtiments, to put in order the Queen of Spain's
apartments in the Luxembourg, with a view to exhibiting a selection of
the paintings belonging to the Crown. This provisional museum was
opened on 14 October; it could be visited on Wednesday and Saturday
every week, in the morning from October to April and in the afternoon
from April to October, except on public holidays.

There one could see 110 paintings and a collection of drawings
which, as a precautionary measure, were exhibited in rotation. Atten-
tion was now paid to the study of methods for restoring old pictures
which had already been injured by time – particularly the processes of
renewing the canvas, or transferring the painting to a new support.
Strollers in the Luxembourg could marvel to behold Andrea del Sarto's
Charity, transferred to canvas by Picault, exhibited alongside its former
wooden support. The choice was eclectic: Raphael, Leonardo, Veron-
ese, Correggio, Titian, Rembrandt, Rubens, Van Dyck, Poussin, Claude,
Clouet, Pourbus, Le Brun, Annibale Carracci, Rigaud, Le Valentin,
Van Berchem...

The number of editions of the catalogue proves how successful this
venture was with the public. But in 1778 the Luxembourg palace was
given in appanage to the Comte de Provence, and the exhibition had
to be closed in 1779. It is interesting to observe that the paintings of the

Galerie Médicis were not included in the donation; it was intended to exhibit these in the Louvre, and they were taken down, rolled up, and removed to the depot of the Surintendance at Versailles.

The exhibition in the Luxembourg was only of a temporary character. In 1765 Diderot, in Volume IX of the *Encyclopédie*, transformed the vague project of Lafont de Sainte Yenne into a veritable museological programme making rational use of the accommodation in the Louvre. The ground floor was to contain the sculptures; the paintings were to be housed in the 'Galerie du bord de l'eau' (the Grande Galerie). On the north (no doubt in a gallery yet to be built) were to go the plans of the fortresses of the kingdom; elsewhere, the natural history exhibits and the coins and medals. At the same time, the Académies were to be installed in a more logical fashion in the Louvre, and the Académiciens were to be provided with accommodation there.

The idea of making the collection of the Crown (hitherto the privilege of the court) contribute to the advancement of the arts and sciences is linked with the Encyclopaedic movement in France — and also in England. The Comte d'Angiviller, appointed Directeur des Bâtiments in 1774, worked methodically for the formation of the Museum in the Grande Galerie of the Louvre. He resumed the policy of regular acquisitions, abandoned since Louis XIV; but in a truly 'museological' spirit he directed his purchases to filling the gaps in the royal collections, so that he could present the public with a more complete picture of the schools of painting. As a result of the neo-classical reaction and a return to favour of history painting, Seicento Italian works were again bought: Guido Reni, Procaccini, Crespi, Solimena, Fetti, and so on. In 1786 the English miniaturist Richard Cosway offered to the King the four enormous tapestry cartoons by Giulio Romano, illustrating *Fructus Belli* and the *History of Scipio*. They are comparable with two other great series of Renaissance cartoons Mantegna's *Triumph of Caesar* at Hampton Court, and Raphael's *Acts of the Apostles* in the Victoria and Albert Museum, London.

The seventeenth-century French collections were intelligently completed by the purchase of works which the academic taste of

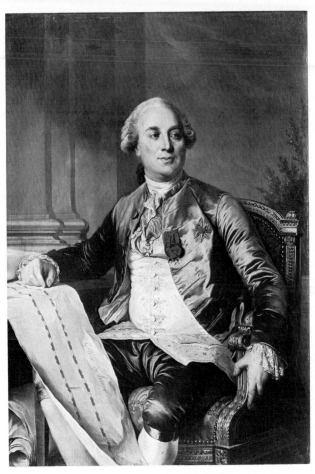

Duplessis *Comte d'Angiviller*

Louis XIV's court had despised: the *Forge*, by Le Nain, the *Last Supper* by Philippe de Champaigne, the *Life of Saint Bruno* series by Le Sueur, bought from the Carthusians in 1776, and the *Chamber of the Muses* and the *Cabinet d'Amour*, also by Le Sueur, removed from the Hôtel Lambert the same year.

But d'Angiviller's attention was turned chiefly to the Northern schools, which were the most poorly represented in the royal collections, and he maintained a team of agents in the Low Countries.

48

Most of the work of these schools now in the Louvre was acquired during this period. In particular, except for the La Caze bequest, the gallery of Dutch painting in the Museum was assembled almost entirely in the reign of Louis XVI. Rembrandt's *Portrait of the Artist with a Gold Chain* and his *Pilgrims at Emmaus* were acquired at this time, to name but two out of a host of trophies; and the purchases made at the Comte de Vaudreuil's sale in 1784 included Ruisdael's *Ray of Sunlight*, Rembrandt's *Hendrickje Stoffels* and his two *Philosophers*,[1] the *Evangelists* by Jordaens, and *Hélène Fourment and her Children*, by Rubens. *Charles I*, by Van Dyck, was bought from the Comtesse du Barry in 1775. D'Angiviller had agents throughout Europe who warned him whenever a good opportunity of obtaining pictures presented itself. He tried to obtain some of the pictures put up for sale by the Belgian religious communities, dissolved by the Emperor Joseph II of Austria. The Emperor, however, simply took possession of the best pieces from the suppressed convents to enrich his gallery in Vienna, thus somewhat limiting the choice of other collectors. In spite of everything, however, d'Angiviller managed to acquire Rubens' *Adoration of the Magi*, from the Annunciades of Brussels, and the *Martyrdom of Saint Lievin* by the same artist, painted for the Jesuits of Ghent. This latter picture returned to Belgium later; it was included in the works allotted to the Brussels Museum in 1803.

The administration did not neglect the Cabinet des Dessins. True, it failed to purchase *en bloc* the collection of drawings assembled by the connoisseur and scholar Mariette, as would have been desirable; but at the entreaties of Cochin, the Conservateur du Cabinet, a selection of more than 1,300 items was bought at the sale for 52,000 livres. Unfortunately, the choice of drawings was dictated by a somewhat academic taste, and the finest works left France.

In a memorandum submitted to the King in 1783, requesting 150,000 livres for the purchase of Dutch paintings in England, d'Angiviller pointed out that the acquisition of these would 'contribute materially to establishing the superiority of the King's gallery, and be of service to the State because of the many foreigners who come to share their enjoyment'. Admittedly the paintings in question were only by Van

[1]Of which one is a school work.

der Werf and even lesser artists, which goes to show how popular these minor genre painters were, when Vermeer was still unknown. The last purchases made at the end of the *ancien régime* were mainly works by Wouvermann, Karel du Jardin, Teniers, Metsu, Terborch (*Lady Entertaining a Soldier*) and Cuyp.

Purchases from living artists were less fortunate. It would take too long to examine in detail all the causes of the 'return to virtue' which took place at the end of the eighteenth century. In any case, the administration which had been blamed in the time of Louis XV for its indifference to the public welfare became so attentive to the latter in the reign of Louis XVI that it extended its concern to the moral education of the people. The Comte d'Angiviller became the apostle of this movement. During this period, far too many Greuzes, Viens and Vernets, too many paintings inspired by ancient history and the history of France 'calculated to re-awaken patriotic virtues and feelings', found their way into the national collections.

Concurrently with the enlargement of the collection, d'Angiviller undertook the restoration of works which had been damaged by the passage of time or the activities of man, and also gave his attention to the framing of the pictures. The magnificent carved frames which had been fashionable since Louis XIV's time were not to his taste; he preferred something simpler, with a cartouche containing the name of the artist and the subject depicted. With an excessive concern for museological consistency, he used this same type of frame for all schools of painting. When the Museum opened, Alexandre Lenoir, the Conservateur of the Dépôt des Grands Augustins, summed up the former Directeur's activities quite fairly when he said of the pictures exhibited: 'd'Angiviller had frames made for them which set them off well, without adding anything to their value.'

No work had been done on the palace since 1670. Abandoned by the kings, from the end of the seventeenth century the Louvre had been invaded by archives, offices, services such as the royal printing works and the Cabinet de Marine, and the various Académies which took up their quarters there in a rough and ready fashion. From 1725, the Académie de Peinture gave exhibitions of its members' work at irregular

intervals in the large room between the Grande Galerie and the Petite Galerie. This room was known as the Salon, a name which was adopted for all future manifestations of this nature. The enormous unfinished palace also served as a place of refuge for the various royal protégés. Not only the approaches, but the interior as well, were filled with stalls, tradesmen, second-hand dealers, and every kind of artisan including a maker of hats. This motley collection wreaked havoc on the palace, constantly risked setting it on fire, and gave the governor endless cause for concern.

In the midst of all this chaos, the Direction des Bâtiments still tried to finish the palace in accordance with the wishes of the Parisians. In 1754, Gabriel undertook the completion of the Cour Carrée as planned in the time of Louis XIV, though lack of credit prevented him from bringing the work to a conclusion. This entailed the construction of a second storey in keeping with the first, and with a flat roof, on the north, south and east sides; on the interior façade he kept to the design of Lescot and Lemercier. Finally, the buildings of various periods which blocked the view of the Colonnade were demolished, and the citizens of Paris were at last able to behold a building which had been made famous by engravings.

Under the directorship of d'Angiviller, various schemes and projects were again undertaken, this time for the completion of the proposed Museum in the Grande Galerie. To provide a more convenient approach to it, Soufflot, Intendant général des Bâtiments, planned a new monumental staircase, the building of which was begun by Brébion in 1781; it led up to the Salon Carré. The problem of lighting and decorating the Grande Galerie, which had been cleared of the plans of fortresses in 1777, occupied several years. Finally, overhead lighting was decided upon; this was judged best for paintings, and a number of sale rooms and private galleries in Paris already employed it. As an experiment, the Salon Carré was provided with it in 1789. During this period, the Galerie was provided with parquet flooring, the timber of the roof was replaced by brick, precautions were taken against the spread of fire by the insertion of fire-resisting walls in the framework of the building and by installing a lightning-conductor — a sensational novelty

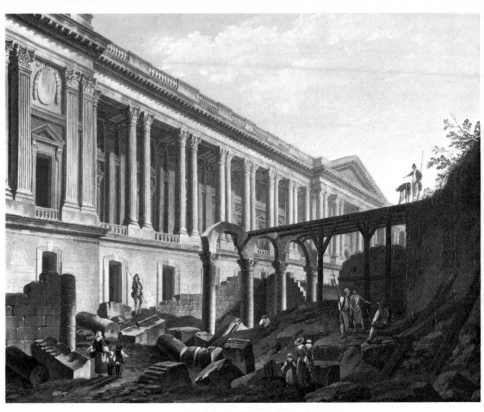

De Machy *The Colonnade*

still, at the time. Finally, the question of décor was considered; to accompany the masterpieces, sculptors were commissioned to provide statues of great men.

In 1784 the painter Hubert Robert was made Conservateur of the future Museum gallery, and given the task of having it fitted out; his assistant was the painter Jeaurat. The Premier Peintre, Pierre, second-in-command to the Directeur des Bâtiments, devoted much labour to this project. The pictures soon began arriving from Versailles and the Luxembourg, and even before they were put on exhibition the public was already requesting the privilege of seeing them. All Paris eagerly awaited the opening of the Museum. In 1787, referring to the old

gallery of plans, the Abbé Thierry said in his *Guide des amateurs et étrangers à Paris*: 'It is intended to turn this gallery into a Museum which will house the pictures belonging to the King, now exhibited in the store-rooms in the Louvre and in the Surintendance at Versailles. Let us hope that we shall see the completion of this glorious project, which may well immortalize Monsieur le Comte de la Billarderie d'Angiviller, who conceived it.' The following year, in his *Etat actuel de Paris*, the Abbé expressed the same wish, and sang the same hymn of praise to the Directeur des Bâtiments: 'All that is needed to complete his fame is to hasten the completion of this monument, so ardently desired by lovers of the arts, which will perhaps give Paris artistic supremacy over Rome.' The Revolution was to deprive d'Angiviller of this honour; but his name will always be coupled with this great institution.

THE MUSÉE NAPOLÉON

The period in which the long-awaited Museum took shape can hardly be called a propitious one. The treasury was bankrupt; on all sides, enemies were threatening the frontiers, and ragged troops, levied in their thousands, were holding at bay the old armies of Europe. Internally, France was a nation wild with enthusiasm and hatreds — civil war, the terror, and executioners with more work than they could handle. Yet during all this, governments which rose and fell like meteors worked devotedly to bring the Museum into being.

The project formed during the *ancien régime* was to be far outstripped by the nationalization of most of the works of art still in France: the art treasures of the Crown, the property of churches, and the confiscated possessions of *émigrés* accumulated in the depots prepared for their reception. In 1790 a 'commission conservatrice des monuments' (which, incidentally, did not fulfil its object) undertook the enormous task of making an inventory of all the art treasures in France. In Paris, the sculpture and pictures from the national monuments — in particular the churches — were sent to the Couvent des Petits Augustins (now the École des Beaux-Arts); manuscripts were sent to other religious houses; the collections of the Crown, from Versailles and other royal residences, were removed to the Louvre. Confiscated *émigré* property was deposited in the Hôtel des Nesles; the Museum Commission was authorized to select from amongst it whatever seemed likely to be of interest for the art gallery which was being formed. To give some idea of the scale on which the National Monuments were ransacked, it may be pointed out that Jan van Eyck's *Madonna of Chancellor Rolin* was taken from the cathedral of Autun; Fra Bartolommeo's large *Mystical Marriage of Saint Catherine*, one of the first Italian paintings to enter France, was later seized from the same church.

As for the property of the *émigrés*, part of it was sold, either for the benefit of the State or for the repayment of creditors — since most of

the great families of France were riddled with debt at the end of the *ancien régime*. The Museum Commission secured a number of master-pieces before the goods were put up for sale; from the Duc de Richel-ieu's collection the Louvre obtained the *Allegories* by Mantegna, Costa and Perugino from Isabella d'Este's *Studiolo* at Mantua. These were taken from Richelieu's château in Poitou, and were joined by Michel-angelo's *Slaves*, found in a house in Paris belonging to the Duke. The famous gilded gallery of the house in Toulouse which is now the Banque de France was stripped of picture by Poussin, Guido Reni, Pietro da Cortona, Carlo Maratta, Guercino, and Alessandro Veronese; and when this gallery was restored in 1870-76 these paintings (two of which are now abroad) were replaced by copies. The statement of objects chosen for the Museum reveals that the majority were works by minor Dutch and Flemish masters, which were very popular at the end of the eighteenth century. Although it is not easy to determine how much of the material in the house of the Directeur Général des Bâti-ments was his own property, and how much of it belonged to the Crown, it seems that the Comte d'Angiviller, who did so much to help in the formation of the Museum, also contributed in spite of himself to the enrichment of its collection. *Saint Matthew and the Angel* — for example — one of Rembrandt's finest works — had formerly been his property.

Shaken by political upheavals, various directorships and commis-sions successively carried on the task of preparing the Museum, to which the painter David lent both the support and the turmoil of his passionate enthusiasm, and of his whole personality. On 27 July 1793 the Muséum Central des Arts was created by decree; on 10 August in the same year the Grande Galerie of the Louvre was officially opened. It was rather dark, being lit from the side; the pictures were placed between the windows, and along the centre were tables on which were arranged bronzes, busts, *objets d'art*, clocks, and other curiosities: 'precious spoils taken from our tyrants, or from other enemies of our country.' The inauguration was only a symbolic one, as the gallery had to be closed again immediately for essential repairs; it was re-opened on 18 November. Out of the ten days in the *decade* which had replaced

the week, five were reserved for copyists, only three for the public, and two for cleaning. On 26 April the gallery had to be closed again for more extensive repairs, undertaken by the architect Reymond. The public was not admitted again till 7 April 1799, and then only to a part of the gallery; the rest was not ready till 14 July 1801. The Galerie d'Apollon was used for exhibiting drawings.

Nevertheless, art treasures were to pour into the Museum from the four points of the compass. Soon after it opened, a whole consignment arrived from Belgium; the Commission temporaire des Arts had taken the initiative in suggesting to the Committee of Public Safety that the vanquished countries could be made to pay their war indemnities in this fashion. Somewhat oddly, the task of exacting these contributions fell at first to the Commission de Commerce et d'approvisionnement; but specialists were despatched to make the selection — among them Jean-Baptiste Wicar, a pupil of David and a member of the Commission temporaire des Arts. Guided by Lieutenant Barbier, another pupil of David, the first consignment arrived on September 19th, 1794, and consisted of the famous Rubens paintings from Antwerp — *The Raising of the Cross*, *The Descent from the Cross*, and the *Coup de Lance*. They were exhibited in the Salon Carré, and such glorification of 'Catholic mythology' was not at all to the taste of the extremists.

The greatest contributor to the Museum, however, was Bonaparte, whose victorious standards were advancing through Italy, the classic land of art. As he was preparing to invade that country, the Directoire government sent him precise instructions to requisition art treasures: 'The citizen commander-in-chief is, moreover, invited to enrich the capital of Liberty with the masterpieces to which Italy owes its reputation, so that the charm of the arts, beneficent and consoling, may add lustre to the brilliance of the military trophies.' Works of art were requisitioned under the terms of armistices and treaties, or accepted in lieu of war taxes; a commission of specialists made the selection. The armistices agreed upon with the Dukes of Piacenza and Modena (9 and 27 May 1796), and the truce signed with the Pope at Bologna (8 June 1796) which was followed by the Treaty of Tolentino (19 February 1797) resulted in the handing over of art treasures from the

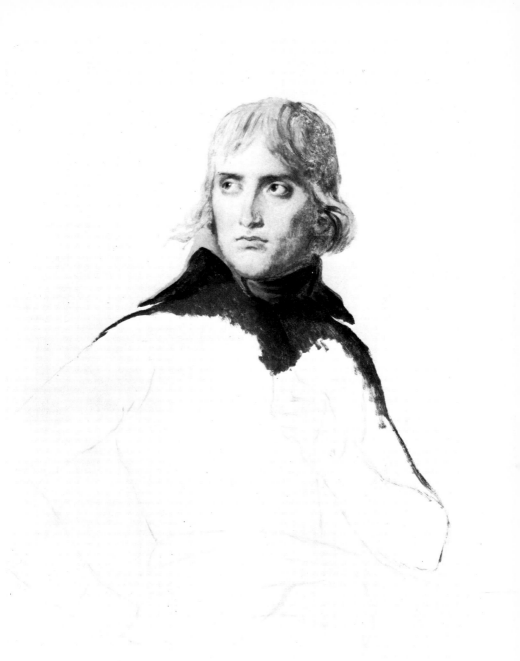

David *General Bonaparte*

galleries of Parma, Modena, Milan, Cremona, Bologna, Perugia, and Rome; requisitioning of works of art from the States of Venice and Rome followed in 1798, and from Florence and Turin in 1800. On 9 and 10 Thermidor in the Year VI (26 and 27 July 1798), the arrival of the first consignment was celebrated in Paris. It was a regular 'victory parade' of the armies of Italy. The captured treasures were brought by water, and unloaded near the Jardin des Plantes; there they were hoisted on to wagons, and taken across Paris, accompanied by the various corporate bodies: the wagons drew up in a circle around the statue of Liberty in the Champ de Mars. Roman antique sculpture could be seen alongside carts loaded with collections of medals, natural history specimens, books, and crates full of pictures; together with these were dromedaries, bears from Berne, and other 'curiosities'. The antiques were preceded by a standard bearing the words:

'La Grèce les céda, Rome les a perdus;
Leur sort changea deux fois, il ne changera plus'

(Greece gave them up, Rome has lost them; twice their fortune has changed, but it will change no more.) But the triumph was an illusion, and after fifteen glorious years was to show itself as nothing but a Pyrrhic victory.

The Louvre certainly deserved the name 'Musée Napoléon' given to it by Cambacérès in 1803, when Napoleon was still only First Consul; Napoleon's name was to remain associated with this policy of appropriating works of art, but although he was its principal instrument, it did not originate with him—it was initiated by the Convention Nationale. In fact, it frequently happened that Napoleon, who wished to deal diplomatically with certain powers, restrained the appetite of his administration, and in particular that of Vivant-Denon, director of the Museum.

However, the administration followed in the wake of the victorious armies; and, vanquished by the Emperor, Europe yielded up its art treasures one after another to France. The German states had to make their contribution to the imperial Museum; Munich was spared, but Berlin, Potsdam, Cassel, Schwerin, Vienna and the Duchy of Brunswick

Prud'hon *Vivant-Denon*

all enriched the Louvre collection in 1806 and 1807 with a large consignment of works by artists of the Northern schools. Napoleon was able to adorn his study at Saint-Cloud – or so it has been thought – with Altdorfer's *Battle of Alexander and Darius* (now at Munich).

After 1810, defeats reduced this flood to a trickle; but even so, a baggage train of crates loaded with Spanish works was halted at Bayonne in 1814 by the downfall of the Empire.

In addition to the masterpieces which were flowing in from all parts of France, and later from all over Europe, new purchases were constantly being made. On 17 February 1795, at one of the most critical moments in the history of the Convention, two pictures were acquired at the sale of the Comte de Choiseul-Praslin: *The King Drinks*, by Jordaens, and *The Carpenter's Family*, by Rembrandt. In 1801, the Museum bought Pieter de Hooch's *Card Players*.

As for Denon, he never missed an opportunity of obtaining a rare work for his gallery, or filling a gap in the collections. His taste can be discerned in such acquisitions as *The Moneylender and his Wife* by Matsys (1806), or Bourdon's *Self-portrait* (1807). One of Denon's most remarkable achievements was to obtain Filippo Baldinucci's collection of drawings which had remained intact since the art historian's death in 1696. The awakening interest in the primitives at that time set in motion a search for early examples of work by the various schools of painting; in 1811, Denon undertook a special mission to Italy to procure some of these. Some pictures he bought, others he seized from among the possessions of the suppressed monasteries; exchanges were planned between the Louvre and the Brera. This mission procured a number of important works which the Louvre still retains, including Giotto's *Saint Francis receiving the Stigmata*, Cimabue's *Madonna with Angels*, Fra Angelico's *Coronation of the Virgin*, the *Visitation* by Ghirlandaio, and Gentile da Fabriano's *Presentation in the Temple*. In exchange for works by Rubens, Rembrandt, Van Dyck and Jordaens, the Louvre received from the Brera four pictures, including Carpaccio's *Saint Stephen Preaching*, and Boltraffio's *Casio Madonna*.

Individuals also contributed to the treasures of the Museum; voluntary gifts are recorded in this period. On 22 Frimaire of the Year VII (11 December 1798), Citizen Clauzel, Adjutant-General of the Army of Italy (later a Marshal of the Empire) offered to the Directory Gerard Dou's *Dropsical Woman*, which had been given to him by Charles Emmanuel IV of Savoy.

The pictures occupied the old quarters of the former Académie — the Salon Carré and the Grande Galerie; furthermore, their continually

The Salle des Cariatides

increasing numbers made any definitive classification impossible. In the Salon Carré, the administration, 'anxious to increase the pleasure of the public, and to provide artists with objects of study', arranged temporary exhibitions of the most recently acquired works. The last of these consisted of 123 pictures collected by Denon in the course of his 1811 mission; it opened on 25 July 1814, after the fall of the Empire, and during enemy occupation.

The Emperor added little to the fabric of the Louvre, but he had at least the merit of having finished off the Cour Carrée, and of bringing a little nearer to realization the 'grand dessein' (later to be completed by Napoleon III) by initiating the junction of the Louvre and the Tuileries on the north side by a building starting from the Tuileries. The building operations were chiefly concerned with the fitting up of the Museum. To accommodate the antiques, Reymond used the apartment

61

which formerly belonged to Anne of Austria (under the Galerie d'Apollon); this section of the Museum was opened on 18 Brumaire in the Year IX (9 November 1800). Between 1806 and 1817, Percier and Fontaine extended it to the south wing of the Cour Carrée; in 1812 the Salle des Cariatides was opened, containing the Borghese collection. The red and white marble of this *antiquarium* was based on the décor designed by Simonetti for Clement XIV in the Vatican Belvedere, and was intended to create an atmosphere reminiscent of the architecture of ancient Rome. As for the Grande Galerie, Percier and Fontaine undertook to redecorate it, making use of schemes devised during the *ancien régime*, and recorded by Hubert Robert in a picture exhibited in the Salon of 1796. Part of the Galerie was provided with overhead lighting; great transverse arches supported on double columns were built, to divide this immense perspective into bays. Actually, the complete project was only finished in our own day; it was inaugurated in 1949.

The magnificent Musée Napoléon was one of the glories of the Empire. People came from all over Europe to visit it; particularly from England, as is proved by the publication of several catalogues in English. The rooms were thronged with copyists. In fact, the Louvre was to play a major rôle in the destiny of French painting. Previously, the education of an artist had been in the hands of a master; henceforth, from Delacroix to Matisse, by way of Courbet and Renoir, it was the great masters in the Museum who supervised artistic education.

Requisition, selection, distribution, installation, removals, reinstallation, classification, restoration, inventories, exhibitions, catalogues, for thousands upon thousands of works — this veritable museological orgy was presided over by Baron Vivant-Denon, appointed Directeur Général of the Museum by Napoleon. The Baron combined an extremely acute mind with reckless bravery, and was the epitome of all the blue-blooded qualities of a nobleman of the *ancien régime*. He had been a courtier of Louis XV, and during the Revolution he managed to find favour with the *farouche* David. He won over Napoleon by his courage during the Egyptian campaign, in which he was a member of the scientific expedition, and he displayed the same courage

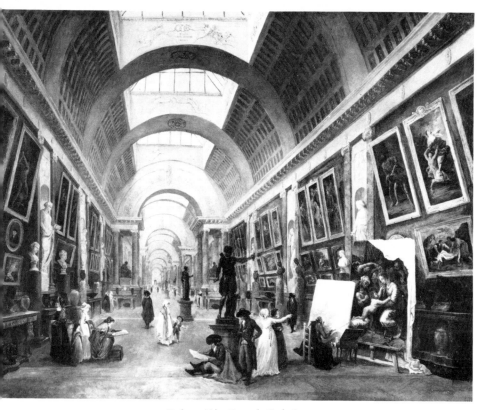

Robert *The Grande Galerie*

when he had to face the enemy again in 1815. A curious print, showing
him working on a staircase in the middle of mountains of books,
objets d'art, statues and scientific instruments, expresses in a picturesque
manner the formidable task which he assumed so cheerfully. In 1814
he was complimented by the King of Prussia himself on the organiza-
tion of the Museum. It is amazing that he was able to accomplish so
much with so few collaborators; to assist him he only had Lavallée,
Secrétaire Général, Dufourny, Conservateur des Peintures, and Ennius
Quirinus, Conservateur des Antiques. The latter was none other
than the Conservateur des Antiques in the Capitol; he was a keen
supporter of revolutionary ideas, and had been Minister of the Interior

and Consul of the Roman Republic in 1798. When the Roman antiques came to the Louvre, he followed them.

The gallery of the Luxembourg Palace, now known as the Palais du Sénat, had been reopened in 1802. The paintings by Rubens had been reinstalled and could now be seen there, as well as works by Philippe de Champaigne, Vernet's series of the *Ports of France*, continued by Hue, and works by living artists, notably David. Thus the idea of making the Luxembourg the 'noviciate' of the Louvre came into being.

A decree of 24 November 1793 had instituted a 'Musée spécial de l'École Française' at Versailles, in order to appease the municipality, who resisted with all their strength the transfer of the royal pictures to the Louvre. A number of paintings considered unworthy to appear in the company of the great masters — *bambochades*, erotic paintings of the eighteenth century, and so on — had thus been relegated to Versailles, together with the diploma pieces of late academicians. This museum played a secondary rôle, and did not last long; in 1800 it was stripped and its pictures allotted to various official residences. By the end of the Empire, it was nothing but a memory.

The Musée des Monuments Français formed in the Dépôt des Petits Augustins is not really connected with our subject, since it contained hardly any paintings; nevertheless, as an institution devoted to medieval and Renaissance art, it deserves to be mentioned amongst the great museological undertakings of the Revolution.

In passing judgment on this wholesale deportation of works of art and 'cultural objects', instituted by the National Convention and continued under the Directoire and the Empire, one must forget the present-day conception of nationalism, which did not apply nearly so rigorously at that period. Not long after the fall of the Empire, Lord Elgin stripped Greece of the Parthenon marbles and transported them to England; and the Emperor of Austria kept in Vienna the treasure of Burgundy and the regalia of the Germanic Holy Roman Empire, after they had retreated from Belgium and Germany before the victorious French armies.

Nevertheless, even in Paris itself this transfer of works of art, especially from Italy, aroused fierce controversy. As early as 1796

a petition protesting against it was addressed to the Directoire. The neo-classical aesthetician Quatremère de Quincy, who initiated it, published it under the title 'Letter concerning the harm done to science by the removal of works of art from Italy'. The petition was signed by a number of distinguished artists: the painter Valenciennes, the architects Percier and Fontaine, and the painters Moreau le Jeune, Louis David, Vien, Girodet, Vincent and Clérisseau. Feelings ran high on both sides, and a counterpetition was addressed to the government in the same year, supporting the opposite point of view. Among the signatories were the painters Gérard, Regnault, J. B. Isabey, and Lenoir, Conservateur of the Dépôt des Petits Augustins.

Rather than passing judgment on this 'looting', it is of more interest from the historical point of view to examine the attitude of mind which prompted it, both under the various revolutionary governments and under the Empire.[1]

The concentration in Paris of some of the greatest European works of art is the outcome of museological policy which was itself closely bound up with the general political aims of the Revolution and the Empire. The Convention and the Directory were convinced that they were liberating the world from tyranny and absolutism; they dreamed of a Europe united under the democratic principles which were the real achievement of the Revolution. The men of this period were imbued with certain political, social and philosophical ideals which they believed would benefit humanity, and which should be extended to include all nations. It therefore seemed natural to concentrate the vital forces of the nation and of Europe in Paris, which would thus set an example of progress to the world. The great achievements in the arts and sciences, born of the patronage of princes and of the Church, had been in some degree 'contaminated by absolutism and obscurantism'; henceforth, they had to be collected together in Paris, in order to contribute to the progress of the human race. This idea is clearly expressed in the letter written on 11 Ventôse of the Year V (28 February 1797) by the Minister of Justice, Merlin de Douai, to Bonaparte, General of the Army of Italy, to persuade him to bring to Paris 'the type used by the pontifical press of the Propaganda'. 'You know to

[1]Museological policy on a European scale during the Revolution and the Empire is further discussed in my book *Le Temps des Musées*, 1967, p. 169–91.

what use this type was formerly put, and you will understand that to send it to Paris, the richest storehouse of human knowledge, is to put into the hands of the government a most powerful means of propagating philosophical principles, the achievements of science and the discoveries of engineering, and of hastening the growth of reason and happiness to which humanity is entitled.' In Paris were to be built up the archives of civilization, making it possible for French scholars to revise the history of politics, the arts, and science, in a spirit of liberation of the nations. This explains the removal of the archives of Simancas from Spain, and of the dossier of the Galileo trial from the pontifical archives.

The name Muséum Central des Arts given to the Louvre by the Convention bears the stamp of this principle, which Napoleon continued to apply on a still larger scale. In fact, he wanted the capital of his thirty *départements* to contain, like ancient Rome, the richest store of treasures in the Empire. But his solicitude also extended to the other cities of Europe, whether they were within the imperial territory or not. The principles of the Revolution, disseminated by his armies, brought about the creation of large museums throughout Europe, in which the public could enjoy collections hitherto reserved for the privileged, for princely courts or for clerical institutions.

Wherever the Napoleonic administration travelled, even where it met with resistance, it left behind museums — in Italy, Belgium, Holland, Germany, and Spain, where the idea of the Prado museum originated with the ephemeral King Joseph. The latter actually prevented his brother the Emperor from taking possession of some works of art and retained them for his own capital, Madrid. Centralization certainly took place in Paris, but on the other hand works were also redistributed and sent to Geneva, Brussels, Mayence and Milan. Although Antwerp had been deprived of its Rubens paintings, Brussels, where a museum had been founded under the Empire, gained one which had been bought by Louis XVI just before the Revolution — the *Martyrdom of St Lievin*.

This concentration of works of art is now foreign to our habits of thinking; but it did not seem particularly scandalous to the enemies of

France who occupied the country in 1814, since they did not interfere with the Musée Napoléon (which was then known as the Musée Royal). In 1814, only works not on exhibition were given back, and many of the pictures which had been requisitioned in Prussia without treaty.

Amongst the allies, certain individuals—and those not the least important—were in favour of the Museum; Baron Humboldt, for example, Minister of Prussia, and a personal friend of Denon. The King of Prussia and the Emperor of Austria, when they visited the Louvre, congratulated Denon on his well-kept galleries. The clauses in past treaties which had enriched its collections were not annulled by the Treaty of Paris; no doubt the various sovereigns who wished to help their 'cousin' in his task of restoring monarchical principles did not wish to deprive him of the works of art in the Museum, which was part of the Civil List of the king of France, and an important element of royal prestige. Thus Louis XVIII was able to say later to the Chambre des Représentants: 'The masterpieces of art henceforth belong to us by rights more stable than those of victory.'

Then came Waterloo. The allies were exasperated at having to kill revolutionary France a second time, and gave her no quarter. Napoleon's valiant escapade cost his Museum its life, as it cost France several of her territorial possessions: the Saar, Landau, Savoy and the Val d'Aosta. The Museum was not in fact very vigorously defended. Talleyrand made an attempt, but did not persist; diplomatic agreement with the allies threatened to present such difficulties that it was judged best not to introduce additional ones on a subject considered to be of only secondary importance. 'Laissez faire' was the order of the day. This attitude clearly emerges from Denon's correspondence with Vaublanc, Minister of the Interior, with the Duc de Richelieu, Minister of the King's Household, and with the Comte de Pradel, all of whom appear to have been ready to leave the responsibility for any actions to their underlings, and were evidently prepared to disown them later, in whatever direction they had operated, on the pretext that they had been acting without orders.

The restoration of art treasures was set on foot immediately after the signing of the military convention (13 July 1815) by Prussia.

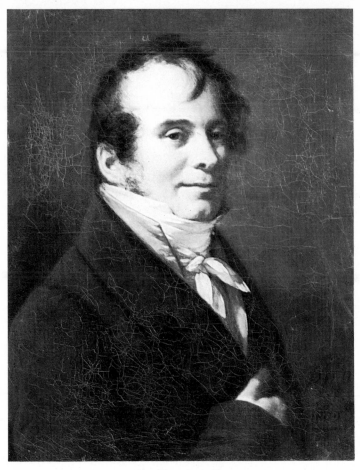

Prud'hon *Lavallée*

Thanks to the threat of the Prussian armies, this favoured the removal of pictures and *objets d'art* which had been taken from the German states. The King of Holland was encouraged by this to appeal for the support of the Duke of Wellington who was in command of the Dutch troops. The Pope, who had no armed force at his disposal, was in a less favourable position, all the more so since the works claimed by his delegate, the sculptor Canova, had been ceded by treaty. The correspondence between Wellington and Castlereagh, chief of the

68

British mission in Paris, reveals the Iron Duke's uncertainty in the face of this confusing—even illegal—situation, since there were no provisions made for works of art either in the Treaty of Paris or in the military convention of 1815. The fact that he was an anglican, and therefore out of sympathy with papism, no doubt made him disinclined to favour the claims of the Sovereign Pontiff. But Canova had a powerful ally in the antiquary Lord Richard Hamilton, who was at that time Under-Secretary of State for Foreign Affairs in the Castlereagh mission. In default of any diplomatic arguments, Wellington's attitude was governed by reasons of morality. He feared, in fact, that the French nation would be reminded of its victories by these trophies, and that they might inspire a warlike disposition; it therefore seemed desirable to him that works of art should be returned to their country of origin. On the 23rd September he wrote to Castlereagh: 'As well for their own happiness as for that of the world... not only then would it, in my opinion, be unjust in the Sovereigns to gratify the people of France on this subject, at the expense of their own people, but the sacrifice they would make would be impolitic, as it would deprive them of the opportunity of giving the people of France a great moral lesson.'

Under the threat of bayonets, therefore, Denon and Lavallée had to resist unaided the claims of the foreign commissioners, in conditions which were intolerable to such punctilious officials. The first commissioners to present themselves—those of Prussia—were so insolent that their sovereign disowned them. On the other hand, Denon readily acknowledged the urbanity of the Austrian commissioners. The last to arrive were those from the Italian states; at their head paraded the sculptor Canova, who insisted on being addressed as 'Monsieur l'Ambassadeur', which won for him the nickname of 'Monsieur l'Emballeur' (the humbug) from the caustic Talleyrand. It was these last that Denon, with Humboldt's support, resisted most firmly, clinging doggedly to the clauses of the treaties.

In November 1815 Lavallée was able to furnish a statement of the works which had been reclaimed; it contained 5,233 items. However, most of the pictures which had been sent to the provinces, some of which were taken outside France, remained where they were. Denon

was able to keep for the Louvre about a hundred canvases and eight hundred drawings. The Florentine commissioners were particularly courteous; by an agreement duly drawn up, they abandoned twenty-nine pictures, and so Denon was able to keep the primitives which he had collected during his mission of 1811, since at that time the Florentines did not appreciate these painters. Thus Cimabue, Giotto, and Fra Angelico remained at the Louvre. The largest painting to be abandoned was left behind by the Austrian commissioner Rosa, representing Austria, of which Venice was a dependent. Veronese's *Marriage at Cana* had been transported from Venice to Paris with great difficulty; this enormous picture had had to be cut in half, and it was not possible to perform the same operation to facilitate its return, because of the way in which it had been put together. Rosa appreciated all these obstacles, and preferred to leave the picture in the Louvre, taking in exchange Le Brun's *Mary Magdalen at the feet of the Pharisee*.

These successes were due to Denon's own personal qualities. The greatest compliment he ever received was paid to him by an enemy. Ribbentrop, the Quarter-master General of the Prussian Armies, had been particularly hostile to him, even going so far as to threaten him with arrest and internment in the fortress of Graudentz; but on leaving Paris he wrote Denon a letter which contained the following passage: 'My gratitude for the pleasant moments passed in your company is joined by that of the whole civilized world, which owes to you the preservation of its great works of art.'

Louis XVIII's government was to prove less generous than the enemy. Denon, who recalled too vividly a glorious past, was not on good terms with the court. In October 1815, weary and aged (he was 62), he requested 'permission to retire from his labours'. His Majesty accepted his resignation, and expressed satisfaction 'with his zealous efforts to save for France some of the masterpieces which she had now lost'. Lavallée, a less skilful courtier than Denon, was not so well treated. He was reproached with ill-timed zeal at the time when the allies were reclaiming their art treasures; the administration accused him of not having consulted it. Full of indignation, Lavallée made a sharp reply to his accusers. In November 1816 he was dismissed.

THE CIVIL LIST MUSEUM

During the Convention, the Louvre was a democratic institution. Throughout the nineteenth century, till the end of the Second Empire, the Museum was attached to the sovereign's civil list and, except for the short interlude of the Second Republic, was a monarchial institution. From the time of the Renaissance, the protection of the arts and the formation of collections had been princely privileges. None of the sovereigns who reigned in France during the nineteenth century — Napoleon III least of all — neglected this powerful means of increasing prestige, and during this period the Louvre was to benefit from a conception which identified the interests of the Museum with those of the monarch.

Immediately after the allies had reclaimed their art treasures, the poor stripped Louvre seemed a veritable symbol of defeat. An attempt was made to restock it; Lavallée, alone now that Denon had resigned, wanted to build up the gallery of paintings again by recalling the works which had been distributed to the provinces by his administration, but he encountered the stubborn resistance of Vaublanc, the Minister of the Interior. Louis XVIII's administration made matters even worse by sending another 300 pictures and 120 *objets d'art* to various museums and churches. However, the King confirmed certain of the artistic gains made during the Revolution; he gave orders that works seized from *émigrés* should remain museum property, except for those which were not on view.

The walls of the Grande Galerie were then covered by bringing in the pictures which had been installed in the Luxembourg in 1802: Vernet's series of *Ports*, Le Sueur's *Life of Saint Bruno*, and above all the *History of Marie de Medici* by Rubens, now removed for the second time from the palace for which it had been designed (and where, in any case, it was not in its original position).

The gaps left in the Louvre by the departure of the antiquities and of the paintings by the great masters were in fact destined to be filled in a manner of which contemporaries could have had not the slightest inkling.

Having created Egyptology, France took the initiative in Assyriology, and was to play a leading rôle in the discovery of early civilization. Works of art were to pour into the Museum in their thousands; moreover, the neo-classical taste which extolled the superiority of Graeco-Roman antiquity made up for the loss of the Vatican sculptures with fine collections of vases, bronzes, and a few original Greek statues. Finally, the increasing interest in the Middle Ages and the Renaissance, due to the Romantic movement, was to initiate the formation of collections of *objets d'art* of those periods.

A second factor, of which contemporaries were beginning to be aware, was to bring into the Louvre so many masterpieces of painting that the walls could scarcely hold them. The Museum was to benefit from the fact that during the nineteenth century France had the good fortune to give birth to a school of painting so rich in talents that only the Italian Renaissance, it has been said, could be compared with it.

Fortunately for contemporary art, the Restoration proved liberal compared with the July Monarchy of Louis Philippe. Most of the hundred and eleven pictures which Louis XVIII's administration bought for a total of 668,256 francs are modern works. Louis XVIII, and later Charles X, did not wish to appear less favourable to artists than Napoleon had done. The picture by Heim, showing Charles X distributing the awards to the Salon prize-winners of 1824, is evidence of his intention to support them. In the Salons, mentions and medals went to the boldest of the innovators; the state bought Delacroix's *Dante and Virgil* (Salon of* 1822) and his *Massacre of Scio* (Salon of 1824). From the regicide David, who was a voluntary exile in Brussels, and who had declined the King's invitation to return to Paris, Louis XVIII bought *Leonidas at Thermopylae* and the *Rape of the Sabines* in 1819 for 100,000 francs, a considerable sum in those days. His administration also bought Prud'hon's *Christ on the Cross* and his *Assumption.* Under Charles X, the Comte de Forbin bought Géricault's

Raft of the Méduse, depicting an event which had been considered a scandal for the royal government; the same Director was also responsible for acquiring David's *Madame Récamier*.

All these works were installed in the Galerie royale du Luxembourg; contemporary masterpieces bought by the state had to spend some time there before joining the Immortals in the Louvre. The Luxembourg gallery was opened on 24 April 1818 for the work of living artists. The recruiting of paintings for this museum did not depend on the Conservateurs of the Louvre, but on other officials of the Administration des Beaux-Arts; these made most of their purchases at the Salons, and their choice was unfortunately guided by that of the juries and followed the official taste of the time.

The museum of Versailles was dedicated by Louis Philippe 'to the glory of great men of all periods', including the revolutionaries, and absorbed most of the funds spent on the fine arts by the July Monarchy. Building work on the Louvre was abandoned; but the collections continued to grow as a result of archaeological researches, and even through the generosity of the King, who liked to take his little daily walk there, in true bourgeois fashion.

Archaeology made rapid strides during this reign, but the activities of the Département des Peintures seemed to slow down; however, a few important items were added to the collection. It seems a pity that more purchases were not made, when prices were so advantageous; Chardin's *Self-Portrait* was bought in 1839, together with that of his wife, for 196 francs. Simone Martini's *Christ carrying the Cross*, which would fetch several hundred thousand dollars today, had been bought in 1834 for 200 francs; Paolo Uccello's *Portraits of Artists* was acquired for 1,467 francs, and the Museum also purchased Mabuse's fine *Carondelet Diptych*. One must not omit to mention the modern works, by Ingres, Delacroix and others, purchased during the reign of the bourgeois King by an Administration des Beaux-Arts which was fortunately eclectic in its tastes.

Louis Philippe gave the Louvre a truly royal present, which it only kept for a few years. Taking up an idea formerly suggested by Denon, the King entrusted to Baron Taylor — a strange and ambitious character

Winterhalter *Louis Philippe*

who had made a name for himself by purchasing and transporting the obelisk of Luxor – the sum of a million francs from his personal fortune, with instructions to go to Spain and form a collection of pictures from that country. The moment was propitious; the Carlist war was at its height – the Jesuits and nine hundred religious houses had been suppressed. Baron Taylor, who knew Spain well, brought back for 1,327,000 francs a collection of 412 Spanish pictures, 15 by Northern artists, and 26 by Italian masters. The collection was lent

to the Louvre by the King, and opened on 7 January 1838 on the first floor of the Colonnade wing. Of course, it contained a good many second-rate paintings, because of the conditions under which it was assembled – Taylor had chiefly aimed at quantity; but there were also a great number of magnificent pictures. These Spanish works were joined by another collection left to the King by a Scottish admirer, F. Hall Standish; this brought in an additional 220 pictures, mostly Spanish, but not of such high quality.

These two collections were claimed by Louis Philippe with his personal goods after the revolution of 1848. The Republic did not come to any arrangement for compensation with the Orléans family; the Spanish museum was given up between 1850 and 1851, after the death of the King and sold in London in 1853 for the sum of 940,000 francs. Louis Philippe's gallery is one of the Louvre's lost opportunities; one does not dare to think of what the Museum would have been if this collection had been retained. Some idea can be gained from the fact that it is the source of most of the Spanish pictures now dispersed in the galleries of Europe and America. Although it was on exhibition for such a short time, contemporary painting reflected its influence; the early work of Courbet and Millet shows traces of it, and Manet, young as he was at the time, was deeply impressed; this early contact determined his definite leaning towards Spanish art. Several canvases returned to France later: the four Zurbarans in the museum of Grenoble, and El Greco's *Christ on the Cross* in the Louvre, bought from Prades in 1908.

Until 1848, most of the Galerie des Peintures was only on show for half the year. In accordance with a custom which originated during the *ancien régime*, the annual Salon was held in the 'Salon' of the Louvre, and occupied part of the Grande Galerie. During the three months of the exhibition, and for a similar length of time while it was being installed, the public was therefore deprived of a large proportion of the pictures in the collection. Under the July Monarchy there were many protests at this state of affairs, which did not even benefit the Salon, since the Louvre was a very inconvenient place for it. The Museum was freed of this encumbrance during the Second Republic.

The July Monarchy may appear to have ended with a favourable balance, but one must not forget that it left the arts in a somewhat adverse situation. Millions of francs swallowed up by the history paintings at Versailles, the misguided restorations at Fontainebleau, the 804,000 francs generously granted to Horace Vernet for covering acres of canvas, the hundreds of pompous history pieces bought at the various Salons which now make hideous, France's provincial museums, the vast decorative works carried out in public buildings or in the Paris churches — the period is irrevocably branded with these errors.

One cannot lay all the blame for this situation on the personality of Louis Philippe alone. The fault is mainly due to the fact that an increasing influence was exercised over the fine arts by an incompetent administration, which looked for inspiration to the aesthetic dogmas propagated by the Institut, and to the rise of the middle classes, who gradually took the place of the aristocratic patrons.

Till the time of Louis Philippe, the king had been accepted as a sort of regent of the arts. It was in his reign that for the first time a conflict arose between the royal patronage and the administration; at the 1832 session of the Chamber, the deputies disputed the King's claim to govern the artists on his own. Nevertheless, authority over the arts remained almost entirely vested in the civil list, on which the Louvre depended, so the King was able to exercise a considerable influence. But the Administration des Beaux-Arts also had large sums at its disposal (sometimes the Parlement voted it special funds, as in the case of the archaeological excavations of Botta). Aided by the École des Beaux-Arts and the Institut, which became more and more actively concerned, this administration helped to increase the discord between official circles and living artists, forcing the latter to take up a revolutionary attitude which was to have dire consequences later.

The short-lived Republic of 1848 played an important part in the fortunes of the Louvre. It was this government which initiated the completion of the palace, finally achieved under Napoleon III. The young republic, born in enthusiasm, was determined not to be outdone by the monarchy in anything concerning the arts. Having decided

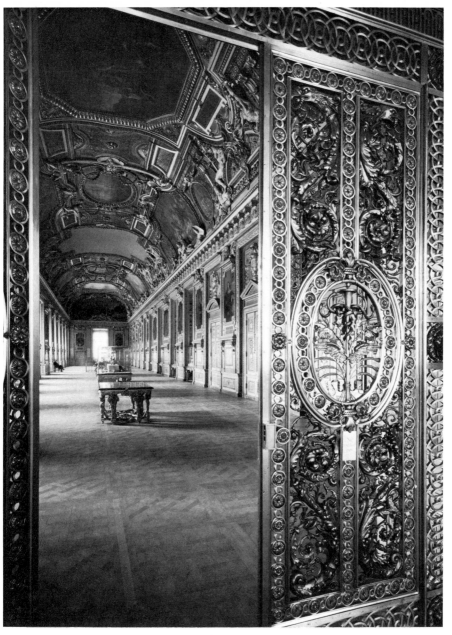

The Galerie d'Apollon

to complete the 'grand dessein', the government wished to dedicate the 'palais du peuple' to the arts and the sciences (thus, in fact, adopting Diderot's project), by housing the enlarged Museum in it, together with the Bibliothèque Nationale, and allotting rooms for industrial exhibitions. It is a pity that this programme was not followed up by Napoleon III and by the Third Republic, which turned the Louvre over to offices.

The sum of money granted by the Assembly was not sufficient to allow the architect Duban to do more than restore – on the pretext of re-establishing their original condition – the outer façades of the Galerie d'Apollon and the Grande Galerie, and put in order the dilapidated rooms in the Museum. The Salon Carré and the Salle des Sept Cheminées were provided with ceilings, heavily ornamented but not unpleasing; the Galerie d'Apollon acquired a ceiling painted by Delacroix – one of his finest works: *Apollo overcoming the Python.* Unfortunately, the original décor was altered to some extent by Duban.

Meanwhile, the Département des Peintures was completely reclassified and reorganized by its Conservateur Villot, who was an amateur painter, a friend of Delacroix, and a man of discerning tastes. He was attached to the Museum administration in various capacities from 1848 to 1874; his painter's studio could be seen for many years in the Louvre, above the Egyptian staircase. On this occasion he compiled the remarkable catalogues which are still the basis of any study of the history of the Département des Peintures. His reclassification remained for the most part unchanged till 1914; it gave evidence of a scientific approach. Pictures were arranged chronologically, and works by the same artist were grouped together. The Salle des Sept Cheminées was devoted to paintings of the Empire period; in the Grande Galerie, works of earlier schools were displayed in order, grouped according to their country of origin. In the Salon Carré were assembled the greatest masterpieces of all schools, on the model of the Tribune of the Uffizi, Florence. On 5 June 1851 the Prince President inaugurated the new installations, accompanied by Monsieur de Nieuwerkerke, a sculptor and a man of good family, who had been

appointed Directeur des Musées in 1849. During the Empire he was the Surintendant des Beaux-Arts, and the salon he held in the Louvre was to be one of the most famous in Paris. His predecessor as Directeur des Musées de la République had been the painter Jeanron. The tradition established during the *ancien régime* of putting an artist in charge of works of art was to remain in force for a long time.

The republican Jeanron was Directeur only for a very short time, but in spite of his brief term of office (28 February 1848–25 December 1849) he made a deep impression on the Museum.

The Conservateurs did not devote their time entirely to classification and restoration; they also continued to purchase works of art. During Jeanron's directorship, the Louvre bought seven pictures for 11,820 francs, four of them by Géricault; during that of Nieuwerkerke, ten pictures were bought for 135,464 francs, among which were a Hobbema, a Perugino, a Rubens, a Memling and three Géricaults.

The annual sum allocated to the Museum for new acquisitions was 50,000 francs, raised to 100,000 francs in 1852. Villot was already complaining of its inadequacy in his own time; but in that fortunate epoch the Parlement did not consider the affairs of the Museum to be beneath its notice, and voted supplementary funds to enable the Louvre to deal with exceptional circumstances. Thus, the Museum was granted 100,000 francs so that it could be properly represented at the sale of the King of the Netherlands' gallery in August 1850, when it acquired Perugino's *Madonna with two Saints and two Angels* for 53,302 francs; the *Portrait of Baron du Vicq* by Rubens for 15,984 francs, and Memling's *Saint John and Saint Mary Magdalen* for 11,728 francs. In the same way the Chambres voted a sum of 23,400 francs to allow the Louvre to buy two pictures by Géricault, the *Wounded Cuirassier* and the *Officer of the Chasseurs*, at the sale of the effects of the late King Louis Philippe, on 29 April 1851.

During the reign of Napoleon III, the Louvre was again to enjoy a brilliant period. A monarchy unsupported by traditional legitimacy is all the more in need of a dazzling façade to gain acceptance. One knows how Napoleon III tried to live down his revolutionary origins

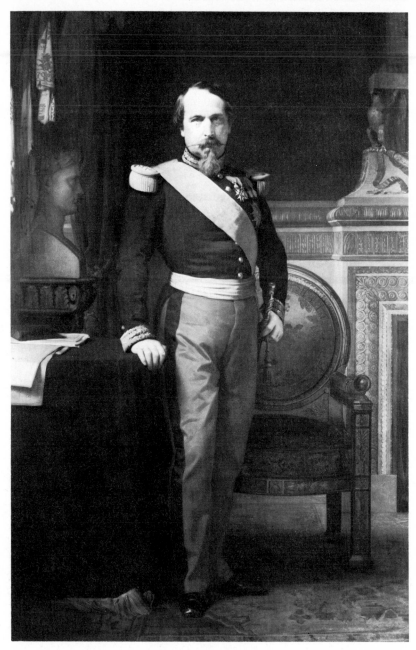

Flandrin *Napoleon III*

by constantly affirming that he was successor of the kings of France. It was in this spirit that he resumed work on the 'grand dessein' — the plan for the completion of the Louvre.

He made his intention clear immediately upon his accession, and had a space cleared for the masons by Baron Haussman, who gained experience for his later undertakings by cleaning up the approaches, where the neighbouring buildings had become entangled with the older parts of the palace. The first stone of the new building programme was laid on 25 July 1852, under the direction of the architect Louis Tullius Joachim Visconti, son of the Conservateur des Antiques in the Louvre. He united the Louvre with the Tuileries on the north, and built a second wing parallel to the Grande Galerie, running about half its length, making a similar addition to its northern counterpart. A number of new courts were thus created. He altered the west outer façade of the Cour Carrée in order to adapt it to the style of his own buildings, and finally provided the Grande Galerie with overhead sources of light. The work went ahead, in spite of Visconti's death in 1854. Three thousand six hundred workmen were employed on it. The Emperor had set a limit of five years in which to complete the task, and this plan was adhered to; the main structure was solemnly inaugurated on 14 August 1857. Four hundred and seventy guests were present at a banquet presided over by Achille Fould, Minister of State; a contractor sat on the minister's right and a stone-cutter on his left. Other workmen were also invited; their presence reflected the socializing pretentions of Napoleon III, a former Saint-Simonian. Unfortunately, Napoleon III was not satisfied with what had been done; on the whole, the work had been carried out with due respect for the past, but it was not rich enough for his taste, and so did not sufficiently advertise the prosperity of the Empire and the magnificence of his reign. He therefore had the whole of it modified between 1861 and 1865 by Hector Lefuel, who covered the palace with an exuberance of decorative sculpture, and destroyed all traces of the old palace in the west part by demolishing that side of the Grande Galerie, thus reducing it by a half — an extraordinary act of vandalism. At the same time, he endowed the palace with those enormous staircases which for

nineteenth-century Europe seem to have been the perfect symbol of power, splendour, and a high level of culture. One finds it hard to believe that these gigantic enterprises were completed in so short a time. Even with the advantages of modern machinery, we are far from matching such records today.

Even as a public museum, the Louvre was still regarded to some extent as having a political function; for instance, Napoleon III made provision for two Salles des États within the Museum, to supplement that already built by Louis XVIII on the Cour Carrée, above the Salle des Cariatides. The Campana collection was installed in the latter in 1862. Following the example of the monarchy, Napoleon III wanted to have his own Salle des États for the opening of the parliamentary session, where both chambers could be assembled to hear the speech from the throne. This was established above the Riding School, and was inaugurated in 1859; it was on the first floor, communicating with the Grande Galerie (the room which now contains the *Marriage at Cana*). However, this 'prestige' room seemed too far away from the Emperor's residence in the Tuileries; Lefuel therefore suggested the construction of a third room adjoining the Tuileries. This was never put to the use for which it was intended; Rubens' paintings for the Galerie Médicis are now exhibited there.

Political considerations underlay everything which Napoleon III undertook for the Museum. One of his first acts was to found what he called the Musée des Souverains, which aimed to legitimize the monarchic principle, revivified by successive dynasties. This museum was installed on the first floor of the Colonnade, where Duban had placed the panelling removed from the Pavillon du Roi; here souvenirs of Charlemagne, Saint Louis, the Valois and the Bourbons could be seen along with those of Napoleon I.

At the beginning of the century, the Museum had received, not undeservedly, the title of Musée Napoléon. The Emperor also cherished the ambition of attaching his name to some great museological creation. The opportunity soon presented itself; the Campana collection in Rome was offered for sale. The Marquis Campana was one of the collecting maniacs so often encountered in the nineteenth century.

He spent nearly ten million on acquiring throughout Italy *objets d'art* of all kind—vases, bronzes, antique terracottas, majolica, furniture, and medieval and Renaissance paintings. Having thus spent his entire fortune, he deposited his whole collection with the Roman pawnbroker's office, of which he was himself the director, and borrowed against this pledge in order to be able to buy more—with the result that his borrowings soon came to four million more than the amount of his surety. He was condemned to the galleys, but saved himself by giving up his works of art. The pontifical government considered reserving for itself the right to buy back the collection in order to complete its own; but it gave up this plan before long. The existence of this immense museum for sale aroused covetous feelings throughout Europe; Russia had already acquired several pieces and the British Museum had begun negotiations. But, thanks to Napoleon III's initiative, France triumphed. Léon Renier, a member of the Institut, assisted by the painter Sébastien Cornu, a pupil of Ingres, was sent to Rome to discuss the purchase. A special fund of 4,260,000 francs was voted as an emergency measure for the acquisition, the transport and the installation of the collections; they were bought for 4,360,440 francs, and were exhibited from 1 May to 1 October 1864 in the Palais de l'Industrie of the Exposition Universelle of 1855. This museum received the name of Musée Napoléon III.

The collection could not be transferred to the Louvre in its entirety; in any case some of the antiques were archaeological finds of little value. The objects regarded as having no place in the Louvre collections were shared out between the departmental museums. The collection of paintings consisted of 646 items, mainly from Cardinal Fesch's collection, which had been broken up in 1843, and from the religious houses of central Italy; it was made up chiefly of fourteenth- and fifteenth-century works which are highly appreciated today, but at that time were considered to be chiefly of historical interest. In that period the Louvre was regarded as a museum of masterpieces, and the Conservateurs of the Département des Peintures gave little heed to items of documentary value. For this reason Baron Reiset only reserved ninety-seven paintings for the Louvre, when he was given the task of distributing

the collection, though when the Académie des Beaux-Arts was consulted it increased the number to 313. The discarded canvases were divided up between sixty-seven provincial museums.

This dispersal aroused vehement protests in the literary and artistic circles of the time, in which Ingres and Delacroix took part. The press took up the affair, and the critics were divided into two camps—for or against the transfer of the collection to the Louvre. Supporters of the autonomy of the Musée Napoléon wanted the collection to become a 'Musée d'études pratiques', or a museum for encouraging industrial art; it was to be a source of models in all genres of applied or decorative arts, on the lines of the Victoria and Albert Museum, London (established in 1852) which aroused a great deal of interest in France.

Émile Galichon, one of the most ardent supporters of this scheme, argued that the entry of the Campana collection into the Louvre would not be in keeping with the original intention of that Museum 'which should confine itself exclusively to pure works of art'.

The 313 pictures which remained in the Louvre were installed in the rooms in the Colonnade, while the antique *objets d'art* were arranged in the old Salle des Gardes, which had become the Salle des États during the Restoration, and which in 1869 was to house the La Caze collection. A painting by Giraud, bought by the Louvre, shows how the room looked before the Campana collection had made way for the La Caze paintings. On 15 August 1863, the feast of the Emperor's patron saint, he opened the museum which bore his name.

Reiset was extremely unwilling to admit the pictures retained by the Académie. He seems to have had nothing but scorn for the Campana collection; perhaps a traditionally classical taste prevented him from appreciating those works by the Italian primitives whose great value had been understood by Delacroix, and yet he himself gave to the Louvre an unsigned work by a primitive artist—this time French: the *Martyrdom of Saint Denis*, attributed to Malouel (1863). When the Empire fell, Reiset lost no time in breaking up the collection. On 8 July 1872 the Minister of Public Instruction made a general distribution of pictures among the provincial museums; the Campana collection lost 141 items, and another 38 during the succeeding years.

It is not so much the actual distribution, but the way in which it was carried out, which is open to criticism. Given the importance of the collection, it was reasonable that Paris should not be the only town to benefit from it; but it would have been better to have divided it into a few large groups of items and kept these groups together in the museums of some of the more important towns, rather than scatter it far and wide. Polyptychs were dismembered, and the separate pieces sent to the four corners of France; series were broken up, *cassoni* were pulled apart, and the distribution was moreover made with so little method that it is now difficult to trace some of the works. In our own time Monsieur Vergnet Ruiz, Inspector-General of Provincial Museums, has applied himself to the task of regrouping, by means of exchanges, a part of the collection in order to form a museum of primitive Italian painting at Avignon—a work demanding much patience, and on which he has spent nearly ten years.

The Louvre, which was poor in Italian works of the fourteenth and fifteenth centuries, kept for itself from the collection a few paintings by Tura, Crivelli, Vivarini, Signorelli, Sano di Pietro, Lorenzo Veneziano, and two great masterpieces, Leonardo's *Annunciation* and Uccello's *Battle Scene*.

The Département des Peintures was further enriched, just before the fall of the Empire, by what was undoubtedly the most splendid gift it ever received. In 1869, Doctor Louis La Caze died, bequeathing his collection to the Louvre; it contained no less than 802 paintings, of which 302, in accordance with the wishes of the donor himself, were distributed amongst the provinces. This prodigious assembly of works of art, containing masterpieces of all the schools of painting, was built up by its owner's taste and flair, rather than his wealth. Doctor La Caze, who lived only for medicine and painting, lived in a house in the rue du Cherche-Midi, completely bare of furniture, among heaps of pictures which had even overflowed into the stables and coach-houses. Some of the greatest masterpieces in the Louvre are there because of his generosity; the quality of his collection can be judged by the following items: Ribera's *Boy with a Club Foot*, the *Portrait of an old Woman* and the *Gipsy Girl* by Frans Hals, the *Reading*

La Caze *Self-Portrait*

Lesson by Terborch, Rembrandt's *Man with a Stick* and *Bathsheba*, the *Benedicite* by Nicolas Maes, *Philopomene recognized by an Old Woman*, and sketches for the ceiling of the Jesuit Church at Antwerp, by Rubens, all of which are amongst the Museum's most valuable possessions. The collection of French works, however, was of capital importance, and included paintings by Le Nain, Largillière, Chardin, two of Fragonard's finest works, and, finally, eight Watteaus — an unprecedented windfall for the Louvre; because of Louis XV's lack of

perception, Watteau would have remained almost unknown in France if it had not been for La Caze.

Numerous purchases were made during the same period, with the evident intention of filling gaps in the collection. Works by Chardin were bought, the *Water-Mill* by Hobbema, the *Lace-Maker* (the Louvre's only Vermeer), and Rembrandt's *Flayed Ox*. An attempt was made to restock the Spanish gallery, so inopportunely lost in 1848. Several pictures from Maréchal Soult's famous collection were bought in 1852, 1858 and 1867: Herrera's *Saint Basil*, Murillo's *Immaculate Conception*, his *Miracle of Saint James* (the *Cuisine des Anges*) and his *Birth of the Virgin, Christ in the Tomb*, at that time attributed to Ribera, and Zurbaran's two great panels, the *History of Saint Bonaventure* and *Saint Apollonia*. Murillo's *Immaculate Conception*, which came from the Hospital of the Venerable Fathers in Seville, cost an enormous sum (586,000 francs plus expenses, which brought it up to 615,000 francs) at the Soult sale in 1852. More than a century later it left the Louvre; in 1941 it was exchanged with the Prado for Velasquez' *Queen Marianna*, since the gallery possessed no authentic work by this artist.

The work of restoring the paintings was being actively carried on at this time; some of the pictures were in poor condition due to their age, and the colours were hidden under darkening layers of varnish. This work sometimes aroused hostile criticism which was echoed in the press — particularly in 1860, when violent disapproval was expressed at the restoration of certain Italian paintings in the Grande Galerie (Raphael's *Saint Michael*, Cima da Conegliano's *Madonna*, and Palma Vecchio's *Adoration of the Shepherds*) and of Rubens' *Galerie Médicis*. Villot was attacked personally; he was then transferred from the conservancy to the administrative branch. Since the Galerie Médicis had been painted by Rubens, it had suffered many vicissitudes. To those already mentioned must be added its stay in the Gobelins from 1828 to 1838; with incredible lack of thought, the paintings themselves had been used as cartoons, and remained rolled up on the looms for years. Villot therefore decided to restore them. The restoration carried out in 1952, before they were installed in their present quarters, revealed the injustice of the attacks on Villot nearly a century earlier; except

for three or four whose deterioration was due to other causes than restoration, these pictures are in a remarkably good state of preservation.

During the war of 1870, the Louvre was used as an arsenal and a clothing store. When Paris was threatened, two hundred and ninety pictures were evacuated to Brest. The antiquities rooms were protected by sand-bags heaped up in front of the windows. The Venus de Milo, however, was the subject of special precautions, which nearly proved fatal to her; she was stored in a courtyard of the Préfecture de Police. The vault protected her from the fire which destroyed the building during the last days of the Commune. When the Empire fell, the Directeur Général, the Comte de Nieuwerkerke, resigned, and the administration was carried on by a Conservatoire of artists, among whom were Courbet, Daumier and Braquemond. The burning of the Tuileries by the Commune destroyed the only old portion of the western end of the Palace; but the fire was prevented from spreading to the Grande Galerie by the action of a battalion of Chasseurs, under Commandant de Bernardy de Sigoyer.

THE NATIONAL MUSEUM

Under the monarchical régimes of the nineteenth century, an institution which made the national collections dependent on the sovereign had not always been regarded with a friendly eye. This mistrust, already visible in the time of Louis Philippe, became more marked over the question of the Campana collection. Certain pamphleteers had protested at the acquisition by the Louvre – a Civil List museum – of a collection which had not been bought with funds from that source, but with money specially voted by the Parlement. They claimed that the State ought to possess a museum distinct from the Louvre, and tried to create discord between the Ministry of State and that of the Imperial Household. When the allies were reclaiming works of art in 1815, had not Louis XVIII tried to persuade the sovereigns concerned that the collections in the Louvre, whose upkeep was provided for out of his civil list, were the property of the Crown?

Under the Republic, this ambiguous situation was to come to an end. The Museum became the property of the Nation, a state of affairs which had both advantages and drawbacks. The Museum no longer benefited from the personal interest of princes; it became simply one of many State institutions, of even less importance, if anything, than the rest. Its fortunes were no longer in the hands of a man for whom it was an important source of prestige; they depended on a 'disinterested' administration, itself dependent on a government and a Parlement for whom the arts had little political importance.

On the other hand, once the Museum had become national property, it considerably stimulated private initiative. Gifts from individuals had already been received under the Second Empire – *objets d'art* from Sauvageot and paintings from La Caze; during the following period these were no longer exceptional, but became the usual method of extending the collections; the Louvre came to depend more on the generosity of private persons than on that of the State. Art lovers

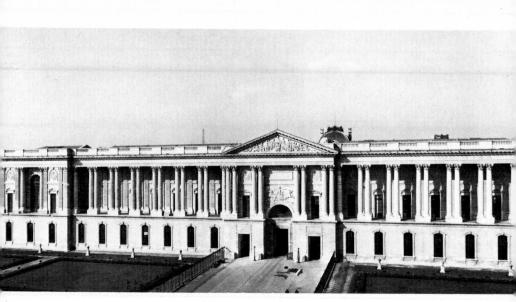

The Colonnade

interested in the future of the Museum eventually pooled their endeavours and formed themselves into a society — the Société des Amis du Louvre, founded in 1897 — which has been responsible for the acquisition by the Département des Peintures of some splendid works, such as the Avignon *Pietà*.

During the early years of the Republic, the Museum was in a very precarious position. Only 162,000 francs of the national budget were allotted for the acquisition of new items — a sum which would not have been sufficient to purchase even one major work. The position changed in 1895, when a law was passed instituting the Réunion des Musées Nationaux; this organization possessed a distinct civil and moral individuality, had its own funds, and was governed by an assembly known as the Conseil des Musées Nationaux. The latter body was divided into two parts in 1941; the administrative council, concerned with financial allocations, and the artistic council, whose rôle was to examine proposed acquisitions suggested by the various heads of departments, who had previously had to submit them to the Comité des Conservateurs. With a view to ensuring that the artistic council should be representative of the taste of all the various elements of

90

society, and that as much control as possible should be exercised over the Conservateurs, this body includes today members of the Institut, officials of the Council of State, of the Cour des Comptes, and of the Ministry of Finance, honorary keepers of the museums, and a certain number of connoisseurs.

The funds of the National Museums were henceforth supplemented by a budgetary allowance, in addition to their own income from various sources: entrance money, sale of the Crown diamonds (1887), sale of Madame Thiers' necklace (1924), and legacies of money.

During the period between 1890 and 1914 Paris was at its height as an international art market. Works of art poured into the French capital from all over the world; opportunities for increasing the collections were therefore frequent. But the Louvre was faced with competition from rich private collectors, from France and elsewhere, and from more recently founded foreign museums which spent considerable sums on stocking their galleries. At that time there was bitter rivalry between museums throughout the world; this is less the case today, since a spirit of international solidarity has developed in the profession. As an example of the desperate struggles to acquire masterpieces, one may cite the case of the *Adoration of the Magi*, by Hugo van der Goes; this was being sold at Montforte de Lemos, in Spain, in 1910, having been discovered in a mysterious way. Paul Leprieur, Conservateur des Peintures, was notified of this by Salomon Reinach, and went with all possible speed to Montforte, only to find that others were there before him — Sir W. Armstrong, Director of the Museum at Dublin, M. Hulin de Loo, Director of the Brussels Museum, and an envoy of Dr Bode, Director of the Berlin Museum. It was the last who carried off the picture, for 1,180,000 gold francs — an enormous sum at that time.

The resources of the Museum were not sufficient to allow it to fill all the gaps in the collection of earlier paintings, as would have been desirable, and to enable it to take advantage of the fact that works of art were changing hands with great frequency between 1880 and 1930. However, a number of important acquisitions were made of works by the primitives: the *Resurrection of Lazarus*, by Geertgen tot Sint Jans,

the *Braque Triptych* by Rogier van der Weyden, bought in 1913 for 800,000 francs, and the Avignon *Pietà*, bought by the Amis du Louvre from the Hospice of Villeneuve-les-Avignon for 100,000 francs; after the exhibition of French primitives in 1904, Dürer's *Self-Portrait* was also bought in 1922, for 300,000. Particular efforts were made to obtain works of schools which were inadequately represented in the Louvre; some good English pictures were bought to this end.

Such was the reputation of the Louvre that it even enjoyed the patronage of foreign benefactors. It owes Patinir's *Saint Jerome*, a valuable addition to the Dutch collection, to the English dealer Lord Duveen. In 1927, the Louvre tried in vain to purchase at the Warneck sale a rare work by Adriaen Brouwer (a landscape) which went for 380,000 francs; with the greatest courtesy Colonel Friedsam, President of the Metropolitan Museum, New York, bought it in order to offer it to the Louvre. In 1948 Mr Percy Moore Turner, an Englishman, presented the Museum with several pictures, including Georges de La Tour's *Saint Joseph*; the Louvre also received a Constable from him in 1952. The most striking demonstration of sympathy with the Museum ever given by a foreigner is the gift made to it by Carlos de Beistegui, a Mexican citizen who collected rare pictures for nearly fifty years; he intended that they should eventually go to the Louvre, and sometimes acted on the advice of the Conservateur in buying pictures beyond the reach of the latter. His collection entered the Louvre in 1953, after the death of its owner. As well as superb portraits by Ingres and David—including the latter's *Napoleon with the Treaty of Campo Formio*—it includes one of Goya's great masterpieces, the *Countess del Carpio*, and admirable pictures by Largillière, Fragonard, Rubens and Van Dyck, together with two valuable French primitives. The money left to the Louvre by the American-born Princesse de Polignac-Singer for the acquisition of masterpieces of painting and sculpture should also be considered as a piece of foreign generosity. Thanks to this legacy, the Louvre has been able to resume the position in the international market which it had occupied before the 1914–18 war; among the works which I have been able to obtain for the Museum through the money thus available mention must be made of the three panels of the

polyptych painted by Sassetta at Borgo San Sepolcro, discovered by me at Bordeaux in 1952.

However, the principal additions to the treasures of the gallery were paintings of the modern French school. Under Villot, paintings of the Imperial school were already being shown in the Louvre, in the Salle des Sept Cheminées; but the canvases of Ingres and Delacroix still waited in the Luxembourg. They were transferred at the beginning of the Third Republic; Napoleon III's Salle des États was allotted to them, and provided with a massive ceiling decoration in stucco which was removed in 1949–50, when the large Venetian room was organized. The inauguration took place on 27 October 1866; Ingres' *Roger delivering Angelica* and his *Apotheosis of Homer* were exhibited there, together with Delacroix's great canvases, the *Massacre of Scio*, *Liberty guiding the People*, the *Women of Algiers*, the *Jewish Wedding*, and the *Entry of the Crusaders into Constantinople* — the last item having been removed from the Galerie des Batailles at Versailles.

A revolutionary spirit inspires all the art of the century. Each group, each artist asserts the right to independence; the powers of innovation of men of genius outstripped the comprehension of society, who laughed at masterpieces which were subsequently to be worshipped. With infallible sureness, the Académie des Beaux-Arts (the chief influence in the Salons) turned public taste in the wrong direction. Ingres and Delacroix, cherished by the Institut and provided with State commissions, enjoyed an official position. Matters were very different for the lesser Romantic masters — for the Barbizon landscape painters, for Daumier, Courbet and Millet. Except for a few purchases at the Salons, by which Millet and Courbet benefited, works by these artists were not bought by the State until they had become dear — in other words, till after the artists were dead — owing to the unfortunate eclectic policy which was pursued. After 1880, successive Conservateurs made praiseworthy efforts to redeem the errors of the Beaux-Arts administration; they would have achieved little, however, without the help of donors. Courbet's *Burial at Ornans* was given to the Museum in 1883 by the artist's sister, Mlle Juliette Courbet; in 1889 a group of art-lovers banded together to purchase the same artist's *The Haunt of the Deer*

93

at the Secrétan sale; in 1890 Madame Pommery gave Millet's *Gleaners*, bought at the same sale, to the Louvre. Two men in particular devoted themselves to the rehabilitation of romantic painting. Thomy-Thierry, a man of refined taste, living quietly in retirement, devoted his fortune to acquiring a collection of 121 pictures by Corot, Rousseau, Dupré, Delacroix, Diaz, Millet, Daubigny, Decamps, Meissonier, Troyon and Isabey, which he bequeathed to the Louvre in 1902. Chauchard, founder of the Magasins du Louvre, bequeathed 140 pictures by the same artists to the Museum in 1910; but his collection had a slightly different character; it was created less to satisfy his personal taste than to fulfil a desire for luxurious surroundings which was quite natural in the case of a successful and important business man who wished to live in a setting worthy of his fortune. He therefore spent large sums on the formation of a collection which was on the whole not so fine as that of Thomy-Thierry; the price of 553,000 francs which he gave for Millet's *Angelus* at the Secrétan sale is still famous in the annals of art dealing.

The minor Romantic artists entered the Louvre without having to pass through a penitential period in the Luxembourg. Théodore Rousseau, constantly rejected from the Salon by hostile juries, condemned to obscurity and poverty by the obstinate lack of understanding of mediocre academicians, now has approximately twenty pictures in the Louvre. During his lifetime, his works had no market value; in 1912 the Museum gave 287,000 francs for his famous *Avenue of Chestnuts* at the Landolfo-Carcano sale.

The State itself made sacrifices in order to obtain for the Louvre some great nineteenth-century paintings which joined works purchased in the Salons on the walls of the Museum. With the help of a national subscription and a contribution from the Amis du Louvre, Courbet's *The Artist's Studio* was bought in 1919 for 900,000 francs. Two years later, Delacroix' *Sardanapalus* was acquired from Baron Vitta for 800,000 francs.

In spite of the scandal they caused, the Impressionists did not have to wait so long at the door of the Museum. They entered the Luxembourg as part of the Caillebotte legacy, of which, unfortunately, only a portion was accepted.

The last gift which we must record in this book is that which Moreau-Nélaton presented to the Louvre in 1906. It is symbolic of the continuity of French painting; Moreau-Nélaton, who was the biographer of Corot, Millet, Daubigny and Manet, had collected works by Manet, Monet, Sisley and Pissarro as well as those by Corot, Delacroix and Daumier. His bequest was housed in the Musée des Arts Décoratifs till 1934, when it was transferred to the Louvre and joined Caillebotte's Impressionists, brought from the Luxembourg in 1929.

With Caillebotte and Moreau-Nélaton begins the great contest of generosity which was to endow the Louvre with the finest collection of Impressionists to be found in any museum. However, this is not the place for describing the episodes of this sensational retribution for official hostility; this book stops short in the years around 1850, and the dramatic story of the Impressionists forms the subject of another volume which I have written for this series, dedicated to the gallery of the Jeu de Paume.

In 1815, after the dissolution of the Musée Napoléon, Vivant-Denon wrote: 'Such an assembly — this comparison of the achievements of the human mind through the centuries, this tribunal where talent was constantly being judged by talent — in a word, this light which sprang perpetually from the inter-reaction of merits of all kinds has just been extinguished, and will never shine again.' Denon, in his mood of despair, was an unreliable prophet; but how could he have foreseen that in the nineteenth and twentieth centuries the Louvre was to fulfil even more exactly the universal mission of the short-lived Musée Napoléon?

The collections of paintings in the enormous palace of the Louvre have been reorganized a great many times during the past century and a half. The Grande Galerie has always remained its backbone; but it benefited considerably from the buildings erected during the Second Empire by Visconti and Lefuel. In 1929 M. Henri Verne, Director of National Museums, decided to rearrange on a more rational basis the multiple collections which had been accumulating in the Louvre since the founding of the Museum. This project entered upon a period of great activity, as far as the Département des Peintures was concerned,

The Grande Galerie in 1939

Packing Murillo's 'Beggar Boy' in 1939

when René Huyghe was appointed head of this department in 1937. He laid the foundations for a logical regrouping of the painting rooms, at that time scattered and overcrowded; but the war put an end to this peaceful activity. In 1939 almost the whole department was evacuated to depots in the Loire region, and these in turn were moved further south at the time of the German advance in 1940. After various other moves, the department's collections finally came to rest in two depots, one of which was the Musée Ingres at Montauban, where Monsieur Huyghe was established. All the large paintings remained in the north of France; they were assembled in the depot at the Château de Sourches, near Le Mans, of which I took over the direction in September 1940.

Moving Courbet's 'The Painter's Studio'

As soon as hostilities were over, the work of reorganization was resumed with the restoration of the Grande Galerie. The alterations of Percier and Fontaine during the First Empire, and Lefuel under the Second Empire, had made it into a hall more than 300 yards long, its walls painted in Pompeian red, and divided into only four bays by the great transverse arches which had been envisaged as long ago as the revolutionary period. This style of décor lent itself admirably to nineteenth-century taste, and during that century the walls were hung with pictures arranged 'en tapisserie' covering them from top to bottom. The fundamental change of aesthetic attitude in our own time required that selected works should be arranged in a single line, and the gallery was therefore redesigned; subdivisions were introduced by means of marble projections with niches containing antique sculpture. These projecting features included pilasters supporting an entablature which had the effect of diminishing the apparent height of the walls. Except for minor details, this impressive scheme of decoration followed the project exhibited by Hubert Robert at the 1796 Salon (now on show in the Louvre

and illustrated here on p. 63). M. Huyghe had intended the walls to be covered with velvet, but this part of the plan was unfortunately discarded by the architectural commission. After a century and a half, therefore, the décor of the Grande Galerie was at last completed; the gallery was inaugurated in 1949 and the paintings of the Italian schools were displayed in it. M. Huyghe was also responsible for the splendid rearrangement of the great monumental works of the nineteenth-century French school in the enormous rooms which had formerly housed, for three-quarters of a century, nearly all the seventeenth- and eighteenth-century French paintings, exhibited in rows one above the other. The same Conservateur must also be credited with having regrouped the unique collection of large Venetian paintings in the former Salle des États; Veronese's *Marriage at Cana* is hung at one end of the room, where it can be viewed from a sufficient distance; the Salon Carré was not large enough to allow of this. The Northern schools were to be placed between the Grande Galerie and the Pavillon de Flore, and the French school was to be arranged in order in the rooms round the Cour Carrée.

When I was put in charge of the Département des Peintures in 1953, and a new allocation of funds became available for further improvements, I felt that the most urgent requirement was the exhibiting of works by Northern artists, and the admission into the Louvre of the French paintings which the City of Paris had very hospitably sheltered for some years in the Petit Palais. New rooms were envisaged round the Cour Carrée and in the Pavillon de Flore, but their immediate construction proved impossible, and I was therefore obliged to modify the original plan, in order to give these masterpieces the benefit of the rooms on the first floor — which, whatever happens, will always be the *piano nobile* of the Louvre. The general current of ideas, sanctioned by numerous post-war books on painting, made it possible to classify a picture gallery otherwise than strictly in accordance with national schools. I therefore determined to exhibit the paintings in such a manner as to show the evolution of styles — as far as this was possible with the accommodation at my disposal — rather than the evolution of individual schools.

The Grande Galerie, up to the Gioconda tribune, was devoted to the growth and maturity of Italian classicism. From the tribune to the far end of the Louvre one could trace more completely than anywhere else in the world the extraordinary flowering of painting in seventeenth-century Europe, in all its varied aspects. The part played by Caravaggio's artistic vision was made clear by a comparison with its development in France and Spain. Proceeding along the gallery, the visitor was reminded in turn of the work of Caravaggio, Guercino, Valentin, the Neapolitan school, Ribera, Zurbarán, Georges de La Tour and the Le Nain brothers. The Grand Galerie ended, however, in the apotheosis of French classicism with the work of Claude and Poussin – both Roman artists. On the far wall, Rigaud's *Louis XIV* viewed this long perspective of masterpieces, many of them there as a result of his patronage.

The triumph of baroque was represented by Van Dyck, Jordaens and Rubens, whose works were displayed in a room leading into the Galerie Médicis. Thanks to alterations carried out in the latter room, I was able to display the Rubens series from the Luxembourg in its original order, in spite of the somewhat cramped quarters. I replaced the imitation rococo frames, dating from the 1900 installation, with frames designed by the architect Emilio Téry, based on the contemporary frames which still survive at Antwerp on the paintings of Rubens, Van Dyck and Jordaens, and taking into account the only information we had on the original frames in the Galerie Médicis – that they were black and gold.

The Golden Age of painting closed with the Dutch school, and the visitor was then introduced to the eighteenth century; this would have been more fully represented when the necessary work had been carried out on the Pavillon de Flore, which had been returned to the Louvre by the Ministère des Finances in November 1961, and where the collections of this period would have been exhibited.

The little rooms built in 1900 on either side of the Galerie Médicis had been modernized, and the paintings were now very well lit. With the assistance of the architect Jean-Charles Moreux, the décor of each of these rooms was designed as a setting for the paintings it was to have contained. The series of rooms on the south side showed the development of Franco-Flemish and Flemish art flourishing in Northern Europe in the fifteenth

century. The Northern rooms were divided into two series; four of them contained gems of seventeenth-century Dutch and Flemish art, and four exhibited what may be called the humanist aspect of Northern-European painting in the sixteenth century – mostly in portraits.

In order to preserve from further damage the Giulio Romano tapestry cartoons which were deteriorating in the Orangerie at Fontainebleau, I found it necessary to install them in the Salon Carré, and this naturally led to the exhibition in the same room of Italian, French and Flemish Mannerist paintings of the sixteenth century. This arrangement was to be ratified three years later by the exhibition 'The Triumph of Mannerism' at Amsterdam, organized on an international basis. The almost impossible problem presented by three rooms which were lit from both sides, between the Grande Galerie and the Pavillon Mollien, was solved very ingeniously by Jean-Charles Moreux: velvet-covered easels were provided, whose position was determined by the requirements of the pictures they supported. These rooms were divided into two galleries; one provided accommodation for the fine collection of paintings bequeathed by Carlos de Beistegui; and, to accompany them (since they were almost all portraits), a magnificent selection of French nineteenth-century portraits, from David to Courbet, was hung in the other gallery.

While all the masterpieces of the French school were shown on the first floor, along with those of the foreign schools, the Louvre possessed a sufficient quantity of French paintings to arrange a special museum of the national school on the second floor, around the Cour Carrée. The first stage of this programme, consisting of the end of the series with the small nineteenth-century pictures, was inaugurated on 14 July 1960 by M. André Malraux, Minister of State in charge of Cultural Affairs, and General de Gaulle, President of the Republic. Work was at once begun on two other wings of the Cour Carrée, as part of the same programme.

In 1965, however, a nationalistic policy led André Malraux to call a halt to the plan for the rearrangement of the paintings that he had approved in 1958 and which was to be completed in 1970. He ordered a return to the traditional division into national schools that had been inaugurated by the Abbé Lanzi at the Musées des Offices in 1788. Now, the sequence was to begin with the French school, which was regarded as the most important.

Another Conservateur-en-chef was made responsible for carrying out this plan, and his first and significant step was the rearrangement of the French school (with the exception of the modern paintings). It was exhibited in the Salon Carré and the first part of the Grande Galerie, but then one suddenly came upon the Italian Primitives, whose size and style clashed with such a monumental setting.

The next stages of this plan presented considerable difficulties: Veronese's *Marriage at Cana* was to be moved into the Galerie Médicis, which already held the great Rubens series, itself to be moved to a gallery in the Cour Carrée that I had already prepared for Le Brun's *Battles of Alexander*. Extensive demolition would have been necessary to move these large canvases and to rearrange the gallery of the Cour Carrée which was too small to accommodate the whole Rubens series, not to mention the risks entailed in moving the *Marriage at Cana* and the three largest Rubens canvases during this operation. Besides, André Malraux' plans had not been well received by the public, who were completely disorientated by the jump from Fragonard to Cimabue in the Grande Galerie. This situation led the new Director of the Musées de France, M. Hubert Landais, appointed in 1977, to decide on a return to the earlier plans, keeping Veronese's *Marriage at Cana* and the Rubens series in the rooms where they had been installed in 1951 and 1953. It was decided that the division into schools should be retained; foreign schools were now to be clearly separated from the French school, centred around the Cour Carrée, with the exception of the large Neoclassical and Romantic paintings, which were to remain in their original position, isolated from the other French paintings, because no other rooms large enough for them could be found. The first floor is reserved for foreign schools, starting in the Salle des Sept Mètres and the Grande Galerie with the Italian school, as it preceded all the others in the creation of Western painting.

Concurrently with all the work on the building, another task concerned with the presentation of the actual paintings is constantly being carried out. Patiently and methodically, the dark varnish with which they were covered in the nineteenth century has been removed – or, rather, lightened, leaving in every case a layer of older varnish, in accordance with the prudent and moderate method initiated by the French school of restorers, at the instigation of René Huyghe and my-

self. In July 1965 I left the Département des Peintures in order to devote my entire attention to these problems of restoration, particularly absorbing at a specially critical period in the life of works of art.

A very great effort has also been made to provide the pictures with antique frames worthy of them. As a result of this policy, which has been followed with perseverance for thirty years, and helped by donations like those of Jules Strauss and Dalbret, the Louvre has at present a finer collection of antique frames than any other museum. In some sections, every one of the works has been reframed.

Few museums have experienced so many changes throughout the ages as the painting collection of the Louvre. The wars, revolutions and changes of government which have affected France during the past century and a half have all contributed to its somewhat disturbed life. In this respect it is very different from a museum such as the Hermitage, which in spite of the evacuation made necessary by World War II has retained the same layout devised in 1861 by Waagen, director of the Berlin museums, in the new building erected between 1840 and 1849 by Leo von Klenze, the great museological architect from Munich.

It is to be hoped that the Louvre Museum of Painting, now that it is at last finished, may enjoy a period of stability, and that whatever plans may be adopted in the future, it will fulfil the double function made possible by its exceptional richness: to express the idea of the universal, and at the same time to glorify the achievements of France.

ITALIAN SCHOOL

Thirteenth and Fourteenth Centuries

CIMABUE (CENNI DI PEPO), active 1240 -1302
Madonna with Angels
Panel: 167 × 108⅝ in. (424 × 276 cm.) Inventory: Inv. 254

This enormous altarpiece was formerly in the church of San Francesco at Pisa. In 1811 Baron Vivant-Denon, the director of the Musée Napoléon, undertook an expedition in search of Italian primitives for his museum, and selected this painting from amongst the property of the suppressed religious houses of Tuscany. It was in the Louvre in 1813, but was not on exhibition till the following year; the Florentine commission of 1815, charged with reclaiming the paintings which had been taken from Tuscany, left it in the possession of the Museum.

This work is related to two other large thirteenth-century altarpieces: the *Madonna* of the Uffizi in Florence, and the *Rucellai Madonna* in Santa Maria Novella. Vasari states that all three were painted by Cimabue, but modern criticism does not accept this attribution in each case. The Uffizi *Madonna* is universally accepted as the work of Cimabue, but the *Madonna* in Santa Maria Novella is usually attributed to Duccio. With regard to the Louvre *Madonna*, opinions vary; many critics regard it as a late work by Cimabue, attributing it to his last years to account for the fact that it displays a greater preoccupation with form than the other two paintings. Others, however, consider it to belong to a later period than Cimabue; but Luisa Marcucci (1956) believes it to be an early work by the master. It has been pointed out, moreover, that the twenty-six medallions on the frame, depicting Christ, the Apostles, angels and saints, seem to be in a more advanced style than the picture itself.

Cimabue's *œuvre* remains in fact very conjectural, for want of documents relating to the surviving works, which would provide a starting point for definite attributions. Vasari recounts that the Louvre *Madonna* won tremendous acclaim for the artist, who was generously rewarded for it by the Pisans.

Cimabue was rediscovered in modern times; when Vivant-Denon chose this picture for the Louvre it was among paintings confiscated from the suppressed religious houses and stored in the Campo Santo, Pisa, and was priced at 5 francs.

It is in remarkably good condition for so old a work. The gold background is covered with an incised pattern.

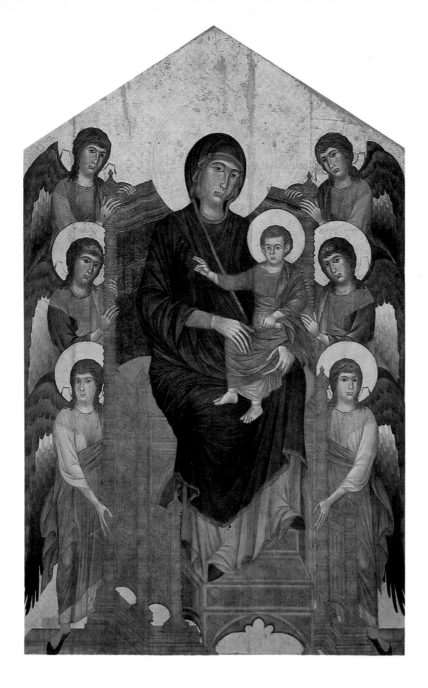

SIMONE MARTINI, 1284–1344
Christ on the Way to Calvary
Panel: 9⅞ × 21¾ in. (25 × 55 cm.) Inventory: Inv. 670 bis

This little panel was part of a larger composition which was divided up in 1826 at Dijon. Four of the pieces (the *Annunciation*, on two panels, the *Deposition*, and the *Crucifixion*) passed into the Van Ertborn collection, which was bequeathed to the Antwerp museum in 1840; the *Entombment* went to the Berlin museum in 1901. The Louvre panel was bought from M. L. Saint Denis in 1834, for 200 francs. The *Deposition* and the *Crucifixion* are signed on the frame 'Symon Pinxit'. The picture is painted on a canvas mounted on wood and covered with a coat of fine plaster.

This polyptych of the Passion was one of the little portable altars which accompanied prelates on their travels and formed part of the furnishing of their 'chapel'. A prelate is represented, kneeling, in the *Deposition* panel; formerly, when it was thought that the painting was executed at Avignon, he was believed to be Bishop Jacopo Stefaneschi. The Louvre panel, however, has the Orsini arms on the back, and the polyptych must have been commissioned by a member of that family.

The distinctly Gothic character of the work, and the fact that it was found in France in the nineteenth century, led G. de Nicola (1906) to attribute it to the last period of Simone's career – the Avignon period between, 1339 and 1344. The latest biographer, however, (M. Paccagnini – 1955) believes on stylistic grounds that the picture was painted in Italy before that date. The iconography of the polyptych, especially the panel with the *Way to Calvary*, has connections with Duccio. As it was sold at Dijon in 1826, Salomon Reinach (1927) believed that it must have been in the Charterhouse of Champmol, the 'Saint-Denis' of the Dukes of Burgundy. Some support is lent to this theory by the fact that the *Way to Calvary* was imitated in a painting on vellum (bought by the Louvre in 1952) attributed to the school of Avignon by M. René Huyghe, but which according to Dr Otto Pächt may be a miniature from the *Grandes Heures* of the Duc de Berry, painted by Jacquemart de Hesdin.

Another piece of evidence, as yet unpublished, also supports Salomon Reinach's hypothesis; it consists of a painting, probably dating from the sixteenth century, in the church of Ranc-les-Saint-Amour in the Jura, which was examined by the Louvre in 1939. It is a literal copy of Simone's *Way to Calvary*, interpreted in a later style.

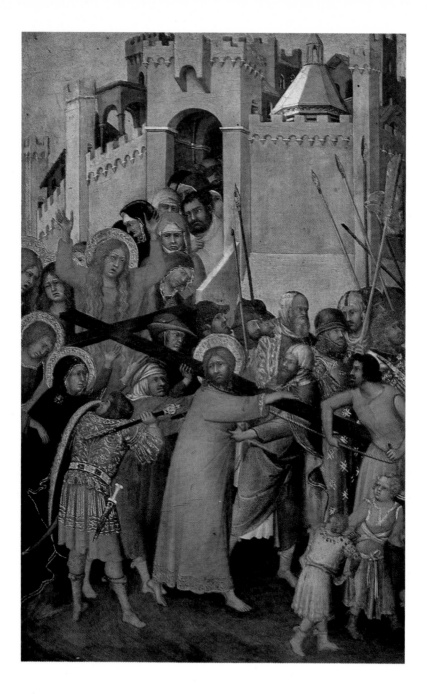

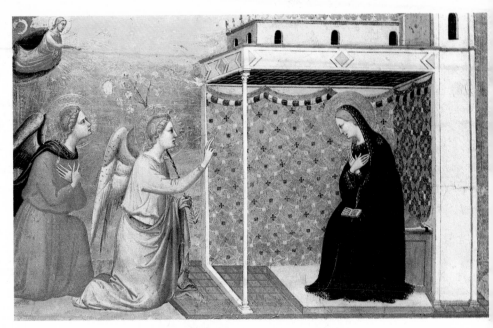

Bernardo Daddi *The Annunciation*

Giotto
St Francis of Assisi

Italian School
St Francis of Assisi

Paolo Veneziano
Madonna and Child

Lorenzo Veneziano
Madonna and Child

French School *The Parement de Narbonne*

FRENCH SCHOOL

Fourteenth and Fifteenth Centuries

FRANCO-FLEMISH SCHOOL, *c.* 1400
Pietà
Panel: Tondo. Diameter 25¼ in. (64 cm.) Inventory: M.I. 692
(Reproduction p. 110)

Bought from M. Jules Pujol of Toulouse in 1864, for 3,000 francs.

On the back of the painting are the arms of France and Burgundy, a fact which suggests that it may have been commissioned by one of the Dukes of Burgundy of the period indicated by the style of the work—either Philip the Bold (d. 1404) or John the Fearless (d. 1419). Moreover, the painting really depicts the Blessed Trinity, beneath whose patronage was placed the Charterhouse of Champmol at Dijon, built and richly embellished by the Dukes in order to house their tombs.

The elegance of the draughtsmanship is reminiscent of Paris, but the softness and fluidity of the modelling and the brilliance of the colours are Flemish in origin. Historians have hitherto dwelt mainly on these characteristics; it is surprising that they have not also pointed out other elements which denote Italian influence. The figure of Christ, for example, derives from Duccio; the flowing contours also recall the Sienese manner, here softening the linear character of the Paris style. The brilliant blues and reds are typically French, but some subtle half-tones are reminiscent of Lombard colouring. This picture is the product of a refined and artistic civilization, the heir of traditions which had already become secularized. These same characteristics, used in a different way, are found again in the *Last Communion of Saint Denis* (also in the Louvre),

109

which is known to have been finished by Henri Bellechose in 1416. The official painter of the Duke had been Jean Malouel, a native of Gelderland, who was in Dijon in 1398; as he died in 1415, it is thought that he may have left the *Last Communion of Saint Denis* unfinished, and by analogy he has been credited with this *Pietà* (known as the *Grande Pietà Ronde*) to distinguish it from a small *Pietà* tondo in the same style, also in the Louvre. All these attributions must remain conjectural, however, for want of any conclusive documentary evidence.

The fact that we have few works by French primitives is not because of any lack of aptitude for painting, as some have suggested; it is because of the extraordinary lack of interest shown in them by the French humanists of the seventeenth and eighteenth centuries, who despised the Middle Ages and destroyed many of its 'out-dated' products.

SCHOOL OF AVIGNON, mid-fifteenth century
Pietà
Panel: $63\frac{3}{4} \times 85\frac{3}{4}$ in. (162×218 cm.) Inventory: R.F. 1569

This painting, formerly in the Charterhouse of Villeneuve-les-Avignon, was very nearly burnt in 1793, being considered merely a religious emblem of no use either to the citizens or to the Republic. It was saved by a priest, and in 1801 it was in the parish church, where its beauty was later noticed by Degas. It remained there till 1872, and was then removed by Revoil, the architect in charge of Historical Monuments, and placed in the Hospice (now a museum) with other works from the Charterhouse. It remained the property of the vestry, however. Its existence was made more generally known during an exhibition of French primitive painting organized by Henri Bouchot in 1904; it was then bought from the municipality by the Société des Amis du Louvre for 100,000 francs, and presented to the Museum in 1905.

The nobility of its style, and the sublime sense of sacrifice which it expresses, make this picture one of the supreme manifestations of Christian art, in addition to being a masterpiece of painting. The panels on which it is painted have become warped with age, but this only serves to increase the effect of intense suffering which it conveys. Out of respect for this great work of art, no restoration work has been carried out either to the support or to the painted surface, once it was ascertained that no further deterioration was taking place.

For nearly fifty years, historians have tried in vain to identify the artist. After some uncertainty at first, when it was believed to be possibly of Spanish origin, it is now universally attributed to the School of Avignon. It is thought to have been painted in the third quarter of the fifteenth century, possibly by Enguerrand Quarton. The Charterhouse of Villeneuve commissioned a *Coronation of the Virgin* from this artist in 1453. This painting is now in the Hospice there, and is very close in style to the *Pietà*.

It has recently been suggested by Jean and Hélène Adhémar that the donor was neither a Carthusian nor even a canon, but a layman, and that the building in the background was inspired by Hagia Sophia, Constantinople.

Henri Bellechose
The Last Communion and Martyrdom of Saint Denis

Franco-Flemish Master *The Altarpiece of the Paris Parlement*

Jean de Beaumetz
Calvary with a Carthusian Monk

School of Paris
King John the Good

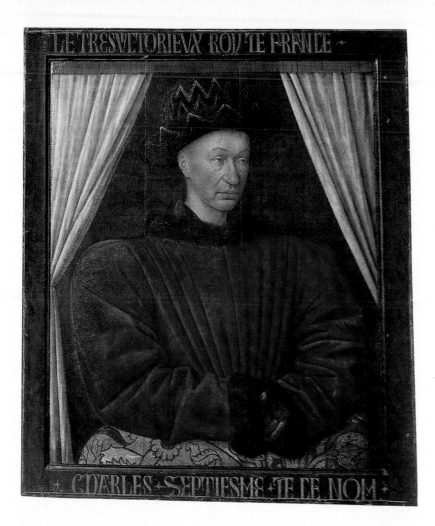

FOUQUET, JEAN, d. between 1477 and 1481
Charles VII, King of France
Panel: $34 \times 28\frac{1}{2}$ in. (86×72 cm.) Inventory: Inv. 9106

In the eighteenth century this picture was in the Sainte-Chapelle at Bourges, which was built by the Duc de Berry, and whose destruction was authorized by letters patent of Louis XV in 1757. These letters refer to 'the painting and portrait of Charles VII one of our former kings, in the said Sainte-Chapelle, which we wish to have transported and placed in our picture cabinet in the

Louvre'. The portrait must have been moved during the Revolution, because under Louis Philippe it was bought for the museum at Versailles, as an 'ouvrage grec', for the sum of 450 francs.

This is a secular portrait, and not a donor picture. It is still in the original frame, on which the following inscription appears: 'le très victorieux roi de France Charles septième de ce nom'. This inscription suggests that the portrait may have been executed either after the truce of Arras in 1444, which gave France time to recuperate, or after 1450, the date of the Treaty of Formigny which ratified France's victory. By the latter date, Fouquet had already visited Italy; he must have done so before 1447, since he painted the portrait of Pope Eugenius IV who died that year. Since the Charles VII portrait is still entirely Gothic in spirit and shows not the slightest trace of Renaissance influence, it was most probably painted in about 1444.

A watercolour copy (now in the Bibliothèque Nationale) which Gaignières made of this portrait when it was still in the Sainte-Chapelle at Bourges revealed that in his time it was without the clumsy brown checkwork on the green background of the painting which was visible up to 1939. At this date the objectionable addition was removed, though it was not possible to eradicate every trace of it.

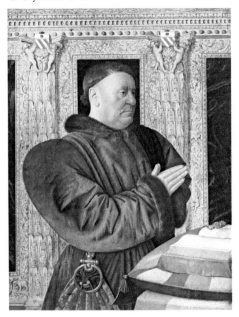

FOUQUET, JEAN
Guillaume Juvénal des Ursins

Acquired in 1835 from the Comte de Hamel for the Versailles museum, where it was taken to be a work of Wolgemuth. The portrait was commissioned by the scholar Roger de Gaignières and executed about 1460. Guillaume Juvénal des Ursins (1400–72) was Charles VII's Chancellor from 1445 to 1461, and Louis XI's Chancellor from 1465 to 1472. He claimed relationship with the Orsinis of Rome (their family arms shown here). The architectural detail indicates the early influence of the Italian Renaissance.

THE MASTER OF MOULINS, *c.* 1490
Saint Mary Magdalen and a Donor
Panel: 21 × 19¾ in. (53 × 40 cm.) Inventory: R.F. 1521

This picture was formerly in the Somzée collection in Brussels, and was bought from the London dealer Agnew in 1904 for 125,000 francs. It must be the left wing of a triptych of which the centre panel and the right wing have not survived.

It was once thought to be a work of the Flemish school, but is now attributed to the unknown master who painted the large triptych of the Virgin in Moulins cathedral, commissioned about 1498–99 by Duke Pierre II of Bourbon and

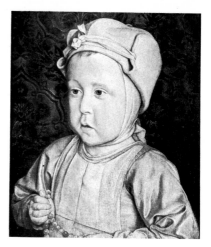

Master of Moulins
Portrait of a Child

Master of Moulins
Charles Orland

his wife Anne of Beaujeu. About ten other paintings have been grouped with this triptych; certain analogies between the facial types and details of costume in these paintings and in the *Virtues* on the tomb of the Dukes of Britanny at Nantes, by Jean Perréal, have led to the supposition that this artist could perhaps be the Master of Moulins. Perréal played an important part in the life of Charles VIII's court and that of Louis XII; in 1487 he was in the service of the Sire de Beaujeu, who became Duke of Bourbon in 1488.

This identification remains hypothetical, however. It has not yet been possible to discover the status of the lady represented as the donor.

The picture is even finer in quality than the portraits in the Moulins triptych. By the ivory complexion of the saint and the more rosy one of the donor, the artist has subtly suggested that they belong to two different worlds.

The empty look in the donor's somewhat prominent eyes, her inexpressive face with its coarse features, are in marked contrast with the Magdalen's profound expression and the intelligence and nobility of her features. This ideal type created by the artist corresponds with the type of Virgin with which he was familiar, but is perhaps inspired by someone he knew. The same contrast can be seen in the hands of the two women. There is no life or spirituality in the stiff, joined hands of the donor, which reveals a petty soul; but the exquisite right hand of Mary Magdalen, immaculate, supple and sensitive, vibrates like an angel's wing. Yet at the same time it is full of humanity, and combines the qualities of gentleness and firmness found in those rare women who are the guiding spirit of their homes. Such a combination of realism and the ideal is only to be found in French art.

117

FLEMISH SCHOOL

Fifteenth Century

VAN EYCK, JAN, *c.* 1390–1441
The Madonna of Chancellor Rolin
Panel 26 × 24½ in. (66 × 62 cm.) Inventory: Inv. 1271

In the early eighteenth century this picture is mentioned as being in the collegiate church of Autun, in Burgundy. It was confiscated during the Revolution, and selected by Alexandre Lenoir for the Louvre. It was acquired by the Museum as a work by Van Eyck, and was exhibited there in 1805.

The solemnity with which the Virgin presents the Christ Child to the donor is reminiscent of early representations of the Adoration of the Magi. Here she is seen as the Queen of Heaven; the Romanesque *loggia*, with its sculptured capitals depicting Old Testament subjects and scenes from the Christmas cycle, is the Temple of Jerusalem; the little garden beyond is the 'enclosed garden', symbol of Mary's purity, and the town seen in the distance, with the range of snow-capped mountains in the background, is the Heavenly Jerusalem.

Van Eyck's picture may be full of symbolic meaning, but it is expressed through the minute representation of outward appearances. The identity of the town has been the subject of much discussion. According to a recent theory, strongly supported with topographical arguments by M. Jean Lejeune, it is a faithful representation of Liège, but there are some serious objections to this identification.

The donor is traditionally held to be Nicolas Rolin, Chancellor of Burgundy (1376?–1462), a personage of considerable importance at the court of Duke Philip the Good. The picture must therefore be later than 1425, when Van Eyck entered the Duke's household; it is usually believed to date from about 1436, on the evidence of the Chancellor's apparent age and also because it has certain affinities of style with the Van der Paele altarpiece, which bears that date. M. Jean Lejeune, on the other hand, considers the painting to be an early work, executed at Liège before 1422; which implies that Hubert van Eyck may have collaborated on it. According to him the two figures in the background are the brothers Van Eyck.

In spite of a certain amount of repainting, and some premature cracking of the surface, particularly on the Virgin's face and cloak, the picture is in exceptionally good condition, a fact which contributes to its high quality. It is very rare for a work of this period to have survived with all its subtleties and refinements, its glazes and its delicate transitions of tone, so well preserved.

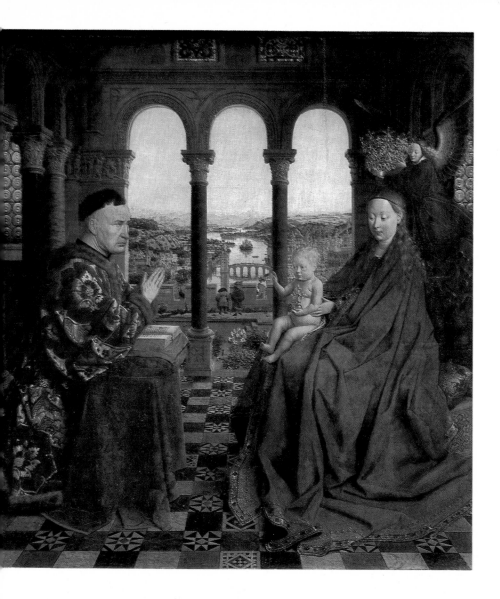

VAN DER WEYDEN, ROGIER, *c.* 1400–1464
The Braque Triptych
Panel: 16¼ × 13½ in. (41 × 34·4 cm.) Inventory: R.F. 2063

The armorial bearings on the back indicate that this portable triptych was the property of Jehan Braque and his wife Catherine de Brabant, of Tournai, who were married in about 1450–51. Jehan Braque died soon afterwards, in 1452; his young widow, who did not marry again till 1461, must have commissioned this triptych in his memory. When she died, in 1497, she left it to his grandson, Jehan Villain. Later, some time before 1586, Villain's heirs presented the 'fort exquis tableau en peincture' to Jérome de Brabant, in order to restore the painting to the family whose arms it bore. In 1845 the picture turned up in England, in the possession of a London artist named Evans; it was purchased by the Marquis of Westminster, who bequeathed it to Lady Theodora Guest. In 1913 the Louvre bought it from Kleinberger, the dealer, for 800,000 francs.

The centre panel of the triptych represents Christ in benediction with Mary Magdalen on the right and John the Baptist on the left. On the back of the left-hand shutter is a death's head on a broken piece of brick, with the Braque coat-of-arms; on the back of the right wing is a cross. Both the obverse and reverse of the triptych bear inscriptions of a theological or moralizing nature. One is a passage from Ecclesiasticus: 'O Death, how bitter is the remembrance of thee to a man that hath peace in his possessions! To a man that is at rest, and whose ways are prosperous in all things, and that is yet able to take meat!' On the frame round the death's head can be read the words: 'You who are so proud and haughty, take heed; my once-beautiful body is now food for worms.' In 1854 Waagen read an inscription, 'Braque et Brabant', now almost invisible.

The picture dates from Rogier's finest period. His visit to Italy (in 1450) inspired him with a feeling for form which later gave way to a greater degree of realism and a certain weakening of style. The dignity and spirituality of the three figures is perhaps an echo of Fra Angelico's art.

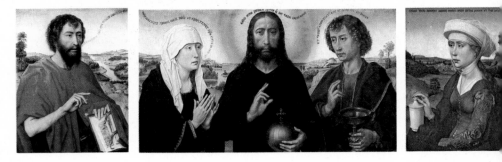

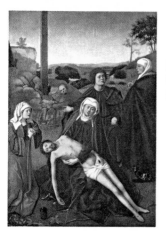

Petrus
Christus
Pietà

Hans
Memling
*Portrait of
an Old
Woman*

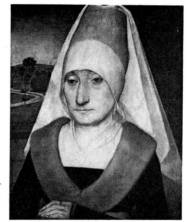

MEMLING, HANS, *c.* 1433–1494
Mystical Marriage of Saint Catherine of Alexandria
Panel: 9⅞ × 5⅞ in. (25 × 15 cm.) Inventory: R.F. 309
(Reproduction p. 122)

This picture was bequeathed to the Louvre in 1881 by M. Edouard Gatteaux; the other wing of the diptych of which it originally formed a part was re-united with it in 1894, when M. and Mme Edouard André left to the Museum the panel showing Jean du Cellier being presented by St John the Baptist. The panel illustrated here depicts St Catherine, in a gown of gold brocade with a red velvet bodice, seated on the left and receiving the ring from the Holy Child. The latter is held by His mother, who sits in the centre of a half-circle formed by St Agnes, St Cecilia (playing a portable organ), St Barbara, St Margaret of Antioch and St Lucy.

The same subject was also painted by Memling in a triptych dated 1479 in the Hôpital Saint-Jean, Bruges. A certain awkwardness of drawing, particularly the over-long arm of St Catherine, suggests that our picture is an earlier work; it still shows traces, moreover, of Dirk Bouts' influence. Memling favoured the theme of the Virgo inter Virgines (with or without St Catherine); he may have borrowed it from the northern Low Countries, where it was a speciality of the painter known as the Master of the *Virgo inter Virgines*. Here the theme is combined with another derived from Memling's native German Rhineland: that of the *hortus conclusus*. Mary and the virgins are in fact gathered in the open air to assist at the mystical marriage; they are in a meadow, in the middle of which an enclosure bounded by a hedge of roses can be seen behind the group.

The châteaux of the Middle Ages used to have a walled garden where fruit trees and medicinal herbs were grown, as well as a few ornamental plants.

121

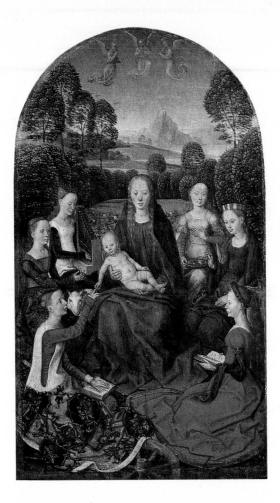

During the Italian Renaissance, this enclosed garden survived under the name *giardino segreto*. When the Virgin became identified with the Spouse of the Song of Songs, the epithet *hortus conclusus* was applied to her; and this enclosed garden, the symbol of her purity, was made in the pattern of the feudal garden.

Thanks to Memling, Flemish art, which had been realist in the case of Van Eyck and austere with Rogier van der Weyden, but always virile, now acquired a certain femininity. The artist subscribed to the courtly tradition, which had a secular origin during the eleventh and twelfth centuries, but was sublimated to the cult of the Blessed Virgin from the thirteenth century onwards.

122

THE QUATTROCENTO

FRA ANGELICO (GUIDO DI PIETRO DA VECCHIA;
in religion FRA GIOVANNI DA FIESOLE), d. 1455
Coronation of the Virgin
Panel: 84 × 83¼ in. (213 × 211 cm.) Inventory: Inv. 314

The predella is in six parts, and represents scenes from the legend of St Dominic (page 124, right), grouped round a painting of the dead Christ with the Virgin and St John.

This work comes from the church of San Domenico at Fiesole; Vasari saw it there, and described it in glowing terms. It was deposited in the Accademia

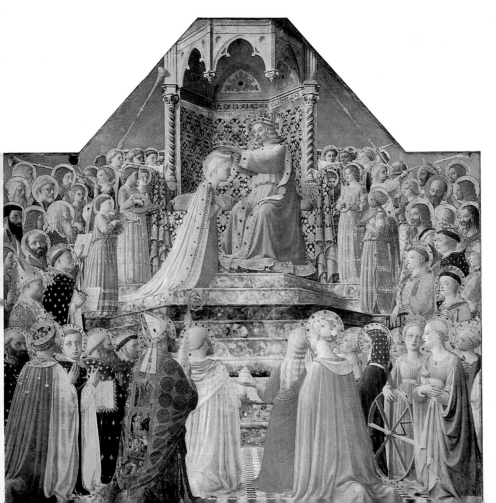

along with other works from the suppressed religious houses; there it was seen by Vivant-Denon in 1811, and chosen for the Musée Napoléon, of which he was director. It arrived there in 1812, and was exhibited in 1814. The Florentine commission of 1815 left it in the possession of the Louvre.

Historians have disagreed over the question of when Fra Angelico painted this picture; it is extremely difficult to establish a chronology for his work. The suggested dates range from 1425 to 1439; around 1435 seems to be the most likely period.

Opinions also differ over the extent to which his pupils were responsible for its execution — a problem which crops up in connection with almost all Fra Angelico's work. The quality of the painting is excellent, but the last two panels of the predella are definitely weaker than the rest. The latest hypothesis is that of Mr. J. Pope-Hennessy, who suggests that the work was finished by Domenico Veneziano. His argument does not rest on any difference of quality, but on what seems to him to be a difference of style between the upper part (Fra Angelico) on the one hand, and the lower part and the predella (Veneziano) on the other. However, the dissimilarity of architectural styles could be accounted for at this date by the survival of a tradition; Fra Angelico could have kept to the Gothic style (because of its religious significance) for the Coronation dais, and used the Renaissance style elsewhere, as Jean Fouquet did in the *Heures d'Étienne Chevalier*. The use of two or more different viewpoints is also quite common in Renaissance painting. Finally the more vivid tonality apparent in the right-hand part of the picture is due to the fact that the surface in that area is more worn.

Fra Angelico
Martyrdom of SS. Cosmas and Damian

SASSETTA (STEFANO DI GIOVANNI), 1392–1450
Virgin and Child adored by Angels
Panel: 79 × 47 in. (205 × 119·5 cm.) Inventory: R.F. 1956. 11
(Reproduction p. 126)

Sassetta *The Blessed Ranieri freeing the Poor*

This Madonna, together with a St John the Evangelist and a St Anthony of Padua, was bought by the Louvre in 1956 from a collection at Bordeaux, for the sum of 50,000,000 francs – partly with the accumulated interest from a Canadian endowment.

I discovered the three pictures at Bordeaux in 1950; they were at that time attributed to Fra Angelico. I immediately identified them as part of the large polyptych by the Sienese artist Stefano di Giovanni (Sassetta), painted between 1437 and 1444 for the church of the monastery of San Francesco at Borgo San

125

Sepolcro, in the Marches. It is surprising that they should have escaped the researches of such critics as Berenson and John Pope-Hennessy, who had made a close study of this altarpiece. An examination of the documents established that these pictures were certainly mentioned during the nineteenth century, but modern critics had dismissed this evidence as unreliable. In 1823 Romagnoli saw a *Madonna and four Saints* and a *St Francis in Ecstasy* from the Borgo San Sepolcro altarpiece, in the possession of Don Pietro Angelucci, parish priest of Monte Contieri; the same panels, assembled as two triptychs, were again seen in about 1855–60 by Cavalcaselle, in the Lombardi collection in Florence. One of these triptychs, showing St John the Baptist and the Blessed Ranieri Rasini on either side of St Francis in Ecstasy, was later bought by Bernard Berenson, and the three panels are now in his villa *I Tatti*, at Settignano near Florence. The other group of three was acquired in 1901–02 by a private collection in Bordeaux, as a work by Fra Angelico. Since I was negotiating the purchase of these three pictures for the Louvre, I could not announce my discovery myself; it was published by Enzo Carli.

The Borgo San Sepolcro polyptych, one of the most important works of the early Renaissance in Italy, was also one of the three finest masterpieces of Sienese art—the other two being Duccio's *Maestà* and Simone Martini's *Annunciation*. It had the unusual feature of being painted on both sides. On the reverse were the *St Francis in Ecstasy* and eight scenes from the legend of St Francis (the most famous of which is at Chantilly); on the obverse was the *Madonna with four Saints*. The two saints in the Louvre were not on either side of the Madonna, according to Enzo Carli's reconstruction, but were both to her left.

UCCELLO (PAOLO DI DONO), 1397–1475
The Battle of San Romano
Panel: 71 × 125½ in. (180 × 316 cm.) Inventory: M.I. 469
(Reproduction p. 128)

This picture is part of a painting in three panels, representing the Battle of San Romano, which used to be in the Palazzo Medici in Florence; the work is mentioned in 1498 in an inventory of Lorenzo il Magnifico. Vasari describes them in 1568, in one of the editions of his *Vite*; in 1598, they again occur in an

inventory of the palace. The Palazzo Medici was sold to Gabriele Riccardi in 1655, and the pictures were transferred to the Medici furniture store, where they were rediscovered in 1784. Two panels were sold in the nineteenth century; the National Gallery, London, acquired one of them in 1857, and the other came to the Louvre with the Campana collection in 1864. The third remained in Florence, and is now in the Uffizi.

Paolo Uccello's most recent historian, John Pope-Hennessy, considers the Louvre painting to be the best preserved of the group. There is some repainting on the foliage in the background.

Botticelli
*Woman Receiving
Gifts from Four
Allegorical Female
Figures*

BOTTICELLI (SANDRO FILIPEPI), *c.* 1445–1510
Allegory
Fresco: $83\frac{1}{2} \times 112$ in. (212 × 284 cm.) Inventory: Inv. R.F. 321
(Reproduction p. 130)

This fresco and its companion piece (Inv. 322, p. 129) were discovered in 1873 under a layer of paint in a villa occupied by Doctor Pietro Lemmi at Chiasso Macerelli, just outside Florence. Both paintings were removed from the wall, suffering some damage in the process, and were bought for the Louvre in 1882, through the mediation of Charles Ephrussi, for 46,517 francs.

The paintings were on the external wall of a loggia, separated by the opening; a third fresco was also discovered, but in a ruinous condition. Their attribution to Botticelli was accepted without hesitation.

The Villa Lemmi was at the foot of the hill at Careggi on which stood one of the houses of Cosimo de Medici. It belonged to the Tornabuoni family, which had friendly relations with the Medicis between 1469 and 1541. It has therefore been supposed that these frescoes may have been painted to commemorate the marriage of Lorenzo Tornabuoni and Giovanna degli Albizzi, which was the occasion for magnificent festivities. One of the paintings might possibly depict Giovanna being welcomed by Venus, who leads her towards the Three Graces – or perhaps they are Virtues; while the other could be Minerva (or possibly Venus again) leading Lorenzo to a gathering of the Liberal Arts, who are seated in a semicircle at the edge of a wood and presided over by Rhetoric. The historical hypothesis remains problematical, and the interpretation of the allegories obscure; the meaning of the pictures is certainly linked with the cycle of Platonic ideas which was a subject of speculation for the humanist

129

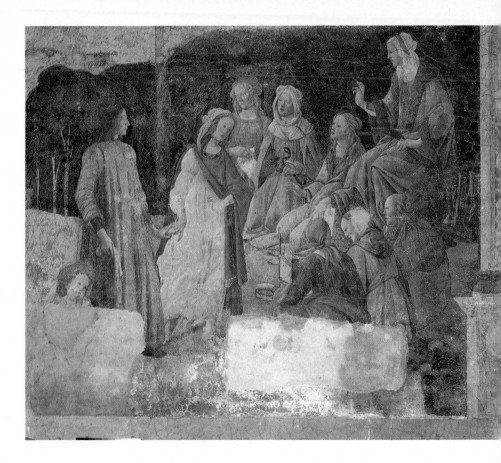

scholars of the time. Marsilio Ficino taught that Love was the 'teacher of the Arts', a most suitable allegory for a marriage; as for Lorenzo Tornabuoni, who paid for his loyalty to the Medici family by dying on the scaffold (4 August 1497), he had been the pupil of Angelo Poliziano who had dedicated a poem to him.

Thieme, however (1897–98), pointed out that, though the man certainly has the features of Lorenzo Tornabuoni, the young girl cannot be Giovanna degli Albizzi, whose face is familiar to us through the medal by Niccolo Fiorentino, the *Visitation* by Ghirlandaio in Santa Maria Novella, and a portrait by the same artist in the Pierpont Morgan Library, New York. The young woman in the Louvre picture resembles the one who follows Giovanna in the *Visitation*. M. Salvini (1958) concurs with these remarks.

D. Ghirlandaio
*Old Man and
his Grandson*

Baldovinetti
*Madonna and
Child*

PISANELLO (ANTONIO DI PUCCIO PISANO), *c.* 1380–1455
A Princess of the House of Este
Panel: 17 × 11¾ in. (43 × 30 cm.) Inventory: Inv. 1422A
(Reproduction p. 132)

The picture first came to light in 1860 in a sale, when it was bought by the German Consul Felix Bamberg. In 1893, the Louvre acquired it from M. Cyrus Picard for 30,000 francs.

The identity of the sitter remains a mystery. The only solid basis for hypothesis is the embroidery on her sleeve, representing the two-handled vase of the Este family (which is also found on the reverse of the medal which Pisanello designed for Lionello d'Este). Attempts have therefore been made to connect the portrait with various princesses of this family; Pisanello was one of the artists employed by them, and stayed on several occasions in Ferrara, where he decorated a room in the Palazzo Schifanoia. Marguerite of Gonzaga (d. 1439) is one possibility; she was the wife of Lionello, and the picture might have been painted at the time of their marriage in 1433. One is even tempted to identify this fresh and modest young face as Genevra d'Este, because of the sprig of juniper on the sleeve – though this may simply be an emblem of happiness and not a pun on her name. She was the unfortunate wife of the redoubtable Sigismondo Pandolfo Malatesta, who subjected Romagna to fire and the sword and whose shameless *affaire* with Isotta degli Atti was the scandal of the age; it was he who commissioned Alberti to build the Tempio Malatestiano at Rimini. He had his wife poisoned in 1440, when she was only twenty-two. It has also been suggested that the lady may be a Gonzaga princess – Beatrice,

131

or Margaret, or the learned Cecilia, whom Pisanello also depicted on a medal.

In 1958 this picture was included in the exhibition 'From Altichiero to Pisanello' at Verona. Comparing the *Princess of the House of Este* with the *Portrait of Lionello d'Este* from Bergamo, which is painted in a freer style, Mr Alfred Frankfurter expressed the opinion that the former, executed with greater finish and precision, was a copy after a lost original. But one could reverse the relationship and compare the *Lionello* unfavourably with the *Princess*. The *St Eustace* in London, a certain attribution, is painted in exactly the same manner as the *Princess*. The most recent writers on Pisanello – Mme Maria Fossi Todorow and M. Raffaello Brenzoni – have no doubts whatever about the Louvre picture.

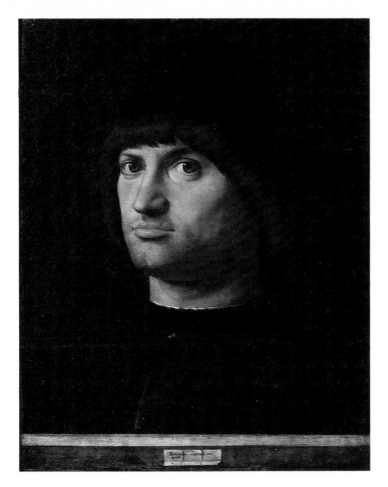

ANTONELLO DA MESSINA, 1430?–1479
Portrait of a Man ('Il Condottiere')
Panel: $13\frac{3}{4} \times 15$ in. (35×38 cm.) Inventory: M.I. 693

At the bottom of the picture is the inscription: '1475. Antonellus Messaneus me pinxit'.

The painting was bought at the Pourtalès-Gorgier sale in 1865, for 113,500 francs.

A dozen of Antonello's portraits have come down to us, of which this is certainly the finest; in fact, together with the *Virgin of the Annunciation* in Palermo, it is his masterpiece.

This is one of the most striking Quattrocento portraits we possess. Few works express so strongly the proud commanding spirit characteristic of the early Renaissance. The clenched jaws and stern expression, the iron will and penetrating intelligence revealed in the face of the sitter, and the scar on his upper lip suggest that he may have been a military leader; hence the nickname 'Il Condottiere'.

The picture belongs to the final stage of Antonello's career. It must have been painted in Venice; he was there in 1475, and in March 1476 he had not yet left the city since he was then working in San Cassiano. From his contact with northern artists in Sicily—among them, no doubt, Petrus Christus—he acquired the Flemish technique of painting in oil. The *Crucifixion* in Antwerp, also painted in 1475, shows how closely he was then studying Flemish painting. The fluid style of the *Condottiere* is usually said to be due to the influence of Giovanni Bellini; in fact, never again was Antonello to approach so near to both the spirit and the technique of Jan van Eyck, which enabled him to suggest in a most striking fashion the transparency of the skin and to hint at the warmth of the flesh. But he is entirely Italian in his way of analyzing the structure of the face to convey a sense of monumentality and suppressed energy.

The work is still on its original panel of poplar wood, and is in exceptionally good condition; only two or three worm holes have been plugged. But the background, the cap and the clothing have darkened so that the face stands out dramatically against the surrounding obscurity.

An old copy has been mentioned in the Willcott collection, Westport.

J. Bellini
Madonna and Child

Ercole di Roberti
St Apollonia

G. Bellini
The Resurrected Christ

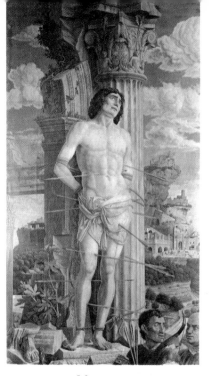

Mantegna
St Sebastian

Mantegna
Our Lady of Victory

MANTEGNA, ANDREA, 1431–1506
The Crucifixion
Panel: $26\frac{1}{2} \times 36\frac{3}{4}$ in. (67×93 cm.) Inventory: Inv. 368
(Reproduction p. 136)

This panel is the central part of the predella of a large altarpiece painted between 1457 and 1459 by Mantegna for the high altar of San Zeno, Verona; it was commissioned by Gregorio Correr, the abbot of that monastery. It was brought to the Louvre in 1798 and put on exhibition immediately. In 1806 two of the predella panels (the *Mount of Olives* and the *Resurrection*) were sent to the museum of Tours. In 1815 the central panel and the two wings were taken back to Italy and exhibited in the city museum at Verona; after 1918 they were returned to the church of San Zeno, where they still remain – though they are not very easy to see. The commission of 1815 charged with reclaiming the works of art taken from the Veneto left the predella panels in the possession of the Louvre and the museum of Tours.

135

The *Crucifixion* was in the middle of the predella, exactly in the centre. Mantegna was striving after an effect of steep perspective such as he had already achieved in the Eremitani chapel at Padua. The figures in the foreground, cut by the frame, increase the effect of recession; the vanishing lines of the ground are curved inwards and, as it were, contracted. The artist's feeling for nature is revealed by the minuteness with which he has represented every detail of the landscape. The accurate delineation of the Roman soldier's equipment is evidence of an attitude to antiquity unknown in Florence at that period. Florentine artists sought to understand and emulate the aesthetic quality of antique sculpture and architecture, but cared little for historical exactitude, which Mantegna on the other hand pursued with the passionate devotion of an archaeologist. In fact, the Veneto was from the fourteenth century onwards the chief Italian centre for the traffic in *anticaglie*; Venetian towns possessed *cabinets d'antiquités* long before these were found in Florence.

136

CARPACCIO (VITTORE SCARPAZO), *c.* 1460–1525
The Sermon of Saint Stephen
Canvas: 60 × 77 in. (152 × 195 cm.) Inventory: Inv. 181

This picture was one of five scenes representing the life of St Stephen, painted
between 1511 and 1514 for the Scuola dei Lanieri, Santo Stefano, Venice. The
series was broken up in 1806, when the religious houses were suppressed. Two
panels went to the Brera, Milan; in 1812 Vivant-Denon exchanged some of the
Northern paintings in the Louvre for Italian works in the Brera, and one of
these panels was transferred under this arrangement. The second (*St Stephen
disputing with the Doctors*) remained in the Brera. The *Consecration of St
Stephen* was in the Kaiser-Friedrich-Museum, Berlin. The *Stoning of St Stephen*,
signed and dated 1520, is in the Stuttgart Museum. The fifth picture, the
Judgment of St Stephen, is lost; but it is known through a copy and some drawings.

The Sermon of St Stephen the deacon, represented in the Louvre painting, took place in Jerusalem. This gave Carpaccio an excuse for filling his canvas with picturesque oriental costumes and architecture. Jerusalem in the early days of Christianity is here based on Constantinople – a fantastic and imaginary Constantinople full of Turkish, antique, Byzantine and Italian elements. Carpaccio refers with pride, in a letter to the Marquis of Mantua, to a view of Jerusalem which he had painted. In the background, to the left, can be seen the mosque of Omar, and on the hill the church of the Holy Sepulchre; but in the middle distance is an exact reproduction of the Arch of Trajan at Ancona, which was later to inspire Palladio's Arco delle Scalette at Vicenza.

It has been thought that the artist was invited to Constantinople by the Turks after Gentile Bellini's visit there in 1479. But his ready imagination could very well have been prompted by drawings brought back by other painters. As for Oriental costumes, there were plenty of these to be seen every day in the port of Venice.

The legend of St Stephen is the third and last of the cycles painted by Carpaccio. The artist, now an old man, was assisted by Francesco Bissolo, a pupil of Giovanni Bellini. It is at this period that he shows himself most sensitive to the quality of light in his pictures.

Perugino *Virgin and Child*

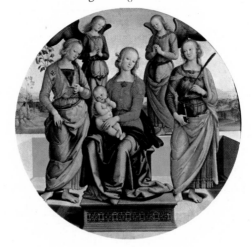

GERMAN SCHOOL

DÜRER, ALBRECHT, 1471–1528
Portrait of the Artist
Parchment pasted on canvas: 22¼ × 17½ in. (56·5 × 44·5 cm.)
Inventory: R.F. 2382

Former Felix collection (Leipzig), Leopold Goldschmidt (Paris). Bought in
1922 from the sequestrator Nicolas de Villeroy, for the sum of 300,000 francs.

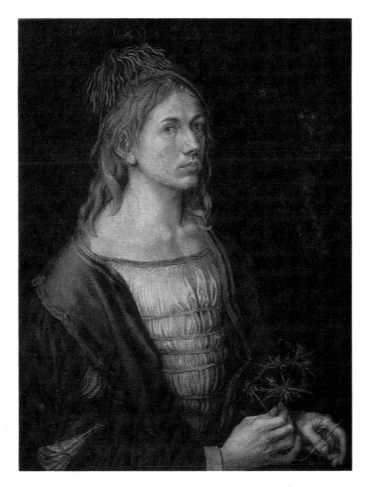

The date, and the plant in the artist's hand, seem to suggest that this is a bethrothal portrait (*Brautporträt*). Dürer has in fact depicted himself in the act of offering a flowering spray identified by botanists as *Eryngium amethystinum*; its German name is 'Mannestreue', meaning conjugal fidelity. This umbelliferous plant is used in medicine, and is regarded as an aphrodisiac. In 1493, Dürer was 22 years old; he had completed his apprenticeship with Wolgemuth, begun in 1486, and had started his tour as a journeyman, which was to last four years. In 1492 it had taken him to Colmar, the home of Schongauer; but he was too late to meet this artist, the object of his youthful admiration, who had died before he arrived there. He was back in Nuremberg in 1494, after Whitsun. 'Hans Frey [one of the senior citizens] negotiated with my father', writes Dürer, 'and gave me his daughter Agnes, with a dowry of 200 florins; and we were married on the Monday before the feast of St Margaret.' The portrait was originally painted on vellum (it was later transferred to canvas); for this reason, Thausing believes that it was sent by Dürer to support his suit.

Goethe saw a copy of this portrait in the museum at Leipzig, and wrote of it: 'I thought Albrecht Dürer's self-portrait, dated 1493, to be of inestimable value'.

The artist was temperamentally inclined to philosophical doubts. He often analyzed his own face in drawn or painted effigies — sometimes idealizing it, sometimes not. Here he seems to have seen himself as in a mirror, with the rather sallow skin which some have ascribed to his Hungarian ancestry, others to some liver complaint. The lines written beside the date in this picture reveal the philosophical and Christian intention of the work:

> *Myn sach die gat*
> *Als es oben schtat.*

In other words: My affairs follow the course allotted to them on high. Marriage has in part determined his destiny; the bridegroom puts his future life in the hands of God.

CRANACH, LUCAS, THE ELDER, 1472–1553
Portrait of a Young Girl
Panel: $15\frac{1}{2} \times 10$ in. (39 × 25 cm.) Inventory: R.F. 1767

The Lutheran Museum at Wittenberg has a late copy of this picture, which according to a local tradition represents Luther's daughter, Magdalena. In 1932, however, Friedländer and Rosenberg expressed the opinion that this could not be the case, because the child was born in 1529, and in their view this picture could not be dated later than the 1520s, for stylistic reasons. But in 1933 M. Edouard Michel pointed out that there existed an engraving of the portrait,

bearing the inscription 'Magdalena D. Mart. Lutheri ex Cathar de Borha Filia. Nata An 1529, mortua die 20 Sept A 1542. Aetatis suae 14'. The age of the child at her death corresponds with that of the subject of this portrait; it must have been painted shortly before she died, because it certainly seems to have been done from life, not from memory. This would fix the data of its execution as 1541–42. Unlike Friedländer and Rosenberg, M. Michel does not find this date incompatible with its style. In 1942 Hans Posse, who does not seem to have known Michel's article, also dated the picture in about 1520, and therefore considered that it could not be Magdalena Luther.

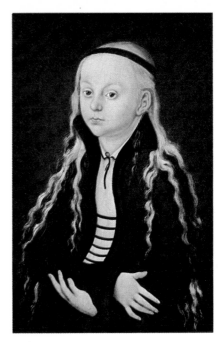

CRANACH, LUCAS, THE ELDER, 1472–1553
Venus in a Landscape
Panel: 149 × 100½ in. (380 × 255 cm.) Inventory: Inv. 1180
Signed with the dragon and dated 1529.
(Reproduction p. 142)

Acquired in 1806 by the Musée Napoléon.

The provenance of this picture is unknown. It is one of a series of paintings in various sizes, representing Venus or a female nude, turned out in quantities by Cranach and his studio; these were popular among the clientèle of humanists for whom he worked. However, this conception of Venus belongs to a German tradition which derives its inspiration from Gothic art. The juvenile air, the slender forms, the tiny breasts and narrow hips, the rounded forehead, all go to make up the physical characteristics of the women (including the Virgins) represented in German art since the fourteenth century. This is quite unlike the conception of Dürer's *Eve* (1504), which was based on an objective and scientific study of the proportions of the human body. The strange pirouetting movement of the legs, crossed over one another, occurs frequently in the

141

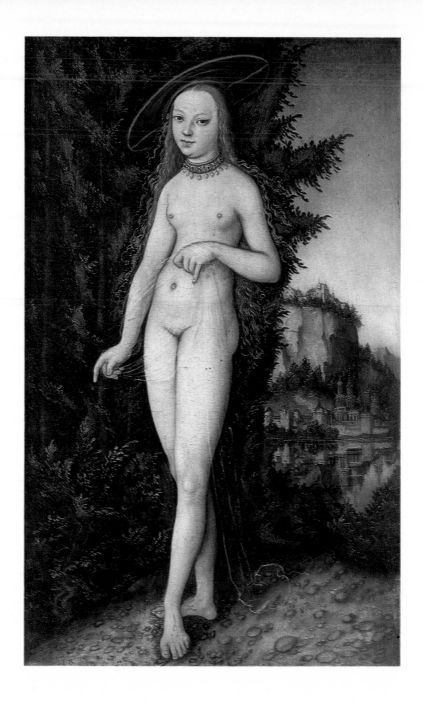

engravings of the Master E.S. As indicated in the romances and the books of sermons, a swaying walk was one of the ways of expressing worldly elegance for women of the Gothic world from the fourteenth century; but here this Gothic mannerism meets and contributes to another kind—the 'mannerism' of art history. Mannerist painters and sculptors, whether Italian, German or French, all admired what Italian aestheticians called *la linea serpentina*, which seemed to them the most beautiful of all forms.

The Venus is clad only in a provocatively transparent veil; in some paintings this is a subsequent addition, but here it is original. The better to set off the ivory whiteness of her body, Cranach has shown it silhouetted against a sombre background of foliage. The landscape conveys in a few strokes an intense impression of the Germanic conception of nature.

HOLBEIN, HANS, 1497–1543
Erasmus
Panel: $18\frac{1}{2} \times 12\frac{1}{2}$ in. (42×32 cm.) Inventory: Inv. 1345
(Reproduction p. 144)

This picture was bought by Louis XIV from Everhard Jabach, the Cologne banker, whose seal appears on the back of it. It is included in Charles Le Brun's inventory of the King's pictures, drawn up in 1683. As well as Jabach's stamp, the picture also bears two of Charles I's seals on the back, and a label proving that it belonged to that monarch; it appears in the first list of his pictures, compiled in about 1624. Together with an unidentified Titian, it was given by the King to the Duc de Liancourt, who had presented him with a John the Baptist by Leonardo, brought to the Louvre by Louis XIV. The Erasmus portrait is also recorded as having been in the Earl of Arundel's collection.

Holbein seems to have been the Dutch humanist's favourite painter; he did several portraits of Erasmus. The earliest seems to be the one belonging to the Earl of Radnor, at Longford Castle (a copy of which is in the Louvre); this shows the scholar turned three-quarters from the spectator, half-length, his hands resting on a book. The Louvre painting shows him writing the first lines of his *Commentary on St Mark's Gospel*, which dates from 1523. The writing is almost illegible in the Louvre picture, but can be read on a smaller copy in the Museum at Basle, usually thought to be also by Holbein, but of inferior quality. In the later portrait at Basle the scholar seems to have aged to an extraordinary degree. There is another early copy in the monastery of St Florian in Austria.

Based on representations of St Jerome, the portrait of a scholar writing or meditating in his study is a subject frequently depicted during the Renaissance.

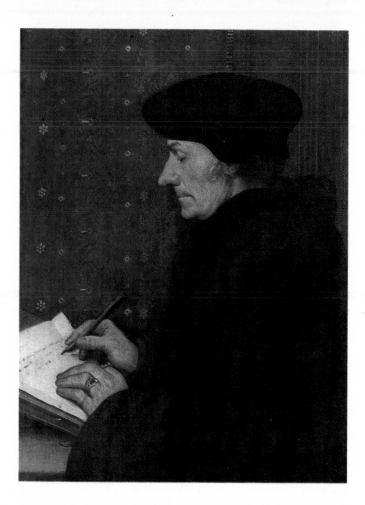

Erasmus often sat for artists; Quentin Matsys painted him when he was younger, and Albrecht Dürer, in a drawing in the Louvre and also in an engraving, showed him with his eyes lowered, looking at his book, as in the Louvre Holbein. Of all these portraits, the Louvre version has the greatest intensity. It shows the humanist when he was about 56; his health was never good, and his age is beginning to tell on him. The hand pressed so firmly on the writing desk is knotted with gout. The expression on his face is attentive, but the trace of an ironical smile betrays the deliberation and scepticism of the rationalist— qualities which Erasmus never lost, even in the midst of the impassioned theological quarrels of his time.

FLEMISH SCHOOL
Sixteenth Century

MATSYS, QUENTIN, 1465 or 1466–1530
The Moneylender and his Wife
Panel: 28 × 27 in. (71 × 68 cm.) Inventory: Inv. 1444
Signed on the roll of parchment, resting on the book: 'Quinten Matsys, Schilder 1514'.

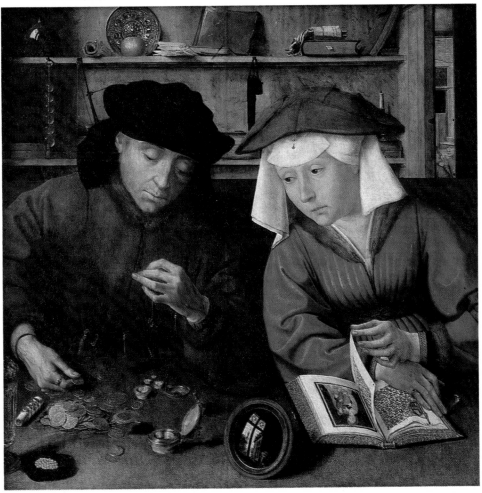

This is one of the best-known works of the Flemish school. It was bought for the Musée Napoléon in Paris, in 1806, for 1,800 francs. Its history can be traced, with a few gaps, back to the seventeenth century; it is believed to have belonged to Rubens. The high reputation it enjoyed can be measured by the frequent praise bestowed upon it, and the numerous copies made of it.

It is painted in a somewhat archaic style, reminiscent of the fifteenth century, and of Van Eyck's detailed naturalism. It is, in fact, known that there formerly existed a work by Jan van Eyck dated 1440, which represented 'a merchant at his accounts, with an assistant, the figures half-length'. It is believed that Matsys must have followed Van Eyck very closely in painting this merchant, evidently a jeweller, counting his gold with his wife at his side. She is turning the pages of a Book of Hours, and seems to have paused, as if fascinated by the precious metal, at a page on which can be made out a picture of the Virgin. An inscription on the original frame — fortunately recorded before the frame was lost — gave evidence of the moralizing intention of the work; it was a passage from Leviticus (XIX. 36): 'Satura justa et aequa sint pondera' (Just balances, just weights . . . shall ye have). This picture has been the source of many currents of inspiration. Matsys himself made use of the same setting for his portraits of Erasmus and Aegidius in 1517. The theme, popularized by a variant painted by Marinus van Reymerswael, gave rise to a whole section of sixteenth-century genre painting. Finally, this painting constitutes a link between the artistic vision of Jan van Eyck and that of Vermeer in the seventeenth century.

The convex mirror in the foreground is a device already used by Van Eyck to show a concentrated image of the fourth side of a room, where the painter is standing (*Arnolfini and his Wife*, the National Gallery, London). Here the window seen in the mirror provides an opening on to the outside world.

Quentin Matsys *Pietà*

146

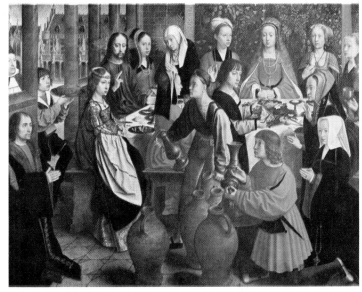

G. David
Marriage at Cana

MABUSE (JAN GOSSAERT) *c.* 1478–d. between 1533 and 1536
The Carondelet Diptych
Panel: 17 × 10¾ in. (43 × 27 cm.) Inventory: Inv. 1442, 1443
(Reproduction p. 148)

Signed at the bottom of the right wing: 'Johannes Melbodie Pingebat', and
dated at the bottom of the left wing: 'Fait l'an 1517'. On the frames: various
inscriptions referring to the Virgin or indicating the donor.

Carondelet is represented, half-length, praying before the Virgin; on the
back of the portrait is his coat-of-arms, and on the back of the Virgin is a *trompe-l'œil* skull, with a pious inscription and the date.

Carondelet was born at Dôle in 1469, and died at Malines on 8 February
1545; he was the son of the Chancellor Carondelet. He was a church dignitary,
holding various offices and benefices, and played a political rôle in the Low
Countries. Having entered the Church, he acquired various important posts.
From 1497 he was a member of the Grand Conseil pour les affaires de Justice.
In 1517 he went to Spain with Charles V, and returned with him to the Low
Countries in 1519. In 1531 he became President of the Privy Council. In
addition, he acquired numerous ecclesiastical dignities; in 1493 he was Arch-
bishop of Palermo and Primate of Sicily. He was a scholar and a humanist,
and a friend of Erasmus, who dedicated his *Saint Hilarius* to him; evidently he
had a liking for having his portrait done, since there are two others of him by
Mabuse, another by Van Orley, and one by Vermeyen.

This work dates from Mabuse's mature period; it shows his preoccupation

147

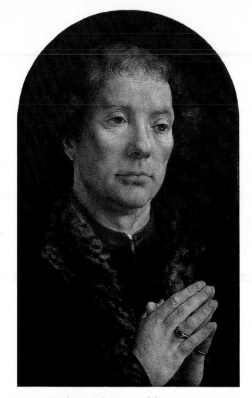

Mabuse *The Carondelet Diptych*

with the sculptured form which he acquired through contact with Michelangelo and antique statues in Rome in 1508. In this year he accompanied Philip of Burgundy, natural son of Philip the Good and Admiral of the fleet, who was sent as a private ambassador to Philip II. According to M. Edouard Michel, the artist based this painting on some antique bust — Euripides, Socrates, or Julius Caesar. The artist was torn between the Flemish tendency towards naturalism and Italian idealization, as can be seen in his portrayal of the Virgin. For this reason the donor portrait is superior to the other wing, both in truth to life and in pictorial quality; it is, moreover, in a better state of preservation. The finest piece of painting is the skull on the back — an illusionistic still-life reminiscent of surrealist works of the modern school.

BRUEGHEL, PIETER, *c.* 1525–1569
The Beggars
Panel: $7\frac{1}{4} \times 8\frac{1}{2}$ in. ($18 \times 21 \cdot 5$ cm.) Inventory: R.F. 730
Signed on bottom left: Bruegel MDLXVIII

This little picture is the only work by Brueghel in the Louvre. It was the gift of Paul Mantz, art critic and honorary Directeur Général des Beaux-Arts, in 1892. Little is known of its previous history.

Attempts have been made to interpret the picture of five cripples and a beggar-woman as an allusion to an historical event; the badgers' tails, or foxes' tails, on their clothes might refer to the Gueux, a rebel party formed against the government of Philip II and Granvelle; but these also occur in the *Combat between Carnival and Lent* in Vienna, dated 1559. Still, the beggars are not quite ordinary beggars; they wear carnival headgear representing various classes

148

of society; a cardboard crown (the king), a paper shako (the soldier?), a beret (the bourgeois), a cap (the peasant) and a mitre (the bishop). The work clearly has some satirical meaning which has so far eluded us; perhaps physical imperfections are meant to symbolize moral decrepitude, which can affect all men irrespective of class.

There is a drawing of a street scene by Martin van Cleve in the Print Room at Munich which is evidently inspired by this picture; it reproduces several of the figures—the cripple with the shako, and the one with the mitre and the foxes' tails. But the mitre in the drawing is real, and not made of paper.

On the back of the painting are two inscriptions which seem to date from the sixteenth century; they record the admiration of two art lovers. One is in Flemish, and in a very fragmentary state; one can make out the word 'ruepelen' (cripples) and a sentence which means 'may your fortunes prosper' — probably the thanks of a cripple receiving alms.

The other inscription is in Latin, and can be roughly translated as follows:
Nature possesses nothing which our art lacks.
So great is the grace given to the painter;
Here Nature, translated into painted images and seen in her cripples,
Is astounded to see that Brueghel is her equal.

Leonardo da Vinci *The Annunciation*

ITALIAN SCHOOL

The High Renaissance

LEONARDO DA VINCI, 1452–1519
The Virgin of the Rocks
Canvas: 78½ × 48 in. (199 × 122 cm.) Inventory: Inv. 777

The earliest known reference to this painting is in 1625, when Cassiano del Pozzo mentions it as being in the château of Fontainebleau. It was also described in 1642 by Pére Dan in his *Trésors et merveilles de Fontainebleau*.

Another version of approximately the same size is in the National Gallery, London; it was bought from Lord Suffolk in 1880. Its pedigree can be traced back to its removal from the church of the hospital of Santa Catarina alla Ruota, Milan, who sold it to Gavin Hamilton in 1789. This picture had two wings (not by Leonardo), representing angels; these were also bought by the National Gallery, and come from the same church. The painting is unfinished.

In a contract dated 25 April 1483, the confraternity of the Conception at San Francesco Grande, Milan, commissioned Leonardo da Vinci and the brothers Evangelista and Giovanni da Predis to paint three pictures (a Virgin with angels); these were to be fitted into a carved wooden frame ordered from Giacomo del Maino in 1480, which Leonardo and the da Predis brothers were to polychrome. Between 1483 and 1506 various disputes arose, which were settled by a new agreement drawn up in 1506. Lomazzo mentions the picture as being at San Francesco Grande in 1586; it was transferred to Santa Catarina alla Ruota at the end of the eighteenth century.

The Louvre version is entirely by Leonardo's hand, and far superior in quality to the London picture, which is thought to have been executed mostly

150

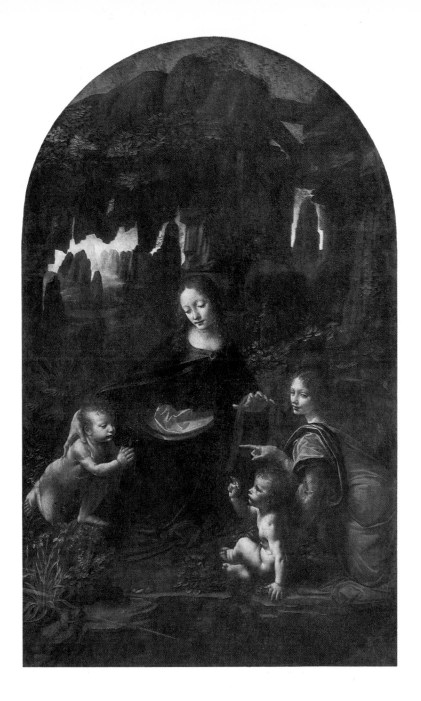

by the da Predis brothers, over a design prepared by Leonardo. The Louvre picture is still in his Florentine manner, and certainly earlier than the London one, which is clearly based on it. It has been suggested that a substitution of the paintings took place, carried out by Leonardo himself. In the Louvre picture the presence of the infant St John the Baptist, patron of Florence, who is pointed out by the angel, and the root of *Iris florentina* to the left, seems to indicate that the work was commissioned for a Florentine church. Perhaps Leonardo took the unfinished painting to Milan at the end of 1482, and completed it in that town; then he may have made a replica for the confraternity of the Conception at San Francesco Grande, leaving out the more direct allusions to Florence (in particular the iris and the finger of the angel pointing to St John the Baptist, who seems to be the principal figure in the Paris version).

LEONARDO DA VINCI, 1452–1519
Mona Lisa (La Gioconda)
Panel: 38¼ × 21 in. (97 × 53 cm.) Inventory: Inv. 779

According to Vasari, this picture is a portrait of Mona or Monna (short for Madonna) Lisa, who was born in Florence in 1479 and in 1495 married the Marquese del Giocondo, a Florentine of some standing—hence the painting's other name, 'La Gioconda'. This identification, however, has sometimes been questioned.

Leonardo took the picture with him from Florence to Milan, and later to France. It must have been this portrait which was seen at Cloux, near Amboise, on 10 October 1517 by the Cardinal of Aragon and his secretary, Antonio de Beatis. There is a slight difficulty here, however, because Beatis says that the portrait had been painted at the wish of Giuliano de Medici. Historians have attempted to solve this problem by suggesting that Monna del Giocondo had been Giuliano's mistress.

The painting was probably acquired by Francis I from Leonardo himself, or after his death from his executor Melzi. It is recorded as being at Fontainebleau by Vasari (1550), Lomazzo (1590), Peiresc, and Cassiano del Pozzo (1625). The latter relates that when the Duke of Buckingham came to the French court to seek the hand of Henrietta of France for Charles I, he made it known that the King was most anxious to own this painting; but the courtiers of Louis XIII prevented him from parting with the picture. It was put on exhibition in the Musée Napoléon in 1804; before that, in 1800, Bonaparte had it in his room in the Tuileries.

It was stolen from the Salle Carrée on 21 August 1911 by Vicenzo Perrugia, an Italian workman. In 1913 it was found in Florence, exhibited at the Uffizi,

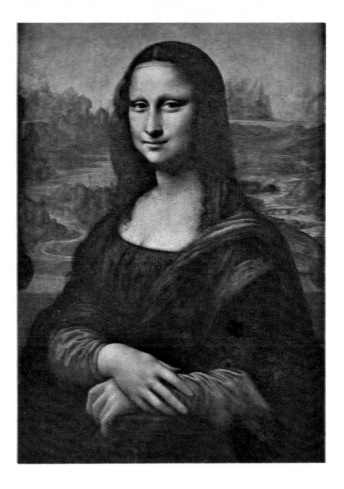

then in Rome and Milan, and brought back to Paris on 31 December in the same year.

Vasari relates that Leonardo worked on it for four years without being able to finish it; yet the picture gives the impression of being completely realized. The dates suggested for it vary between 1503 and 1513, the most widely accepted being 1503–06.

Taking a living model as his point of departure, Leonardo has expressed in an ideal form the concept of balanced and integrated humanity. The smile stands for the movement of life, and the mystery of the soul. The misty blue mountains, towering above the plain and its river, symbolize the universe.

LEONARDO DA VINCI, 1452–1519
Virgin and Child with Saint Anne
Panel: 66¼ × 51¼ in. (168·5 × 130 cm.) Inventory: Inv. 776

This picture was seen in Leonardo's studio in the château of Cloux, near Amboise, by the Cardinal of Aragon and his secretary Antonio de Beatis, in October 1517. Paolo Giovio, in his life of Leonardo, mentions it in 1529 as being in Francis I's study at Fontainebleau. There is no reason for doubting this contemporary evidence; the picture must therefore have left the royal collection, probably as a gift, at some unknown date, because Richelieu bought it at Casal in Piedmont in 1629. In 1636 it was presented to Louis XIII together with the Palais Cardinal (now the Palais Royal).

The National Gallery in London owns a cartoon by Leonardo of the same subject, but differing in important respects from the Louvre painting. We know from a letter that in 1501 Leonardo made another cartoon, which is now lost. The picture was commissioned by the Servites, in Florence. It is unfinished; perhaps it was abandoned because of the artist's sudden interest in mathematics, and his engagement as engineer in the service of Cesare Borgia. He must have worked on it again in Milan, round about 1508 to 1512, but still did not bring it to completion. Another hand seems to have finished the lamb, which he had perhaps only sketched in; the landscape, Saint Anne, the Virgin and the Christ Child are the work of Leonardo himself. The paint is applied thinly; it is limpid and transparent, so that in some places the underlying sketch is visible. This has become apparent since the very dark varnish was lightened and some overpainting removed in 1953.

The theme of the Christ Child on the knee of the Virgin, who is herself seated on Saint Anne's lap, is fairly rare, but examples of it can be found from the Middle Ages onwards—the stream of life flowing through three generations. Leonardo must have chosen this unusual theme for symbolic reasons, which have been variously interpreted. Sigmund Freud made out the shape of a vulture in the Virgin's garment, and suggested a psychoanalytical explanation —since as a child Leonardo dreamt that he had been attacked in his cradle by a vulture.

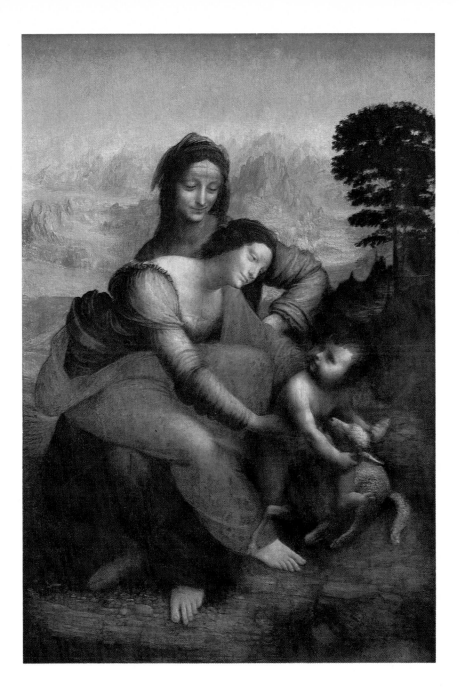

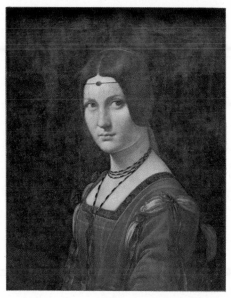

Leonardo da Vinci *Portrait of a Lady*

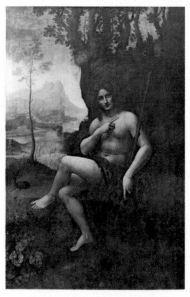

Leonardo da Vinci *Bacchus*

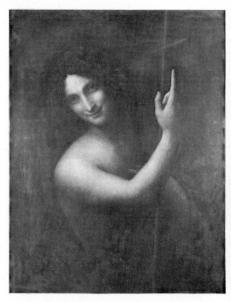

Leonardo da Vinci *St John the Baptist*

RAPHAEL (RAFFAELLO SANZIO) 1483–1520
Madonna (La Belle Jardinière)
Panel, rounded at top: 48 × 31½ in. (122 × 80 cm.) Inventory: Inv. 602
Signed: Raffaello Urb. MDVII
(Reproduction p. 158)

This picture figures in the inventory drawn up by Le Brun, Keeper of the King's Pictures, in 1683. As there is no earlier reference to it, it is presumed to have been acquired by Francis I. As it is dated 1507, it cannot be the Virgin painted for Filippo Segardi, which Raphael left unfinished when he went to Rome in the summer of 1508.

The name by which the picture is known was bestowed upon it because the Virgin is out-of-doors in a country setting; it is already referred to as 'La Jardinière' in the eighteenth century (Mariette, *Abecedario*).

During his Florentine period (1504–08) Raphael painted about a dozen Madonnas. It has been thought that this preoccupation with the theme of maternity and childhood arose from the fact that Raphael's mother died when he was only eight.

A cartoon which Raphael prepared for this picture is now at Holkham Hall, in the Earl of Leicester's collection. A number of preparatory drawings and early copies are in existence. Delacroix copied the figure of the Christ Child (Robaut 24), and the composition inspired this *Madonna of the Sacred Heart* (Robaut 26).

The unusual character of the town on the right of the picture has never been pointed out; it is entirely Gothic in style, with its tall spires, its paired windows surmounted by an *oculus*, the high buildings with pitched roofs and the pepper-pot tower. There are other instances of this in Raphael's work (the *Dream of the Knight* in the National Gallery, London, the *St George*, the *Madonna* in the Kaiser-Friedrich-Museum, Berlin, and the *Canigiani Madonna* in the Alte Pinakothek, Munich). Raphael may have seen urban landscapes of a Gothic nature in Lombardy; the snowy hill-tops in the little *Conestábile Madonna* in the Hermitage seem to prove that he had seen the Alps. In some of his pictures, however, the buildings in these towns are so very northern that their presence can only be explained as an imitation of the Flemish primitives. The little *St Michael* is another example of Raphael's imitation of the Gothic (see following page). No doubt he was attracted by the transparency of the technique in Flemish paintings, and the purity of their sentiments. His work was completely transformed when he went to Rome, and he lost his taste for the Gothic and for Flemish art.

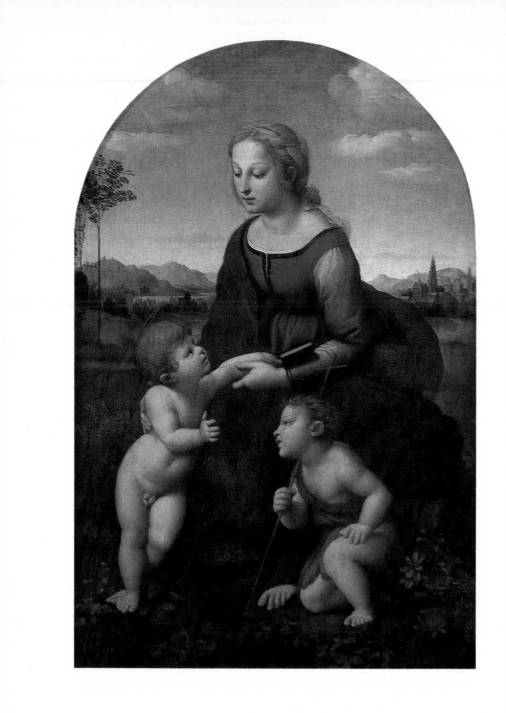

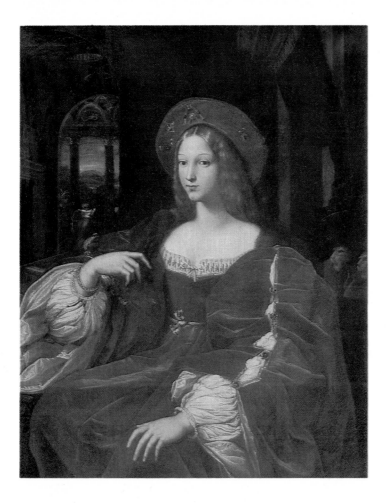

RAPHAEL (RAFFAELLO SANZIO) 1483–1520
Joan of Aragon
Panel, transferred to canvas: $47\frac{1}{5} \times 37\frac{2}{5}$ in. (120×95 cm.) Inventory: Inv. 612

Knowing of Francis I's weakness for the fair sex, and his liking for pictures by the great Italian masters, Cardinal Bibiena presented him with this picture when he was appointed papal legate to the King of France. Alfonso d'Este saw it at Fontainebleau in November 1518. The Cardinal had commissioned it from Raphael in 1517; it shows Joan, daughter of Ferdinand of Aragon, Duke of Montalto, third natural son of Ferdinand I, King of Naples. It is

probably for this reason that the picture is often referred to in inventories or by writers as 'The Queen of Naples', or 'The Vice-Reine of Naples'; or even 'The Queen of Sicily'. In fact Joan, who was sixteen at the time, was betrothed to Ascarino Colonna, Constable of Naples, whom she married in 1520. She was a well-educated woman, one of the most distinguished of her time; and poets vied with one another in celebrating her dazzling beauty. This picture well matches the description of her by her doctor, Agostino Nifo: 'Her complexion tends towards red and white, her hair is long and golden, her ears small and round, the same size as her mouth; her eyebrows, of short hairs lying smoothly, are shaped like the arc of a circle; her eyelids are tinted with black and her lashes have very little of this colour; her nose is straight, her mouth tiny...'

Raphael did not paint the portrait direct, however, but apparently worked from a sketch which he had sent one of his pupils to make in Naples. Vasari, who had not seen the picture, said that Raphael only did the head and Giulio Romano all the rest. Before 1965 it was difficult to judge of the picture's quality owing to the layers of dark varnish with which it was covered. These have been lightened, under my direction, by M. Jean Gabriel Goulinot, and the cleaning has revealed a painting in a remarkably fine state of preservation, and of such a high quality in every detail that it can be attributed without hesitation to Raphael's own hand.

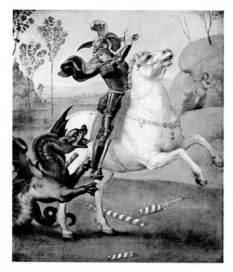

Raphael *Saint George and the Dragon*

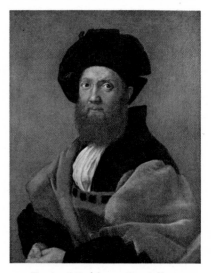

Raphael *Balthasar Castiglione*

| Raphael | Raphael | Raphael |
| The Madonna with the Blue Diadem | St Michael | The Holy Family of Francis I |

CORREGGIO (ANTONIO ALLEGRI), 1494–1534
The Mystical Marriage of Saint Catherine
Panel: 41¼ × 40¼ in. (105 × 102 cm.) Inventory: Inv. 41
(Reproduction p. 162)

The history of this picture can be traced right back to the beginning. Vasari mentions it as being in the house of a Modenese doctor, Francesco Grillenzoni; in 1582 Cardinal Luigi d'Este bought it, and presented it to Catarina Nobili Sforza, Countess of Santa Fiora and grandniece of Pope Julius III. It was still in her possession in 1595. In 1614 it was in Rome, the property of Cardinal Sforza of Santa Fiora, who had no doubt inherited it. It was subsequently owned by Scipione Borghese, and then by Cardinal Antonio Barberini; the latter gave it to Mazarin in about 1650. Louis XIV bought it from Mazarin's heirs in 1661, for 15,000 livres.

Correggio first depicted this subject in a small composition of which several versions exist; that in the Naples museum is most likely to be the original one, though its attribution is not certain. The Louvre painting dates from about 1520; it is related to a group of Madonnas in which Correggio expressed his ideal of femininity – graceful, and with a touch of coquetry. The group includes the *Madonna suckling the Child* in Budapest, the *Madonna with the Basket* in the National Gallery, London, the *Madonna adoring the Child* in the Uffizi, and the *Madonna with St Sebastian* in Dresden. In all these works, painted at the same period (just after 1520), there is a 'loving' quality which gives a feeling

161

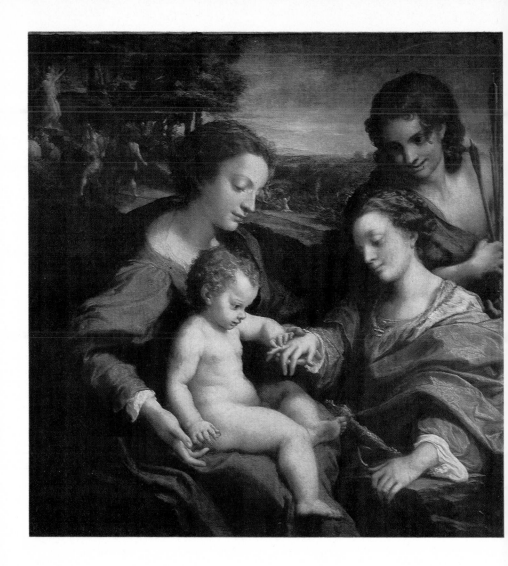

of intimacy to the pictures of a mother and child. Perhaps they reflect the artist's own conjugal happiness; in 1520 he married a young orphan girl named Girolama Merlina, whose delicate and graceful beauty had charmed him. In all the pictures the child is of the same type; perhaps the model was Correggio's son Pomponio, baptized 3 September 1521.

In 1958 the varnish which covered the painting was lightened to some extent, revealing its almost miraculous state of preservation. The only damage is to the arch of the saint's eyebrow. With its poplar-wood panel intact, it is one of the best preserved works of the Italian Renaissance.

A number of replicas of this painting has been made, many of which still survive; it has often been a source of inspiration to artists. In the nineteenth century it was copied by Ricard, and several times by Fantin-Latour.

GIORGIONE (GIORGIO BARBARELLI?), 1477?–1510
Concert Champêtre
Canvas: $43\frac{1}{4} \times 54\frac{1}{4}$ in. (110 × 138 cm.) Inventory: Inv. 71
(Reproduction p. 164)

The earliest reference to this picture is in 1627 when, along with the other Gonzaga paintings in Mantua, it became the property of King Charles I. At some unknown date it was acquired by Everhard Jabach, a banker living in Paris, who may have obtained it from the Earl of Arundel. It finally passed into Louis XIV's collection.

The painting may perhaps have been bought by Isabella d'Este, which would explain its presence in the Gonzaga collection. We know that in 1510, when she heard of Giorgione's death, she wrote to Taddeo Albano of Venice asking him to obtain for her a painting of a 'Notte' (probably a Nativity) which she thought was amongst the artist's possessions. Taddeo Albano replied that nothing of that kind was to be found amongst the property he had left. So perhaps she then bought the *Concert Champêtre*.

In the seventeenth century the picture was enlarged by the addition of a fairly wide strip at the top edge and another at the left side. These strips are now hidden by the frame. Some additions were made during the seventeenth century to the foliage at the left.

The painting figures in old inventories as a work by Giorgione; Waagen, in 1839, was the first to question this attribution, believing it to be by Palma

Vecchio. Since then, historians have expressed varying opinions. Contemporary critics are divided into those who uphold the original attribution to Giorgione and those who believe it was painted by the young Titian under Giorgione's influence. In 1955 it was possible to study this picture alongside other paintings by Giorgione, at the exhibition of his work in the Palace of the Doges; but the problem is still unsolved. The opinion of the majority is in favour of Giorgione's authorship; the Titianesque characteristics are sometimes explained (by Pallucchini, for example, and Giorgio Castelfranco) by the hypothesis that Titian finished the painting. This is not impossible, since Giorgione died young, and left behind half-finished works which were completed by Palma or Titian. X-rays reveal an alteration in the position of the nude woman on the left— possibly evidence in favour of this theory.

The subject of the painting, the intimate fusion of figures and landscape in the warm summer light, and the harmony of colouring, make this picture one of the most complete expressions of Venetian art.

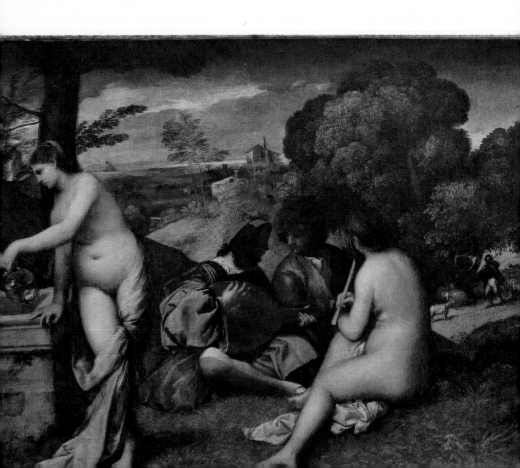

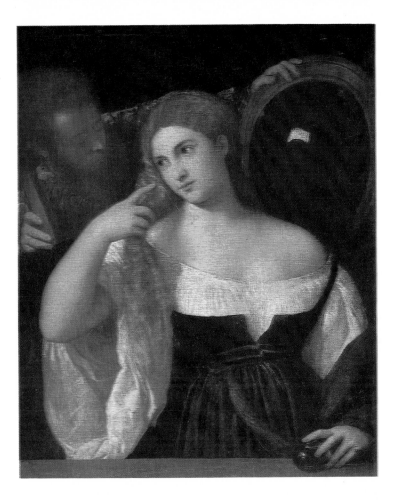

TITIAN (TIZIANO VECELLIO), 1477–1576
Young Woman at her Toilet
Canvas: 38 × 30 in. (96 × 76 cm.) Inventory: Inv. 755

This picture was acquired with the Gonzaga paintings from Mantua by Charles
I in 1627. Later it was bought by the banker Everhard Jabach, and from him it
passed into Louis XIV's collection. It is mentioned in the inventory of Le
Brun, Keeper of the King's Pictures, in 1683.

165

In Charles I's collection the painting was known as 'Titian's Mistress'. Various attempts have been made to identify the two sitters, and the names suggested include Alfonso d'Este and Laura di Dianti, Francesco Covos and Cornelia, Federigo Gonzaga and Isabella Boschetti, Alfonso di Ferrara, Marquese del Guasto and Maria of Aragon. It has also been claimed that the couple represent the artist and his mistress Violante. Some of these identifications are impossible for chronological reasons, and all are now rejected.

The picture is usually dated about 1515, and belongs to the 'Giorgionesque' group of paintings by Titian together with the *Flora* in the Uffizi, and the *Sacred and Profane Love* in the Borghese Gallery. The rounded oval of the woman's face, her shining eyes, the Venetian blonde of her hair with its auburn lights, and her pearly shoulders, all go to make this picture the very incarnation of the Venetian ideal of feminine beauty, opulent and sensual.

The Louvre picture is most closely related to the Uffizi *Flora*, but the latter is in better condition. The former, which is described in Bailly's inventory of 1709 as having been enlarged, has suffered a certain amount of damage and undergone several restorations. It was transferred to a new canvas in 1751; damp caused it to flake, and in 1818 it was refixed. For this reason, and because of the darkness of the background, only a very cautious cleaning-off of the varnish was possible; enough was done, however, to reveal the colours and tonal relationships of the picture. Previously, the blue dress had appeared green, and the hair was lost against the linen chemise.

The existence of numerous copies testifies to the picture's fame; even the royal collection possessed one (mentioned there in 1709). The most famous, once thought to be an original, was in the collection of the Regent, the Duke of Orléans, and had belonged to Queen Christina of Sweden.

TITIAN (TIZIANO VECELLIO), 1477–1576
Christ Crowned with Thorns
Canvas: 119¼ × 70½ in. (303 × 180 cm.) Inventory: Inv. 748
Signed: Titianus F

This painting was formerly the altarpiece in the Santa Corona chapel in Santa Maria delle Grazie, Milan. It was sent to Paris in 1797, and exhibited in the Louvre from 1798 onwards.

Vasari and Ridolfi both mention it as being in Santa Maria delle Grazie. It was probably painted in about 1542, when the chapel was being decorated with frescoes by Gaudenzio Ferrari.

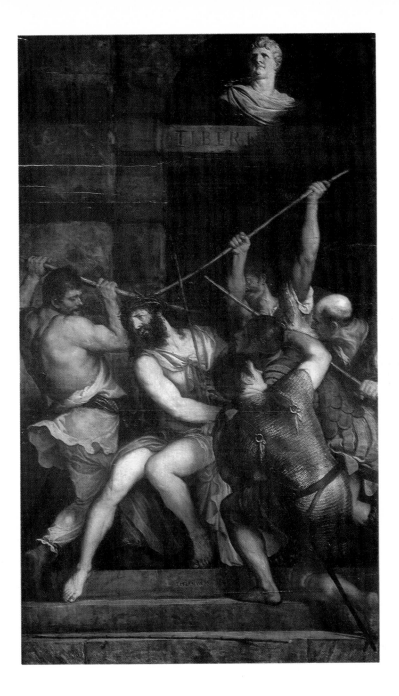

Professor Suida has pointed out that this is, for Titian, an unusually mannerist work. The literal imitation of the antique is itself a mannerist characteristic; it is seen in the bust of Tiberius, and also in the attitude of Christ, reminiscent of the Laocoon, in details of the crouching soldier's military equipment, and the breeches of the soldier on the left—a garment worn by barbarians in antiquity. The monumentality and the sense of movement in the composition, the emphatic drawing, and the exaggeration of the muscles are all mannerist features which Titian could have borrowed from Giulio Romano's frescoes at Mantua.

Thirty years or so later, Titian again made use of most of the elements of this composition in a picture now at Munich. He omitted the greater part of the antique details, and sought to express pathos not through naturalism, but by means of the nocturnal atmosphere which bathes the figures in a dramatic *chiaroscuro.*

The Ospedale Maggiore in Milan has a very good contemporary copy, showing only the figures without the upper part. There is also a copy in the Accademia in Venice. A drawing in pen and bistre wash, attributed to Giovanni Domenico Tiepolo and sold in Paris (Georges Petit), 30 May 1921, is evidently based on an engraving of the picture; it shows various figures in the same attitudes, but reversed.

Included in the Comte de Pourtalès' sale, 1 April 1865 (No. 119), was a little painting on paper, described as 'the first precious sketch of the magnificent picture (by Titian) in the Louvre'. I saw this picture a few years ago, and believe it to be a study made after the picture at the end of the seventeenth century.

Titian *The Entombment*

Titian *The Pardo Venus*

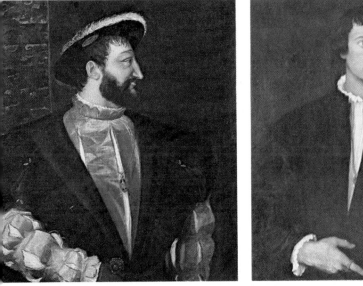

Titian *François I*

Titian *The Man with the Glove*

TINTORETTO (JACOPO ROBUSTI), 1518–94
Paradise
Canvas: $56\frac{1}{4} \times 142\frac{1}{2}$ in. (143×362 cm.) Inventory: Inv. 570
(Reproduction p. 170)

Seized by the French commissioners of the Directoire in 1797 in the Bevilacqua Palace at Verona; arrived in Paris 27 July 1798.

169

The fire in the great Council Chamber in the Doges' Palace in Venice on 20 December, 1577, had resulted in the almost total destruction of a fresco of the Last Judgement by Guariento. A competition was announced for a composition representing Paradise with which to replace it. Four of the sketches submitted survive; one by Veronese (Lille Museum), one by Jacopo Bassano (the Hermitage, Leningrad), one by Palma Giovane (the Ambrosiana, Milan), and this one. There is also a pen and wash drawing for the project by Federico Zuccari. Veronese and Bassano were the successful entrants; but, presumably because of Veronese's death in 1588, the commission passed to Tintoretto. He executed the enormous composition of 500 figures in sections, between 1588 and 1590, in the Scuola della Misericordia. Domenico Tintoretto helped his father to complete it when it was in its allotted position.

This work, which depicts the souls in heaven and the angels circling in elliptical orbits round Christ crowning the Virgin, is extremely important in the history of the concept of space in painting; Tintoretto here inaugurates the baroque painter's conquest of spaces. One cannot say for certain that he was inspired by Copernicus' system; but in any period artists and writers naturally tend to think along similar lines to the scholars of their day. It is also possible that this conception of concentric celestial circles was inspired by Dante's description in Canto 30 of the *Paradiso*. Carried out with the assistance of pupils, and blackened by the atmosphere of Venice, the canvas in the Doges' Palace no longer conveys the impression of airiness and space retained by the sketch, painted *alla prima* and with its fresh colours unimpaired. It was greatly admired by Goethe, when he saw it in the Bevilacqua Palace in Verona in September 1786.

Veronese (Paolo Caliari), 1528–1588
The Marriage at Cana (detail)
Canvas: $262\frac{1}{4} \times 354\frac{1}{4}$ in. (666 × 990 cm.) Inventory: Inv. 142

This picture was ordered from Veronese by the Benedictines of San Giorgio, Venice, to decorate their refectory (built by Palladio). It was delivered on 8 September 1563, and installed at the end of the refectory in the same year. It was chosen for the Louvre by the French commission on 11 September 1797 and was exhibited in the Salon Carré in 1801. In 1815 the Austrian commissioners agreed to exchange it for Le Brun's *Feast in the House of Simon*. It remained on exhibition in the Salon Carré till 1951, when it was transferred to what had formerly been Napoleon III's Salle des États.

There are 132 figures in this huge painting. It was completed in a year, when the artist was 34. He received 324 ducats for it, plus the cost of his food and a cask of wine.

The Frenchman, Salomon de Brosse, and Zanotti, the author of *Della pittura veneziana* (1771), speak of a tradition preserved in an old manuscript which could still be seen in the monastery of San Giorgio in the eighteenth century.

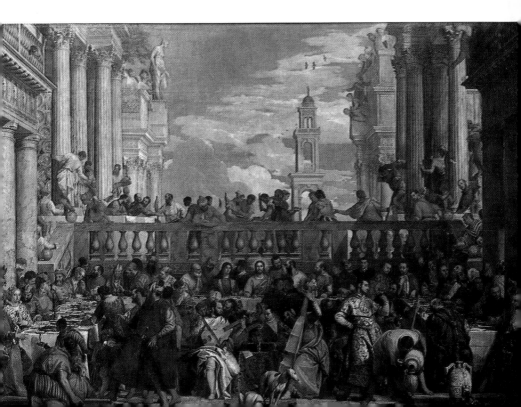

According to this tradition, the feast here represented was an ideal banquet in which some of the great Renaissance princes were depicted as taking part. At the table, the newly-married couple are supposed to be Alfonso d'Avalos, Marquese del Vasto (Charles V's governor in the Milanais), and Eleanor of Austria, the Emperor's sister, who married Francis I after Pavia. Leaning towards the bride and groom are Francis I and Mary of England, sister of Henry VIII; the man with the turban, next to them, is Suleiman the Magnificent, the Turkish Sultan. Next comes Vittoria Colonna, Michelangelo's patroness; and after her the Emperor Charles V. The central figures in the foreground can be identified from their known portraits. The man on the right, standing, and drinking a toast, is presumed to be Veronese's brother Benedetto; the orchestra is made up of artists, with Titian holding the contrabass, Veronese himself playing the viola, Tintoretto the violin, and Jacopo Bassano the flute. The bearded man leaning towards Veronese and also playing the viola could be Palladio.

In this large decorative canvas Veronese has abandoned classical perspective, with its single vanishing point, to make use of multifocal perspective.

Veronese *Calvary*

Jacopo Bassano *Marriage at Cana*

FETTI, DOMENICO
Melancholy

In this picture, acquired by Louis XIV in 1685, Fetti is inspired by the famous Dürer engraving, but his work is more religious in character. A replica from the artist's hand is in the Venice Accademia.

173

CARRACCI, ANNIBALE, 1560–1609
Fishing Scene
Canvas: 53½ × 99½ in. (136 × 253 cm.) Inventory: Inv. 210

The picture and its companion, *Hunting Scene* (page 175), were given to Louis XIV by Prince Camillo Pamfili in 1665. They were included in Le Brun's inventory in 1683; and in November 1695 they were in the apartments of the King's younger brother. It was no doubt for this purpose that they were given two sumptuous gilt frames, each with attributes suited to the subject of the painting—among the finest examples of the art of frame-making in the time of Louis XIV. In 1955, when the varnish was being cleaned, the nineteenth-century gilding covering the original gilding was removed.

These landscapes date from Carracci's Bolognese period, before 1695. At this time he was extremely interested in landscape, and his experiments are a foreshadowing of Poussin's classical compositions; but in these pictures he is exploring in a different direction, in the tradition of the Bassani, whose studios continued to turn out landscapes which were prized all over Europe.

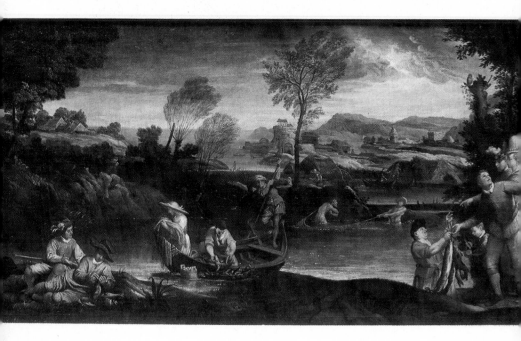

CARAVAGGIO, MICHELANGELO DA
(MICHELANGELO AMERIGHI), 1573–1610
The Death of the Virgin
Canvas: $145\frac{1}{2} \times 96\frac{1}{2}$ in. (369 × 245 cm.) Inventory: Inv. 54
(Reproduction p. 176)

This picture was painted in 1605–06 for the chapel of Laerte Cherubini, the jurist, in Santa Maria della Scala, the church of the Discalced Carmelites in

Caravaggio
The Fortune-Teller

Trastevere, Rome; it scandalized the good fathers, and had to be removed. It was bought by Vincenzo Gonzaga for what in those days was a very high price – 280 gold ducats, plus 20 by way of commission to the agent. On 28 April 1607, it was taken to Mantua. Charles I bought it with the Gonzaga collection in 1627; in 1649 the Commonwealth government sold it to Everhard Jabach, the banker, from whom it was acquired by Louis XIV.

Ecclesiastical circles accused Caravaggio of having made the Virgin a commonplace type of woman. Some claimed that he had modelled her on a swollen corpse fished up out of the Tiber, others that his model had been a courtesan from the Ortacci quarter. These accusations were unjust, because he seems to have used the same model who sat for the *Madonna dei Palefrenieri* – a poor but respectable woman named Lena. Artistic circles hailed the work with great enthusiasm. Such an unusual masterpiece was coveted by many; the Duke of Mantua acquired it through the intervention of Rubens, who was at that time in his service. The details of this purchase are shown from three letters written by Giovanni Magno, the Duke's agent in Rome, to Cheppio,

175

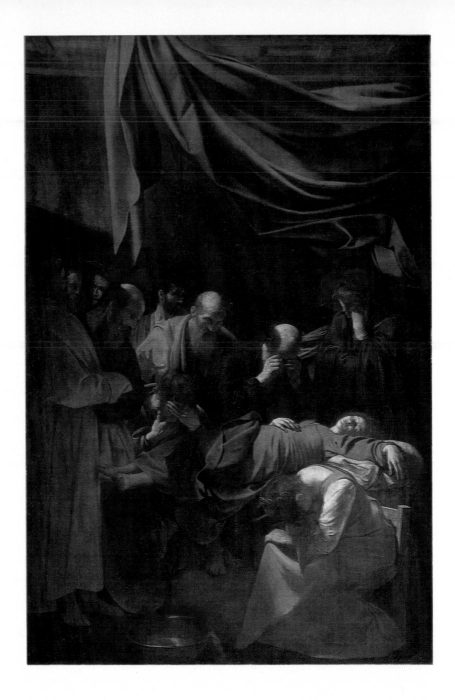

counsellor at the Mantuan court. Yielding to the demand of the artists of Rome, Giovanni Magno had to make the picture available for public admiration, and exhibited it from 7 to 14 April 1607. Rubens himself took charge of the making of the packing-case for its journey to Mantua. Caravaggio, uneasy on account of the brawl in which he had been involved the previous year, was no longer in Rome at that time.

Untouched as we now are by all the passions it aroused, we are free to admire what the artists of the time saw in it — a monument of human pathos, which attains an antique grandeur. The reason for Caravaggio's troubles with the Roman clergy, however, can well be understood; in striking this note of evangelical simplicity, he was foreshadowing the Protestant art of Rembrandt. The representation of the Blessed Virgin as a woman of humble class, and not as the Queen of Heaven, had been demanded a century earlier by another reformer who was also ahead of his time — Savonarola.

ARCIMBOLDO, GIUSEPPE, 1527?–1593
Summer
Panel: 30 × 25 in. (76 × 63·5 cm.) Inventory: Inv. 1964-31
Signed and dated 1573
(Reproduction p. 178)

Acquired in 1964 from M. Neger, with three other pictures in the same series: *Spring, Autumn* and *Winter*.

These *teste composte*, as the contemporary critic Lomazzo called them, were painted by Arcimboldo between 1560 and 1587 in Vienna and Prague, where this Milanese artist was court painter to the Emperors Maximilian II and Rudolf II. This method of creating a figure with a conglomeration of other figures — plants, animals, and various objects — was practised by Leonardo da Vinci and Jerome Bosch; it also occurs in the satirical caricatures of the Reformation and the Counter Reformation. It is found in Indian miniatures, examples of which may have been in the imperial *cabinet de curiosités* which was rich in oriental objects. The artist could also have derived the idea from the mural decorations of covered markets or inns, which were adorned with coats-of-arms or still-life paintings evoking the goods that were eaten or sold there.

Arcimboldo composed actual portraits in this manner, but he also used suitable emblems to make up allegories of the seasons and the elements.

FRENCH SCHOOL

Sixteenth and Seventeenth Centuries

SCHOOL OF FONTAINEBLEAU, *c.* 1550
Diana the Huntress
Canvas: $75\frac{3}{4} \times 52\frac{1}{2}$ in. (192×133 cm.) Inventory: Inv. 445
(Reproduction p. 180)

This picture was bought at the Lebreton sale in 1840 for 226 francs. It was first sent to Fontainebleau. A smaller copy was ordered for Versailles from Hippolyte Flandrin, and cost more than the original (400 francs).

At the time of its purchase, the painting was taken to be an allegorical portrait of Diane de Poitiers, Duchesse de Valentinois, Henry II's mistress. This identification was subsequently abandoned, but has lately been taken up again. Père Dan, author of *Trésors et Merveilles de la maison royale de Fontainebleau*, written in 1642, records in the Pavillon des Reines Mères (no longer standing) 'a portrait from life of Madame Gabrielle Destré, Duchesse de Beaufort, as Diana'. He says it is the work of Ambroise Dubois, who was a contemporary of Gabrielle d'Estrées. The face of the Louvre *Diana*, however, is not that of Gabrielle. In the catalogue of the exhibition *The Triumph of Mannerism* (Amsterdam, 1955), Charles Sterling returns to the earlier identification of the model as Diane de Poitiers, after comparing the face with known portraits of this royal favourite.

The character of Diana played an important part in poetry and painting in the reign of Henry II, not only because of Diane de Poitiers but also because of the passionate attachment of the French kings to the pleasures of hunting. The general pose of this striding Diana was probably inspired by an antique marble (a copy of a fourth-century work) brought back from Italy by Francis I, and now in the Louvre (No. 589). Louis XIV had a bronze replica made of it for the Jardin des Buis (now the Jardin de Diane) at Fontainebleau. The style created at Fontainebleau by Rosso and Primaticcio has also left its mark on this painting; the lengthened proportions recall Primaticcio, and the modelling of the bust is reminiscent of figures by Rosso. The style is much closer to work done in 1550–60 than to the group known as the Second School of Fontainebleau, at the end of the sixteenth century; which excludes the possibility of attributing it to Ambroise Dubois. In fact, the picture calls to mind sculpture rather than painting—in particular the work of Jean Goujon. The head, with its blue eyes and blond hair, is very beautiful and very individual, in spite of the mythological idealization. The canvas has been slightly enlarged on the left.

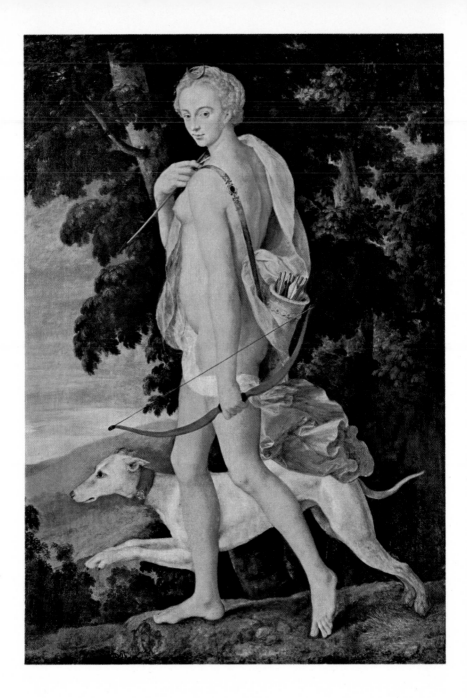

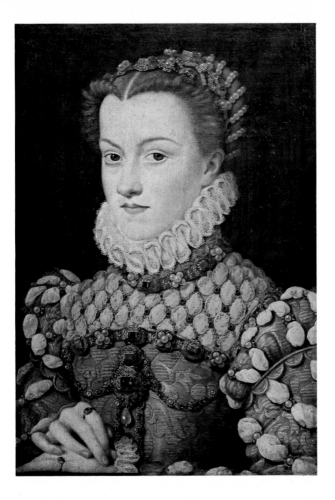

CLOUET, FRANÇOIS, 1515–1572
Elizabeth of Austria, Queen of France
Panel: $14\frac{1}{4} \times 10\frac{3}{4}$ in. (36 × 27 cm.) Inventory: Inv. 3254

In 1755 this picture was in the King's Cabinet des Ordres; it had probably been placed there by Pierre Clérambault, Keeper of the Royal Collection, who must have removed it from the Gaignières property before the latter was sold. During the Revolution it was sent to the Dépôt established in the convent of the Petits Augustins, converted into the Musée des Monuments Français. In 1817 it was transferred to the Louvre.

A replica of the painting dated 1571, in the museum at Chantilly, makes it possible to date this portrait of Elizabeth of Austria (1554–92), daughter of Maximilian II, Emperor of Austria, and of Maria of Austria, who married Charles IX on 27 November 1570.

The Print Room in the Bibliothèque Nationale has a drawing for the portrait, bearing the same date.

The attribution to Clouet has sometimes been doubted, but the outstanding quality of the work, the limpid flesh tones, and the rich finish of the costume make it reasonably certain that the painting is by him.

There is something a little sad in the Queen's expression. Her life was not happy; she loved the King passionately, but his feeling for her was simply an affectionate regard, and a genuine appreciation of her good qualities. His heart belonged to Marie Touchet.

Brantôme has left an appealing description of this princess: 'She was very beautiful with a complexion as fair and fine as any lady in her court; and had a most pleasant manner. She was also wise, virtuous and kind, and never harmed or offended a single soul, nor uttered the slightest harsh word. She was of a serious disposition, moreover, and spoke but little, and then always in her native Spanish.' After the King's death in 1574, she did not wish to marry again, and retired to Vienna, where she founded a convent of Poor Clares. She died there, aged 38, on 22 June 1592.

The painting is executed with great finish, but is not highly detailed; the skilful use of transparent glazes serves to show up the delicate complexion so much admired by Brantôme. The work stands out by reason of its excellent condition.

As with all royal portraits, a number of replicas exist, contemporary or later; some are faithful copies, others introduce variants.

French School
Charlotte de Roye

Corneille de Lyon
Clément Marot

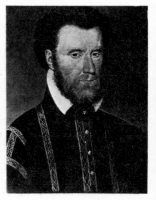

French School
Jean Babou

L. Le Nain *The Return from haymaking*

LE NAIN, LOUIS, 1593?–1648
Peasant Family
Canvas: 38¼ × 48 in. (97 × 122 cm.) Inventory: R.F. 2081
Signed: Le Nain fecit ano 1642
(Reproduction p. 184)

La Caze bequest, 1869.

The task of distinguishing the respective styles of the three brothers signing themselves 'Le Nain' was carried out about thirty years ago by Monsieur Paul Jamot, then Keeper of Paintings in the Louvre; this signature is found on a number of pictures. Recently discovered documents and paintings have caused some confusion among the critics, and seem to have invalidated Paul Jamot's hypotheses; they show that the three brothers did in fact produce their work collectively. This is supported, incidentally, by the fact that they never used any other form of signature but 'Le Nain', as a kind of studio stamp. It explains the existence of complex pictures where brilliant passages of painting are to be found alongside mediocre areas executed by assistants or pupils. But there are also others of a high level where the brothers worked alone or with each other, without help from outsiders; and the present picture is one of these. It is an element in the reconstruction of the *œuvre* of Louis, the most gifted.

The Louvre has two paintings depicting peasant families by Le Nain; one of them (M.I. 1088) is an austere and virile work. This one, however, strikes a note of profound intimacy, a warmth of spirit, like the atmosphere of a domestic festivity.

The general harmony of greys and browns is in keeping with the spirit of austerity reigning in French painting in the time of Louis XIII. Unlike the Flemings, who made their scenes of rustic life an occasion for depicting the unleashing of the coarsest sensual instincts, Louis Le Nain saw in the peasant soul a profound gravity, even solemnity; the expression of a life of toil whose hard realities have bestowed on it a sense of its own dignity. The spirit of the 'honnête homme', the symbol of the seventeenth century, permeates these peasants. The paint quality is flowing and rich, with touches of impasto used not simply for effect, as in the work of Frans Hals, but giving proof of a sensitive brush, searching out the modelling with attention and feeling.

Several early copies give evidence of the painting's reputation.

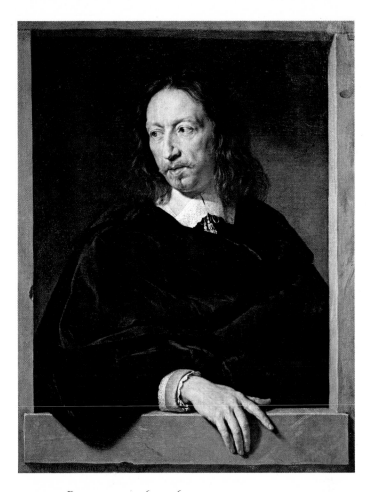

CHAMPAIGNE, PHILIPPE DE, 1602–1674
Portrait of a Man
Canvas: 35¾ × 28¼ in. (91 × 72 cm.) Inventory: Inv. 1145
Signed and dated: Ph. Champaigne F. A. 1650

Bought at the Saint Martin sale in 1806, for 3,780 francs.

The sitter was formerly identified as Robert Arnauld, of Andilly, the eldest of the twenty children of the lawyer Antoine Arnauld, who retired from the world and withdrew to Port-Royal when he was nearly sixty.

One is indeed tempted to see this convinced Jansenist in the noble and austere face here depicted, whose expression seems to reflect an intense preoccu-

185

pation with the problems of spiritual life. However, comparison with the engraved portrait by Edelinck proves that such an identification is not possible. Nor does the date support the theory that the portrait might represent Arnauld de Luzancy, Robert Arnauld's second son; he would have been 27 in 1650, and the man shown here is older.

As the mannerist portraitists such as Antonio Moro or Bronzino had done earlier, Philippe de Champaigne concentrates on the two elements which express the sitter's character – the face and the hand. Rarely has the work of this artist reached such a high standard of execution; the work is absolutely intact, with all its original glazes. The lightening of the varnish has revealed its full quality; a tiny sample of the varnish has been left on the upper part of the window frame, at the right, and shows how much it was disfigured.

Philippe de Champaigne's strict objectivity betrays his Flemish descent; like Van Eyck, he faithfully portrays the features of his sitter in all their physical reality. But in the cool tones of this picture he turns away from Rubens, whom he imitated in his early work, and comes closer to a more truly French colour harmony. The black garment has kept all its qualities of transparency, which is very rare in old paintings.

It is characteristic of the intelligence of Baron Vivant-Denon that he should have purchased this picture in 1806, when the popularity of the 'Davidian' style of painting was at its height. But although its realism differs essentially from the idealized portraits of David, the profound honesty with which it is painted is not so far removed from the art of the painter of *The Horatii*.

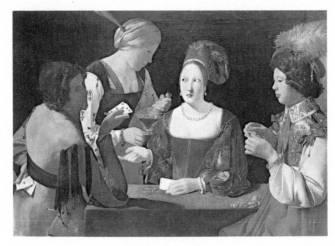

La Tour *The Cheat*

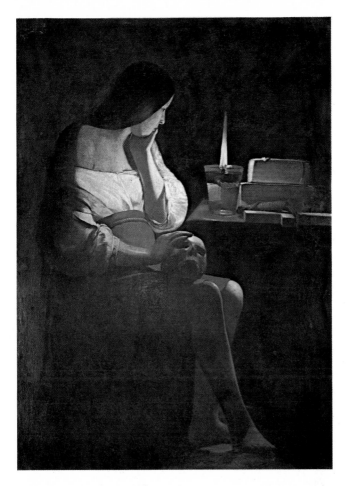

LA TOUR, GEORGES DE, 1593–1652
Saint Mary Magdalen with a Candle
Canvas: 50½ × 37 in. (128 × 94 cm.) Inventory: Inv. R.F. 1949–11
Signed: G. de La Tour fec.

Terff collection. Bought in 1949 from the Administration des Douanes.

 In the somewhat uncertain chronology of George de La Tour's work, this picture has been allotted a date some time between 1630 and 1635, by analogy with the *Saint Mary Magdalen with a Mirror* (Fabius Collection, Paris), which has been dated between 1635 and 1645. There is an engraving after the latter painting by J. Le Clerc.

187

During the seventeenth century, great devotion was shown to Mary Magdalen in all Catholic countries. She was the perfect lover of Christ, her beauty made yet more appealing by reason of her repentance, which had a special attraction for a period so passionately interested in problems of mysticism, quietism and asceticism. The theme of the repentance of sinners and of trials sent by God is illustrated in such subjects as the Repentance of St Peter, Mary Magdalen, and Job. A number of written works give evidence of the cult of the Magdalen—one by Cardinal Bérulle, for example, published in 1627—and this cult was the more widespread since Provence possessed two great sanctuaries dedicated to her: the grotto of La Sainte Baume, and the Saintes Maries de la Mer. M. Pariset, to whom we are indebted for a detailed study of the picture, has suggested that Georges de La Tour took a gipsy as his model; there were many in Lorraine in the seventeenth century.

This picture and the one in the Fabius collection seem to have been inspired by several themes popular with Italian or Dutch artists—the repentant Magdalen, Melancholy and Vanity. The artist has given it a feeling of philosophical meditation in keeping with the spirit of the time; the saint's body is enveloped in mysterious darkness, and her pensive face illumined only by the candle. The bare limbs increase the impression of destitution; on the table are some books and a candle, and, on a wooden cross, a blood-stained scourge—a reminder of the more violent side of the Magdalen's penitence.

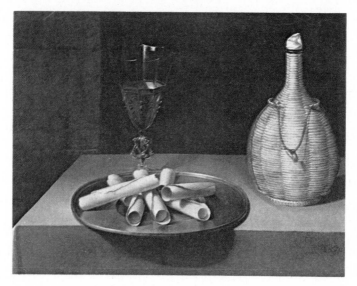

Baugin *Le Dessert de Gaufrettes*

Poussin *Self-Portrait*

Poussin *The Triumph of Flora*

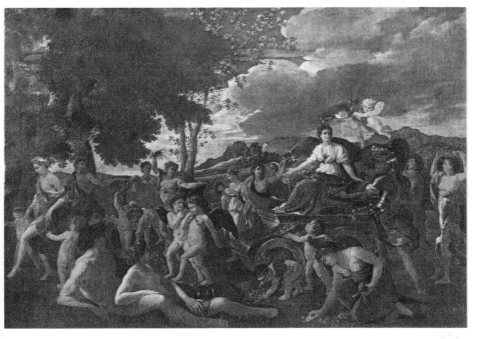

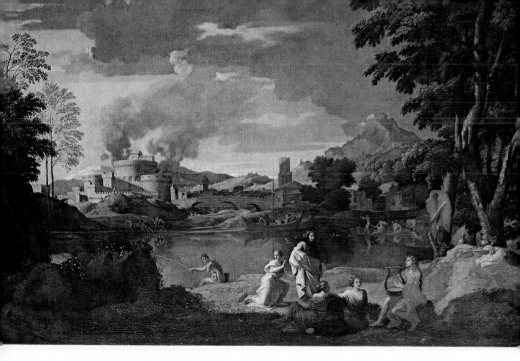

POUSSIN, NICOLAS, 1594–1665
Orpheus and Eurydice
Canvas: 47 × 78¾ in. (120 × 200 cm.) Inventory: Inv. 7307

This picture was engraved and dedicated to Louis XIV by Étienne Baudet, together with three others representing a *Scene of Terror, Polyphemus and Galatea,* and *Diogenes.* It appears in the inventory of Bailly, Keeper of Pictures at Versailles in 1709–10. Louis XIV acquired it in 1685 from the painter Branjon.

It has been thought that this may be the picture which Félibien mentions as having been painted for the King's architect Le Brun, between 1655 and 1660; but there is no proof to support this identification. Moreover, as Charles Sterling has pointed out, it belongs stylistically to an earlier period. The rigorous composition, the solidity of the structures, the firmness of handling and the brilliant disposition of areas of light and dark in the sky, are more characteristic of his work between 1648 and 1650, when he painted the Louvre *Diogenes*, the Hermitage *Polyphemus* and *Hercules and Cacus*, the *Landscape with St Matthew* in the Berlin Museum and the *Landscape with St John on Patmos* in the Art Institute of Chicago.

In all his work, Poussin celebrates the alliance between man and nature which is the expression of classicism. To man, who makes history, nature lends her air of eternity. Here, in the peace of an afternoon, Orpheus sings to his

190

cythara while the nymphs bathe; but already the serpent is about to bite Eurydice and despatch her to the Underworld. The landscape echoes the mood of the drama; in the castle in the background a fire is breaking out, darkening the sky with its smoke.

Poussin places the story of Orpheus in the Roman Campagna; he borrows several elements from the Eternal City, such as the Torre delle Milizie, and a tower based on the Castel Sant' Angelo as it looked when it was the Mausoleum of Hadrian. Dense smoke pours from a fire which devastates the former, and darkens a sky already overcast with sombre clouds. The fall of the light divides the landscape diagonally into bright and dark areas—a division clearly seen on the Torre delle Milizie.

Many of Poussin's pictures have darkened, chiefly as a result of a red underpainting which has begun to show through the colours. The *Orpheus*, however, is free of this; it has kept its original transparency even in the darker passages, and the whole painting is particularly well preserved.

CLAUDE LORRAIN (CLAUDE GELLÉE), 1600–1682
Village Fête
Canvas: $40\frac{1}{2} \times 53\frac{1}{4}$ in. (103 × 135 cm.) Inventory: Inv. 4714
Signed and dated: Claude inv. Romae 1639
(Reproduction p. 192)

Given to Louis XIV in 1693, together with its companion piece, *A Sea Port* (Inventory: Inv. 4715), by the architect and gardener Le Nôtre.

There are several versions of this painting; two are reproduced in the *Liber Veritatis* (in the British Museum), a kind of register in which Claude recorded and drew the pictures he painted and sold. The earlier of these two (No. 13 in the *Liber Veritatis*) was painted in 1637 for Urban VIII, with a companion piece, *A Sea Port;* it next passed into the possession of the Barberini family, and was sold in 1798. It is now in England, in the collection of Lord Yarborough. The Louvre version, dated 1639, differs from the other in several respects; it is reproduced as No. 39 in the *Liber Veritatis*, and also had a companion piece— *A Sea Port at Sunset.* Another version used to be in the Stroganoff Collection, St Petersburg; according to an engraving of 1742, it was done in 1669, towards the end of the artist's life. The theme of *dolce far niente*, the tranquil repose beneath majestic classical trees, the rustic dances to the music of flutes, have often charmed Claude Lorrain; it is a reminiscence of the Golden Age, whose naïve virtues are supposed to survive in country folk.

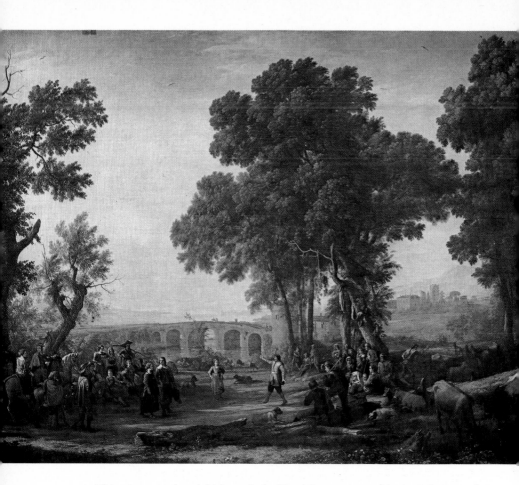

This picture, painted fairly early in Claude's career, reveals the influence of Flemish art. The composition, with a group of trees in the centre, and openings on either side through which the light appears, was often used by Flemish landscape painters from the time of Brueghel; Paul and Matthew Bril frequently employed it, and Claude continued in their tradition in Rome. In accordance with classic sixteenth-century procedure, the bridge harmoniously unites the middle and far distances. Through the opening on the right can be seen a city bathed in a golden mist, more characteristic of the Roman Campagna than of the north. Following the usual practice of studios in the Low Countries, Claude often employed other artists to paint the little figures in his pictures; but this does not seem to have been the case here, to judge by the unity of conception between figures and landscape.

192

FLEMISH SCHOOL
Seventeenth Century

RUBENS, SIR PETER PAUL, 1577–1640
The Joys of the Regency (Galerie Médicis)
Canvas: 155 × 116¼ in. (394 × 295 cm.) Inventory: Inv. 1783

In the spring of 1625 the 21 canvases of the *Life of Queen Marie de Medici* were installed in the Palais du Luxembourg, on the first floor in the west wing of the Cour d'Honneur. They were taken down and rolled up in 1781–82, when the

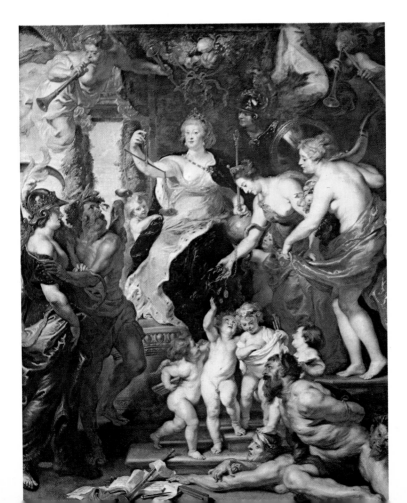

palace became an appanage of the Count of Provence. In 1803 they were put back in the east gallery of the Luxembourg, the quarters of the Sénat Conservateur; in 1816 they were exhibited in the Grande Galerie of the Louvre, but were removed between 1828 and 1838, to be used as cartoons for Gobelin tapestries. In 1900 they were put up, incorrectly, in a room which had been intended under the Empire to serve as a Salle des États, and which the architect Redon had redecorated with rich stucco work. They were rearranged in their original order in 1953.

In 1620 Marie de Medici, having become reconciled with her son at Brissac, turned her attention to her palace in Paris, the Luxembourg, and its decoration, begun in 1613. Towards the end of 1621 she summoned Rubens to consider this question; he had worked for her sister, the Duchess of Mantua, and had perhaps also been recommended to her by Baron de Vicq, Paris ambassador of the Low Countries. Rubens arranged with the Queen to do two galleries, one in her honour and one in honour of Henry IV. She decided to begin with her own gallery. Rubens corresponded with Peiresc and also the Abbé de Saint-Ambroise, who asked him to submit the preparatory sketches. On 3 November 1622 Rubens had received the measurements for the three largest pictures in the gallery. On 9 May 1623 the Queen asked him to come to Paris to install the pictures; he brought the first nine on 29 May. The gallery was inaugurated on the occasion of the marriage of Henrietta of France and Charles I, King of England, which took place on 8 May 1625; the last pictures were delivered in February 1625.

The Joys of the Regency was hastily painted in Paris to replace the picture of *Marie de Medici leaving Paris*, a subject which did not please the Queen. On 13 May 1625 Rubens related this to Peiresc. Here is ample proof of Rubens' genius of improvisation; perhaps the rapidity of execution of this particular work is responsible for its outstanding quality in an *ensemble* remarkable for its unity. In fact, this same unity suggests that the part played by collaborators may not be so great as has hitherto been believed.

Rubens *Village Fête (detail)*

RUBENS, SIR PETER PAUL, 1577–1640
Hélène Fourment and her Children
Panel: 44½ × 32¼ in. (113 × 82 cm.) Inventory: Inv. 1795
(Reproduction p. 196)

La Live de Jully sale, 1769 (20,000 livres); bought by Dujeu; at the Randon de Boisset sale (1777) it was withdrawn at 10,000 livres, and handed over to the dealer Lebrun for 18,000 livres. At the Comte de Vaudreuil's sale (1785) it was bought for Louis XVI's collection for 20,000 livres.

Isabella Brandt, Ruben's first wife, died in 1626. The artist remained a widower for several years, then on 6 December 1630, at the age of 53, he married Hélène Fourment, a relative of his late wife. She bore him five children, one posthumously; and until his death in 1640 he constantly recorded his young wife's blond loveliness—in portraits (one, the *Fur Wrap* in Vienna, shows her semi-nude), in *scènes galantes*, and indirectly in subjects from the scriptures, the lives of saints, or mythology. Hélène's beauty corresponded to an ideal conception which he had formed in his youth.

Hélène Fourment is shown here in a pose similar to that of the Munich portrait, where she has her son François on her lap. In this picture her eldest child Claire Jeanne (born 18 January 1632) stands in front of her, and she is holding François, who was born 12 July 1633. To the right, scarcely visible, is a baby's hand, holding on to the chair; this must be Isabelle Claire, born 3 May

195

1637. From the apparent age of the children, the picture seems to have been painted in about 1636–37.

The painting is in a perfect state of preservation. In certain areas it has hardly been carried further than the sketch stage — especially at the top and bottom of the right-hand side, where the ground is scarcely covered. No doubt this is why it was covered with disfiguring layers of thick brown varnish in the nineteenth century. These were removed in 1952, revealing the pearly quality of the painting; an earlier varnish left untouched by the cleaning lends a golden warmth to the picture's tonality.

VAN DYCK, SIR ANTHONY, 1599–1641
King Charles I
Canvas: 107 × 83½ in. (272 × 212 cm.) Inventory: Inv. 1236
Signed on the right: A. van Dyck f.

Belonged to the Comtesse de Verrue in the eighteenth century, then to the
Marquis de Lassay. Afterwards in the Comte de la Guiche's collection, which
was sold in 1771; then in the collection of Crozat, Baron de Thiers (1772). The
Comtesse du Barry, who claimed Stuart connections, bought it next, and took it

to Louveciennes; she did not keep it long, however, because in 1775 it was acquired by the Crown of France for the considerable sum of 24,000 livres.

Van Dyck came to the English court in 1632, and had an immediate success with Charles I, who knighted him. He became 'principalle Paynter in Ordinary to their Majesties at St James's', and from 17 October 1633 he received an annual pension of £200. He painted a great many portraits of the King and the royal family; the Louvre picture is included in a statement for 'Sa Magtie le Roy' drawn up in French by Van Dyck. Payment was made on 14 December 1638; the portrait is referred to in the statement as 'le Roi à la chasse', and whoever checked the bill has altered the price from £200 to £100.

The King is represented in informal attire, without any of the attributes of royalty; he has dismounted from his horse on his return from hunting. Only his majestic expression and proud attitude reveal him as 'the first gentleman in the kingdom'. The arrogant pose with hand on hip was from mediaeval times associated with nobility; Rigaud uses it for his portrait of Louis XIV in full regalia.

To the left of the picture, a glimpse of the sea and a sail make discreet allusion to his Britannic Majesty's maritime empire.

A number of copies of this painting are in existence.

During his stay in England, Van Dyck's style changed rapidly under the influence of fashionable society. He idealized his sitters, took pleasure in painting silken stuffs and elegant poses, and his art acquired a certain degree of conventionality. This particular portrait was painted when he first came to London, and still shows the fresh and forthright manner of his Antwerp period. It therefore has a greater quality of immediacy than any of the other portraits of Charles I.

JORDAENS, JACOB, 1593–1678
The Four Evangelists
Canvas 52½ × 46½ in. (132·7 × 118 cm.) Inventory: Inv. 1404

May have belonged to the Dutch painter Pieter Lastman; the inventory of his possessions made after his death (1632) includes '4 Evangelisten van Jac. Jordaens'.

In the eighteenth century the picture was in the collection of Joseph-Hyacinthe François Rigaud, Comte de Vaudreuil, Grand Falconer of France in 1780; under the restoration he was made Governor of the Louvre, and he died there in 1818. To liquidate his debts, however, he had to put his collection up for sale in November 1784. The sale lasted several days; this particular picture was bought for the King for 4,000 livres on 25 November.

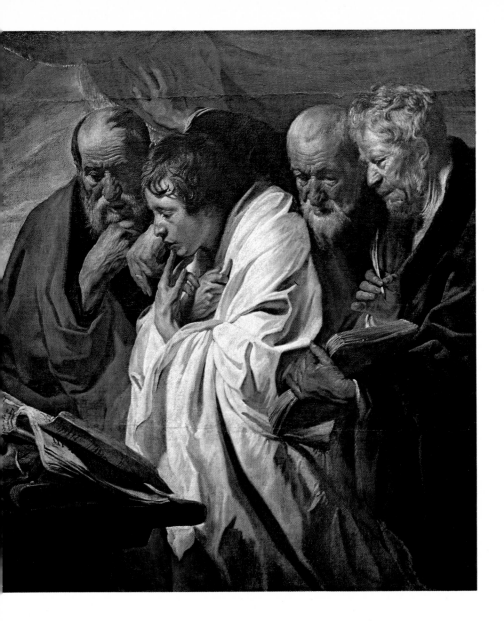

The traditional title of the painting has sometimes been questioned, and the subject identified as *Christ among the Doctors*, but this hypothesis must be rejected. Even the youngest of the evangelists is much older than Jesus was when this incident took place. The three older evangelists are grouped round John, who seems to be reading with rapt attention the sentences he has been inspired to write.

Till the fifteenth century the evangelists were represented according to traditional prototypes formed during the Gothic period. The Florentine Renaissance sought to individualize them; in the sixteenth century they came under the influence of Michelangelo's prophets, and artists made use of agitated movement and expressions to convey the idea of divine inspiration. The Carracci, and still more Caravaggio, showed them not only as apostles, but as men of the working class.

This painting, which must have been executed between 1620 and 1625, belongs to the first — and best — period of Jordaen's artistic production. The grouping in the *Adoration of the Shepherds* of 1618 (National Museum of Stockholm) resembles that in the Louvre picture, and one of the Evangelists is of the same type as one of the Stockholm shepherds. The paint is handled vigorously, in a technique very different from that of Rubens, with very little use of glazes; the brush works in varying degrees of impasto, the quality of which seems to underline the physical presence of the figures.

Jan Brueghel *The Battle of Arbelles*

DUTCH SCHOOL

Seventeenth Century

HALS, FRANS, 1580–1666
The Gipsy Woman
Panel: 22¾ × 20½ in. (58 × 52 cm.) Inventory: M.I. 926
(Reproduction p. 202)

Sale of M. de Marigny, Marquis de Ménars (Madame de Pompadour's brother), in 1782. In the collection of the expert Rémy, then in that of La Caze, who bequeathed it to the Louvre in 1869.

This painting is usually dated in about 1628 to 1630, during which period Hals produced the *Hille Bobbe* (Berlin), the so-called *Mulatto* (Cassel) and the *Jolly Drinker* (Amsterdam). However, in the Louvre painting the satirical intention is less pronounced. This gipsy woman is painted naturalistically, and is still simply a portrait; the broad smile on her face is not the wild laughter which transforms Hals' other genre portraits into stage characters.

The interest in low life which characterized the work of Frans Hals and his fellow artists of the school of Haarlem probably reflects the grimness of social conditions in Holland during the troubled period of the wars of independence; but it also has its place in an international aesthetic movement which originated in Roman circles early in the seventeenth century, generally described as 'Caravaggesque'. In the Low Countries, this tendency was combined with the native interest in genre painting, originating in Antwerp in the sixteenth century; its last manifestation was in English art, in the work of Hogarth, whose characters from low life derive from those of Frans Hals.

Together with Velasquez and Rembrandt, Frans Hals is the creator of the modern craft of painting. Before the seventeenth century, artists tried to conceal the method of execution; in their view, only drawing, composition and colour counted. For Frans Hals, the actual handling of the paint is the chief means of expression. The execution must be spontaneous, and the picture should appear to be dashed off with brio in a moment of inspiration. Hals abandoned the meticulous finish of the primitives and the deliberate brushwork of the classical school; he used broader brushes, in order to leave visible the movements of his hand, and one has the sensation of being present at the creation of the work. In his early period (to which this painting belongs), the exuberant movements of the brush across the canvas suggest the actuality of life itself, seized in all its explosive force; later, the conflict of strokes in such pictures as the *Governors* and the *Governesses* reveal an old man's impatience and anxiety.

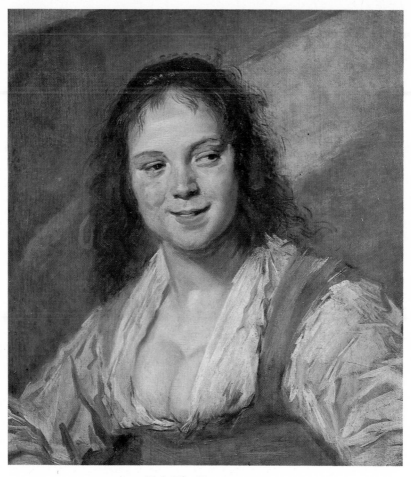

Hals *The Gipsy Woman*

REMBRANDT, HARMENSZ VAN RYN, 1606–1669
The Pilgrims at Emmaus
Panel: 26¾ × 25½ in. (68 × 65 cm.) Inventory: Inv. 1739
Signed: Rembrandt f. 1648
(Reproduction p. 204)

Willem Six sale, Amsterdam, 12 May 1734, No. 57 (170 florins), Comte
Lassay's sale, Paris, 17 May 1775; Randon de Boisset sale, Paris, 3 February
1777, No. 50 at the latter sale for 10,500 livres.

Rembrandt *Hendrickje Stoffels*

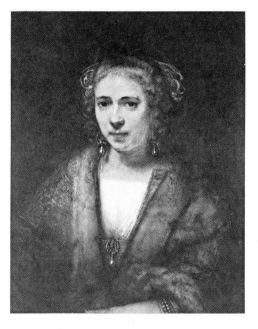

In Rembrandt's religious painting, his Protestantism reveals itself in his rejection of all the various traditions — iconographical, dogmatic, hagiographic and rhetorical — which interposed themselves between God and man in the imaginations of seventeenth-century Catholic artists.

Stripped of all historical character, both setting and costumes introduce us to a world of biblical simplicity. Rembrandt is the only Christian painter to have fully appreciated the profoundly mystical significance of this scene. Italians such as Veronese and Titian made it a pretext for worldly display; Delacroix exploited its dramatic quality; and the stupefaction of Caravaggio's disciples on recognizing Jesus conjures up an echo of coarse laughter, reminiscent of boon companions celebrating their reunion in some tavern. In Rembrandt's picture, all is silence; the action of the scene is an interior one, taking place in the heart.

The two pilgrims make only the slightest gesture; the serving boy is unaware of anything unusual. Christ's features are growing indistinct; he is becoming an apparition, and is about to disappear.

Rembrandt treated the theme of *The Pilgrims at Emmaus* — the expression of divine love — on several occasions. The Louvre possesses another picture of the same subject, wrongly catalogued by Bode (597) as the work of Rembrandt. In the version he painted as a young man (Musée Jacquemart-André, Paris), Rembrandt expressed in a dramatic fashion, by means of a theatrical effect of

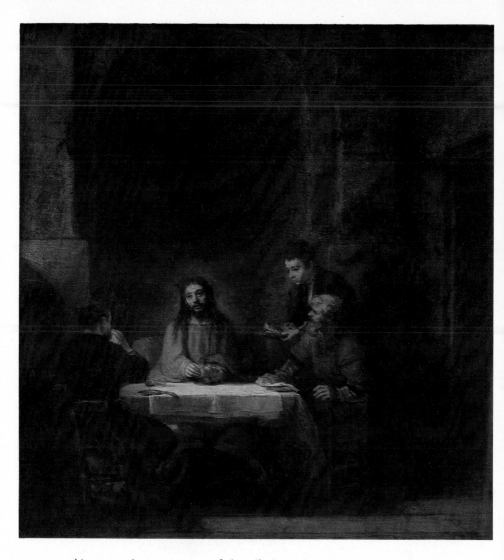

chiaroscuro, the amazement of the pilgrims when their travelling companion reveals himself to be Christ.

The Louvre picture is in excellent condition, as was revealed by the cleaning of the varnish in 1952. The amber transparency of the shadows takes on a mystical quality, enveloping the principal scene with a soft and mysterious atmosphere. Impasto is used with great restraint.

204

REMBRANDT, HARMENSZ VAN RYN, 1606–1669
Bathsheba
Canvas: 56 × 56 in. (142 × 142 cm.) Inventory: M.I. 957
Signed: Rembrandt f. 1654

W. Young-Ottley sale, London, 25 May 1811; W. Young-Ottley sale, London, 4 March 1837. In the possession of the dealer Peacock in London. Marquis Maison's collection, Paris. Paul Perier sale, Paris, 16 March 1843, No. 75. Bequeathed to the Louvre by La Caze in 1869.

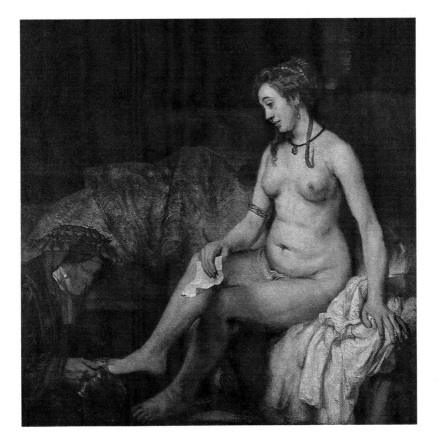

This painting is connected with an unhappy period in Rembrandt's life. In the year it was painted, Hendrickje Stoffels had to appear before the consistory of her church, and was banished from it on being convicted of being Rembrandt's mistress. The present picture had contributed to the scandal; it is Hendrickje who is here represented in the nude. She was a young peasant from Randorp, 22 years old, whom the artist had engaged as a servant in 1649; in that year Geertghe Dircx (his son Titus's nurse), who had also been his mistress, and with whom he had legal disputes, had to be taken to a lunatic asylum.

Hendrickje had a modest and affectionate nature; a portrait of her in the Louvre (p. 203), painted in 1650, reveals her frank and gentle character. She became Rembrandt's faithful companion till her death, six or seven years before his own, and was his favourite model during this time.

Bathsheba, painted from Hendrickje Stoffels, and *Danae* (1636) for which his wife Saskia van Uylenborgh was the model, are his two most important nudes — the only ones in which he was concerned with rendering the sensuality of flesh. For the Italians, nudes were a pretext for conjuring up the impersonal ideal beauty of goddesses; Rembrandt, however, painted the body of a real woman, in all its living and breathing truth.

X-rays show that he had at first intended the head to be more upright; the thighs had also been draped with a piece of material which he subsequently removed. The recent cleaning of the varnish has revealed the excellent state of preservation of this work.

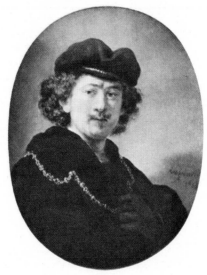

Rembrandt *Self-Portrait*

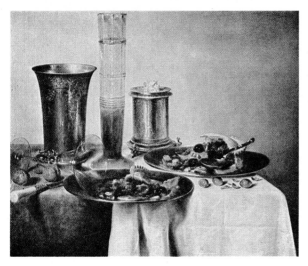

Willem Claesz Heda
A Dessert

RUISDAEL, JACOB ISAAKSZ VAN, 1628/29–1682
The Ray of Sunlight
Canvas: 32¾ × 38½ in. (83 × 98 cm.) Inventory: Inv. 1820
Signed with monogram
(Reproduction p. 208)

Acquired at the Comte de Vaudreuil's sale in 1784.

Nowadays, when we are able to distinguish the most subtle nuances in abstract pictures which would formerly have been dismissed as a boring jumble of colours and lines, the realism of Ruisdael's painting may seem a little monotonous. Yet he painted every subject that came to hand – the sea, the dunes, forests and châteaux, churches and cemeteries, towns, villages, farms, mills, fields of corn, the flat lands where he lived and the mountains which he probably never saw.

Unlike Rembrandt, he rarely painted a purely imaginary landscape; this picture, however, is one of the exceptions, and is unlike most of his work in every respect. He usually takes a low viewpoint; here he imagines himself to be on high ground, with an extensive view in front of him which seems to contain all the varying aspects of nature – mountain, river and plain, as well as château and town – as if he were trying to express a synthesis of the universal.

In spite of the broad vista presented to the spectator, who has apparently had to climb to a height in order to take it all in, the sky seems to absorb the whole of it. The wind, which moulds the cloud formations, causes an arbitrary distribution of light and shade during the fugitive instant when the clouds are pierced by a ray of sunlight. Although human elements are present (of a conventional kind, it is true), the vision creates an impression of poignant solitude;

207

the work is of such high quality that it attains a philosophical level. The painter Fromentin, in his *Maîtres d'autrefois*, understood better than any other this spiritual range of the Haarlem painter; 'the greatest figure after Rembrandt', he said (Vermeer was still unknown). 'I imagine', he also wrote, 'that if Ruisdael had not been a Protestant, he would have belonged to Port-Royal'. There is certainly an echo of Pascal in this sense of solitude in the midst of the world, experienced by a man who could seem so attached to the outer aspects of things. In the work of this artist—probably an unassuming person, who lived in poverty and died in an institution, and who can certainly never have thought of expressing 'ideas' in his canvases—there is a profound echo of the meta-physical anguish experienced by some of the great contemporary thinkers.

VERMEER OF DELFT, JAN, 1632–1675
The Lace-Maker
Canvas: $9\frac{1}{2} \times 8\frac{1}{4}$ in. (24 × 21 cm.) Inventory: M.I. 1448
Signed: J. V. Meer

The history of this picture can be traced with very few breaks right from the seventeenth century. On 16 March 1696 it featured at Amsterdam in an anonymous sale which included no less than 21 of Vermeer's pictures; this particular picture (No. 12) only fetched 28 florins. Bought by the Louvre at the D. Vis Blockhysen sale in Paris, 1 April 1870, for 7,270 francs.

The style of dress, the manner of painting and the relationship with other works indicate a date around 1664 for this picture. André Malraux believes that the model who posed for *The Lace-Maker* (and for other pictures as well) was Catherine Vermeer, the artist's wife.

This picture belongs to a group of small, almost square, paintings, in which a single figure is shown half-length (*Woman with a Red Hat*, Washington; *Young Girl with a Flute*, Washington). Out of this very exiguity Vermeer derives an effect of rare intimacy and of mystery. Paul Claudel has remarked on the subtlety of the composition which permeates even the lace bobbins in her hands. The recent lightening of the varnish has made it possible to appreciate the colour values of the ash-grey background. Some earlier restorer caused slight damage to the signature; otherwise the work is in very good condition.

Meindert Hobbema
The Water-Mill

SPANISH SCHOOL

EL GRECO (DOMENICOS THEOTOCOPOULOS) 1548–1614
A Saintly King (?)
Canvas: 46 × 37½ in. (117 × 95 cm.) Inventory: R.F. 1507

Formerly in the château of Chenonceaux. Passed into the Manzi collection in about 1875, then into the possession of M. Glaenzer, from whom it was bought in 1903 for 70,000 francs.

Most historians consider that the picture was painted shortly before 1600; Camon Azmar, however, (El Greco's most recent historian) does not believe it was painted before that date. The painting obviously represents a king, since all the royal attributes are present – crown, sceptre with fleur-de-lys, and 'main de justice'; he wears modern armour, except for the fact that the forearms are bare. The column, no doubt, symbolizes the might of the warrior.

Various identifications of the principal figure have been made: Ferdinand V, 'the Catholic', King of Castile and Aragon, conqueror of Granada, who drove the Moors from Spain; St Louis, King of France; Ferdinand III, the saintly King of Castile and León, famous for his victories over the Moors. Camon Azmar regards it as a secular portrait representing a victorious king of Spain – a Visigothic king, one of the sovereigns already mentioned, or Alfonso VI of Castile and León, the conqueror of Toledo in 1085.

There is an inferior replica, without the page, in Madrid; Camon Azmar attributes this to El Greco's son.

An X-ray photograph recently made in the Louvre laboratories shows that the head of the page was at first painted more realistically, and subsequently idealized; the eyes were originally shown wide open, then El Greco lowered the eyelids to make the boy more subsidiary to the main figure.

The predominantly glaucous tone of the picture and the curiously melancholy expression of the warrior king (no doubt some swashbuckling epic hero), contribute to the quality of strangeness in this work.

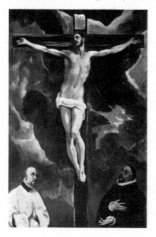

El Greco
*Christ
on the Cross*

El Greco
*Don Antonio
de Covarrubias*

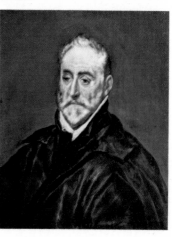

RIBERA, JOSÉ DE
The Adoration of the Shepherds

This picture, transferred from wood to canvas, is dated from 1650. Musée Napoléon. It belongs to Ribera's more tender vein; he is better known for his beggars and martyrdom scenes.

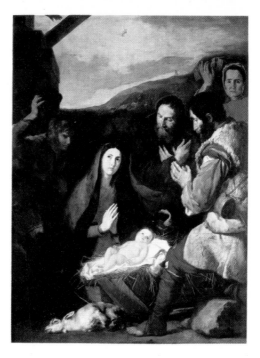

RIBERA, JOSÉ, *c.* 1589–*c.* 1656
The Club-Footed Boy
Canvas: $64\frac{1}{2} \times 36\frac{1}{4}$ in. (164 × 92 cm.) Inventory: M.I. 893
Signed in the lower right hand corner: Jusepe de Ribera español f 1642

Part of the La Caze bequest, in 1869.

This young vagabond is standing silhouetted against the landscape, carrying his crutch with the proud air of an hidalgo bearing arms. His smile seems to be making game of his own infirmity; he is also careful to inform us, by means of the scrap of writing he holds, that he is dumb as well as crippled, because he appeals to the charity of the passer-by with a card on which is the inscription: 'Da mihi elemosinam propter amorem Dei'.

This is one of the painter's last works, and one of the most bitter. The contrast of light and shade gave him pleasure; he studied the composition of the Renaissance painters in Italy, and perhaps also the work of Flemish artists, but in spite of all that he clung to the profoundly Spanish tradition of realism, even after having spent nearly all his life in Naples.

213

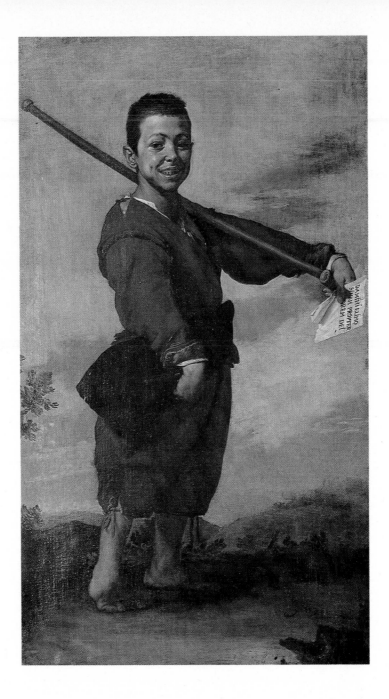

Moved by a Christian awareness of human weakness, Spanish artists often painted pictures of beggars, cripples and idiots. This is a derivation of the taste for scenes of low life in art, instituted by Caravaggio; Ribera was, in Naples, its most fervent adherent.

In this work, however, Ribera abandons Caravaggio's magical *chiaroscuro*; he had employed it to give dramatic intensity to his genre subjects, but the constant and indiscriminate use he made of it give many of his works a contrived air. The direct realism of the *Club-Footed Boy* is far more moving; its profound psychological penetration recalls Velasquez. The striking effect is increased by the low viewpoint; the figure towers above the spectator, who is imagined to be at ground level, and is silhouetted against the sky like a Mantegna hero. In this same sky, and what little of the ground is visible behind the figure, Ribera shows the mastery of landscape which he only very rarely had an occasion to display — in the scenes from the *Story of Jacob* in the Hermitage, for example.

The boy is reminiscent of the *Drunken Silenus* in the gallery at Naples, dated 1626. The face, with its strong cast shadows, is harshly lit by direct sunlight. This spectacular presentation makes a direct appeal to the spectator.

ZURBARÁN, FRANCISCO DE, 1598–1662
The Exposing of the Body of St Bonaventure
Canvas: 98½ × 89 in. (250 × 225 cm.) Inventory: Inv. M.I. 205
(Reproduction p. 216)

Deposited from the College of St Bonaventure in the Alcazar, Seville, in 1810. Brought back to France by Maréchal Soult. In Maréchal Soult's sale in 1852. Acquired by the Louvre for 5000 francs in 1858 from the Duc de Dalmatie, son of the Maréchal, with another picture by Zurbarán from the same series — *St Bonaventure disputing at the Council of Lyons with the envoys of the Emperor Palaeologus* — which fetched 20,000 francs.

In 1627 Francisco de Herrera contracted with the College of St Bonaventure in Seville to execute a series of paintings illustrating the life of the holy doctor. However, he only painted four pictures, and for reasons unknown Zurbarán completed the series in his place. In my book *Histoire de l'avant-garde en peinture* I put forward the hypothesis that this substitution took place for reasons of aesthetics; Herrera's very free and bold style must have displeased a Sevillean public accustomed to the rigorously formal construction of Montañes' sculpture, to which the work of Zurbarán exactly conformed.

215

Of the four pictures by Herrera, three survive; two are in the Louvre, bought at my suggestion, and one in the Prado. Of the four by Zurbarán, two are in the Louvre and one at Dresden (*The Prayer of St Bonaventure*); the Berlin Museum's *St Bonaventure and St Thomas Aquinas* was destroyed during the last war.

The austere scene of the *Exposing of the Body* is a solemn act of homage made to the saint by the dignitaries who were present at the Council of Lyons during which he died (15 July, 1274): Gregory X and Jaime I, the conqueror of Valencia.

216

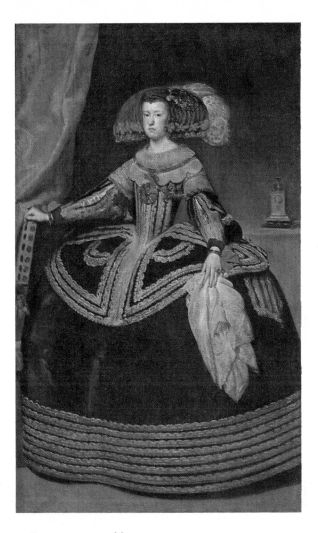

Velasquez, Diego, 1599–1660
Marianna of Austria, Queen of Spain
Canvas: 82¼ × 49¼ in. (209 × 125 cm.) Inventory: R.F. 1941–31

This picture was saved from the fire at the Alcazar, and is mentioned in inventories in 1772 and 1774. In 1816 it was moved from the Palacio del Buen Retiro to the Academia San Fernando, then in 1827 to the Prado. In 1941 it was in-

217

cluded in an exchange of works of art arranged between the museums of Madrid and the Louvre.

Marianna was the daughter of Ferdinand III, Emperor of Germany, and of Maria, sister of Philip IV of Spain; she was born in Vienna in 1634. She was to have married the Infante Balthasar Carlos, but he died prematurely and his uncle, a widower, took her as his second wife. The marriage took place in 1649. The Queen died in Madrid in 1669.

Velasquez was absent at the time of the marriage; he painted the portrait after his return, in the middle of the year 1651. The court of Vienna wanted the picture; the King therefore ordered a replica from Velasquez, who carried it out himself without recourse to the sitter. It was so successful that the King could not bear to part with this new masterpiece, which was sent to the Escorial. However, a copy was actually despatched to the Emperor on 23 February 1653; it is now in the Kunsthistorisches Museum, Vienna (Cat. 621A). This last is inferior in quality to the two others, and shows similarities with the style of Mazo.

There are therefore two copies of this work by Velasquez himself. The one still in the Prado (Cat. No. 1191) is more finished; the subsequent addition of a large drapery at the top explains its greater dimensions. The Louvre version is more lightly handled, almost in the manner of a sketch. Opinion is divided over the question of which of the two is the finer and, more especially, which was painted first. At the moment historians incline to the view that the portrait done from life is the one in the Prado, and the copy originally intended for Vienna is the one in the Louvre. F. J. Sanchez Cantón, however, Assistant Director of the Prado, believes that the Louvre version was painted first.

Bartolomé Esteban Murillo *The Angels' Kitchen*

Goya F. *Guillemardet* Goya *Mariana Waldstein*

GOYA Y LUCIENTES, FRANCISCO JOSÉ DE, 1746–1828
The Countess del Carpio
Canvas: $71\frac{1}{4} \times 48$ in. (181×122 cm.) Inventory: 1942–23
(Reproduction p. 220)

Marquis de Socorro's collection, Madrid; bought from his heirs in 1913 by M. Carlos de Beistegui; in Biarritz; Carlos de Beistegui legacy in 1942; entered the Louvre in 1953.

This picture is considered to be one of Goya's finest female portraits; Beruete y Moret, Sanchez Cantón and M. A. L. Mayer all heap praises upon it. The latter regards it as the artist's finest painting of a woman.

Maria Rita Barrenechea y Morante, born in about 1700, married Count del Carpio in November 1775; she died in 1795, and perhaps it is the approach of death which stamps such anxiety on the feverish, languid face, with its great dark eyes. The slender silhouette seems to materialize like a ghost in front of the plain background; in this simple picture, free of all rhetorical devices and exercising a curious fascination by reason of this very simplicity, one finds the strange 'supernatural' quality common to all the masterpieces of Spanish painting. The sylph-like body is only the fleshly covering of a burning spirit. We know that the Countess del Carpio was a cultivated woman; she wrote some poetry which was printed at Jaen in 1783.

The pose is a curious one; the position of the feet, one at right angles to the

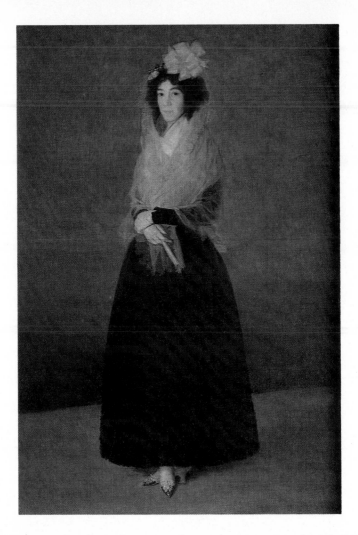

other, suggests that she is about to perform a dance step, but this is belied by
the calm and relaxed position of the crossed hands with the fan.

This picture is sometimes called the 'Marquesa de la Solana'; the Count del
Carpio only inherited this title a few months before his wife's death. This por-
trait is usually considered to belong to Goya's 'grey' period, just before the
illness (1792) which made him deaf and gave his art a more pathetic quality.
This picture is a subtle harmony of greys and black, with a single note of
colour — the pink ribbon rosette in the woman's hair.

ITALIAN SCHOOL
Eighteenth Century

GUARDI, FRANCESCO, 1712–1793
The Departure of the Bucentaur for the Ascension Day Ceremony
Canvas: $26\frac{1}{4} \times 39\frac{1}{2}$ in. (67 × 100 cm.) Inventory: 2009

Seized from amongst Comte de Pestre-Senef's collection. Selected by the Museum commission, with eleven other paintings in the same series, at the Dépôt at the Hôtel de Nesles on 7 Prairial of the year V. Sent to the Museum of Toulouse, which handed it over to the Louvre, in exchange for a portrait by Ingres and another picture by Guardi, in 1952.

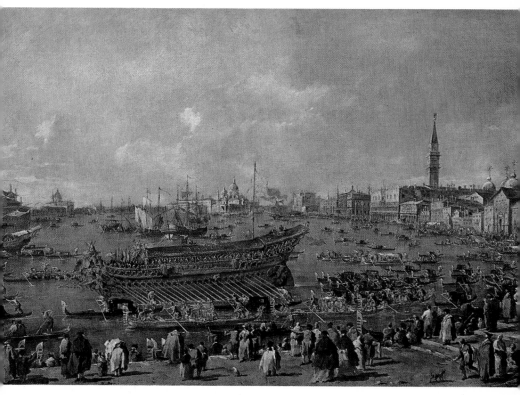

This work is one of a series of twelve pictures representing the 'Solenità dogali', in which the artist has faithfully copied the scenes drawn by Canaletto and engraved by Giambattista Brustolon to commemorate the festivities at the coronation of the Doge Alviso IV Mocenigo, in 1763. This has led to some confusion, and the canvases were formerly attributed to Canaletto, though their style was quite unmistakably that of Guardi. One of the pictures (No. 1330, Louvre Catalogue), bears the arms of Alviso IV Mocenigo.

Under the Empire, the series was unfortunately broken up; seven remained in the Louvre, one was sent to Brussels, two to Nantes, one to Toulouse and one to Grenoble. The return of the Toulouse painting to the Louvre, though an exchange, is the first step in an attempt to reassemble the set and display them in a special room.

Two pictures in the series represent the Feast of the Bucentaur, the most sumptuous of all the Venetian festivals. It took place each year on Ascension Day, the anniversary of the setting out of Doge Pietro Orsolo's expedition, which had achieved the conquest of Dalmatia in about AD 1000. In a magnificent state barge, known as the Bucentaur, the Doge visited the Lido and celebrated the marriage of Venice with the Adriatic, by casting a ring into the sea. The canvas shows the Bucentaur leaving Venice; another in the series (in the Louvre) represents the Doge going to hear Mass at San Niccoló del Lido. Another picture, in the Museum of Copenhagen, depicts the return of the Bucentaur to Venice.

Guardi *Festival of the Bucentoro*

ENGLISH SCHOOL

GAINSBOROUGH, THOMAS 1727–1788
Conversation in a Park
Canvas: $28\frac{3}{4} \times 22\frac{1}{2}$ in. (73 × 67 cm.) Inventory: Inv. R.F. 1952–16

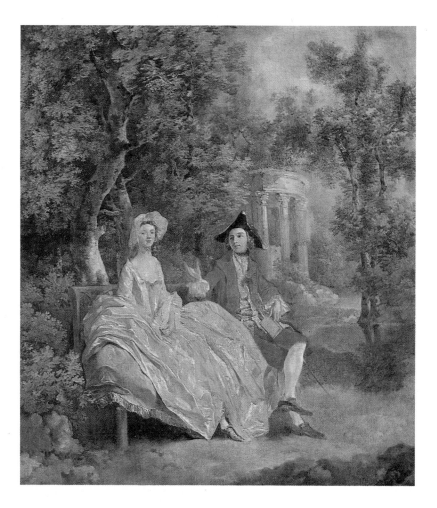

Anonymous sale by Peter Coxe, 24 June 1806, No. 66; G. Watson Taylor sale at Erlestoke Park, 25 July 1832, No. 128; in Archdeacon Burney's collection in 1834; sold by the latter to the dealer Sedelmeyer in 1896; bought from Sedelmeyer by M. Camille Groult in 1905. Given to the Louvre by M. Bordeaux-Groult in 1952.

This charming picture belongs to Gainsborough's early period, when he was working in London and Suffolk. The theme of the conversation in a park evokes Watteau and his school; it denotes a French influence, which played a considerable part in the formation of the artist — he was in fact a pupil of the French engraver Gravelot at the St Martins Lane Academy. This picture has been thought to represent Thomas Sandby and his wife. At the Watson sale in 1832, it was described as depicting the artist and his wife. The painter's marriage took place in 1746; a very similar work, *Mr and Mrs Andrews*, is dated 1748.

The open-air portrait is a familiar theme in the English school, whereas in eighteenth-century France the portrait is usually in an interior. The evocation of nature by the English portrait painters is on the whole conventional; it is quite another matter with Gainsborough, however, who has treated the landscape for its own sake.

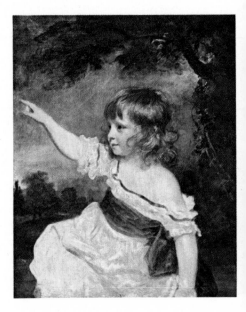

REYNOLDS, SIR JOSHUA
Master Hare

In 1788, when Reynolds was at the summit of his reputation, he painted this portrait for one of his aunts, Anna Maria Lady Jones. The sitter was Francis George Hare, the nephew or adopted son of Lady Jones.

Two years after it was painted this picture was already famous. It was bought by Baron Alphonse de Rothschild in 1872 and bequeathed to the Louvre in 1906.

FRENCH SCHOOL

Eighteenth and Nineteenth Centuries

WATTEAU, ANTOINE, 1684–1721
The Embarkation for Cythera
Canvas: 50½ × 76 in. (128 × 193 cm.) Inventory: Inv. 8525

This picture was Watteau's diploma piece for the Académie royale de Peinture et de Sculpture; it entered the Louvre on 4 April 1795, with the pictures belonging to the Académie, and was exhibited in 1799. It was not on exhibition in 1810, but was on view again in 1816.

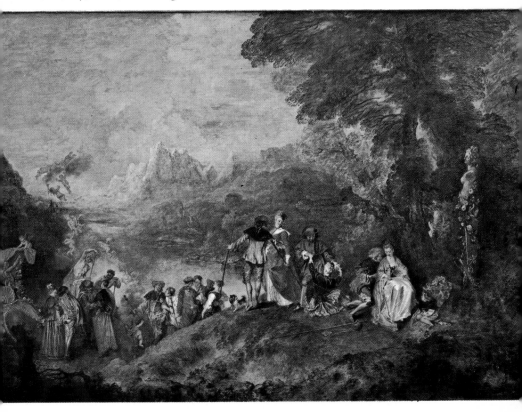

Watteau's nomination was accepted by the Académie in 1712, but he had to be called to order several times, and on 9 January 1717 he was given six months to execute his reception piece. He was received on 28 August in the same year, on presentation of his picture, entitled *Pilgrimage to Cythera*.

Love is a traditional theme of French poetry since the Middle Ages. *L'Astrée* had given it distinction; in 1663, the Abbé de Tallemant in his *Voyage à l'île d'Amour* had imagined the destiny of love as a voyage to an island of blessedness. From the beginning of the eighteenth century, the idea of the departure for Cythera recurs in numerous ballets and operas, notably in *Les Trois Cousines*, a comedy by Dancourt first acted in 1700.

The handling of the paint in scumbles and glazes, thinly applied, with very little impasto, is close to that of Rubens in his final period; Watteau was able to study his style of painting in the *Kermess*, which was then in the royal collection. Even the subject is derived from Rubens' *Jardins d'Amour*. Moreover, Watteau made a very close study of the Rubens paintings in the Galerie Médicis, when he was lodging (between 1707 and 1709) with the decorator Claude Audran III, who was the 'concierge' (director) of the Luxembourg. There are also reminiscences of Italy in this enchanted land; the general atmosphere of the painting is Venetian, and the distant mountains in their blue haze recall Leonardo's *La Gioconda* and *Saint Anne*.

Watteau made another version of it for his friend Jean de Julienne; this was bought by Frederick II. There was an opportunity of comparing the two paintings in 1950, when works from the Berlin Museum were exhibited at the Petit Palais.

The Embarkation for Cythera has preserved its paint quite untouched — a state rare amongst pictures — since the varnish has never been cleaned off; in the

 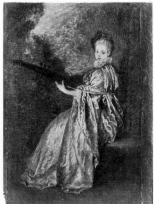 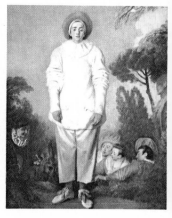

Watteau *L'Indifférent* Watteau *La Finette* Watteau *Gilles*

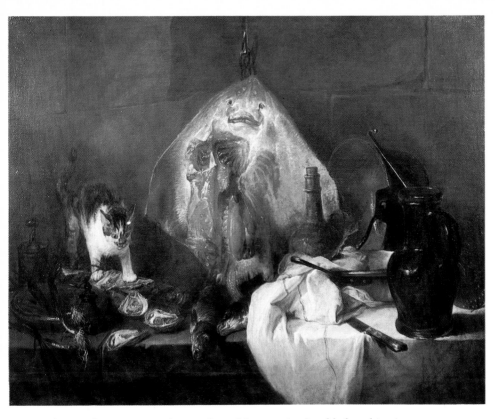

nineteenth century new layers of varnish were simply added, making it opaque and brownish in colour. In 1956 these coats of varnish were lightened, and the picture regained its original transparency and brightness while retaining a layer of old varnish to protect the surface of the paint.

CHARDIN, JEAN BAPTISTE SIMÉON, 1699–1779
The Ray
Canvas: 45 × 57½ in. (114 × 146 cm.) Inventory: Inv. 3197

One of the artist's diploma pieces, on the occasion of his reception into the Académie royale de Peinture et de Sculpture in 1728. Passed into the Louvre with the Académie collections in 1795.

Artists who were not members of the Académie royale de Peinture et de Sculpture, and who therefore could not exhibit their work in the Salon, took part once a year in what was known as the 'Salon de la Jeunesse', held on the feast of Corpus Christi in the open air, in the Place Dauphine, and lasting two

hours. On 3 June 1728 Chardin exhibited several pictures there, including *The Ray* and *The Buffet*. Some academicians who saw the work persuaded Chardin to present himself for membership of the Académie royale; on 25 September of the same year, contrary to the usual practice, Chardin was accepted and admitted on one and the same day. The Académie did not insist on a picture specially painted for the occasion, as was usually the case, but retained *The Ray* and *The Buffet* as his diploma pieces. It is related that the artist had deceived several academicians, among them Largillière and Cazes, by showing them some of his still-life paintings, which they took for Flemish works. Certainly, the source of inspiration is obvious in *The Ray*, which surpasses the best work of Jan Fyt.

The rich quality of the paint surface, which is in perfect condition, has been revealed by the recent cleaning of the varnish. The picture is exceptionally well preserved for a work by Chardin; his paintings often suffered from too heavy a use of oil with his pigment. Perhaps this one owes its good condition to the fact that it dates from his early days, when he was applying himself to improving his technique by creating a *chef-d'œuvre* carefully executed according to the best principles of true craftsmanship. Later, he trusted too much to his inspiration, and yielded to his passion for worked-up impasto.

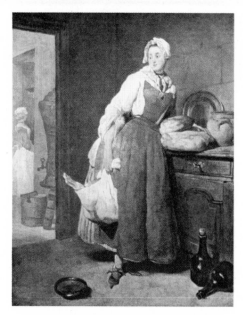

Chardin *La Pourvoyeuse*

Pater *The Toilette*

Elisabeth-Louise Vigée-Lebrun *The Artist and her Daughter*

BOUCHER, FRANÇOIS, 1703–1770
Diana resting after her Bath
Canvas: $22\frac{1}{2} \times 28\frac{3}{4}$ in. (57 × 73 cm.) Inventory: Inv. 2712
Signed: 1742 Boucher (Reproduction p. 230)

Exhibited in the Salon, 1742. Comte de Narbonne's sale, Paris, 24 March 1850.
Bought from Van Cuyck in 1852 for 3,200 francs.

This painting, and the *Leda* exhibited in the same Salon (now in Stockholm)
are unquestionably François Boucher's masterpieces. As a decorative artist,
Boucher had amazing facility; in this painting, done for the Salon, he wished to
excel himself. It places him in the ranks of the great masters, and on looking
at it one begins to realize how gifted he was, even though he did not always
make full use of his talent. Renoir understood this well; he was particularly
fond of the *Diana*. 'Boucher's *Diana bathing*', he remarked (according to

229

Vollard), 'is the first picture which really captivated me, and I have gone on loving it all my life as one loves one's first sweetheart – although I am constantly being told that one should not like that kind of thing, and that Boucher is a mere decorator – as if that were a defect! In fact, no one has understood the female body better than Boucher – he knew just how to paint the rounded, dimpled young bottom.'

The slender nudes and the hunting theme recall the School of Fontainebleau, of which certain traditions persist in the eighteenth century. The paint surface is intact, and the old varnish, which contains no artificial colouring, gives it a slightly golden tone.

All who really love painting for its own sake, and are not swayed by changes of fashion, cannot fail to admire this miraculous picture. It is a masterpiece in the true classical manner; the technique is not too obvious, all the values are harmoniously balanced, and the elegance of the drawing and the purity of the forms are more important than the more sensual charms of colour. It calls to mind the *Grande Odalisque* of Ingres, with its combination of pale flesh tones and cool blues.

230

FRAGONARD, HONORÉ, 1732–1806
Women Bathing
Canvas: 25¼× 31½ in. (64× 80 cm.) Inventory: M.I. 1055

Sale (du Barry?), 11 March 1776, No. 77 (550 livres); Varanchan sale, 28 December 1777, No. 12 (542 livres); Abbé de Gévigney's sale, 1 December 1779, No. 594; in the collection of L. La Caze, who bought it in 1854 from M. Féral senior for 3,000 francs. Left to the Louvre in 1869.

A display of virtuosity in the Rubens manner seems to have been the artist's intention, with a skilful use of scumbling and glazes, and impasto only in the high-lights — a triumph of luminous transparency. The swirling composition is also reminiscent of Rubens.

Fragonard must have seen a good many paintings of this kind in the studio of his master, Boucher; but it is still more probable that he here gives proof of

the deep impression made on him by the Nereids in Rubens' *Débarquement de la Reine* in the Galerie Médicis. This gallery was a veritable school for painters in the eighteenth century, particularly for 'free painters', who did not work along the lines laid down by the Académie which followed the tradition of decorative art established under Louis XIV. Perhaps it was in order to retain his freedom of action that when he was accepted by the Académie he never submitted a diploma piece.

This painting is sometimes thought to date from before his first visit to Italy in 1756, when his discovery of Tiepolo changed the direction of his work.

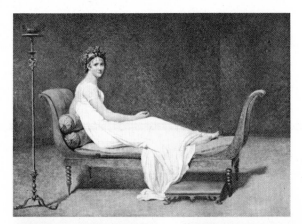

Jacques-Louis David
Madame Récamier

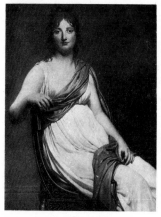

Jacques-Louis David
Madame de Verminac

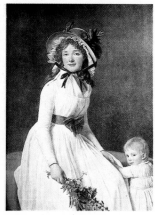

Jacques-Louis David
Madame de Sériziat

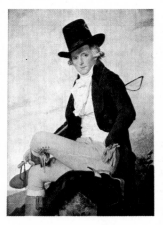

Jacques-Louis David
Monsieur de Sériziat

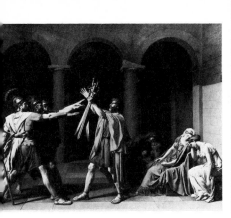

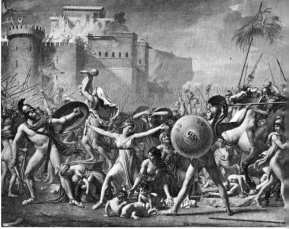

Jacques-Louis David *The Horatii*

Jacques-Louis David *The Sabines*

DAVID, JACQUES-LOUIS, 1748–1825
*The Consecration of the Emperor Napoleon I and
the Coronation of the Empress Josephine (detail)*
Canvas: 240 × 360½ in. (610 × 931 cm.) Inventory: Inv. 3699
Signed on the right, dated on the left 1805–1807
(Reproduction p. 234)

David was commissioned by Napoleon to paint a large composition com-
memorating his consecration, which had taken place in Notre Dame in Paris,
on 2 December 1804. The picture was exhibited in the Salon Carré in the
Louvre in 1808, then in the Salon of that year; it was next placed in the Tuiler-
ies, in the Salle des Gardes. Under Louis Philippe it was installed at Versailles
in a room decorated in imitation of the Empire style, together with David's
Distribution of the Eagles and Gros' *Battle of Aboukir*; in 1889 it was transferred
to the Louvre, and its place at Versailles was taken by Roll's *Marseillaise*.
In 1947 this latter picture was replaced by a replica of David's *Consecration of
Napoleon*, begun by the painter in 1808 and not finished till 1822, in Brussels;
this replica was bought by the Musées de France in England, in 1946.

David seems to have derived his general composition from Rubens' *Corona-
tion of Queen Marie de Medici*.

In accordance with David's usual method, numerous studies, both painted
and drawn, preceded the actual execution of the work. The best-known of
these is the portrait of Pius VII, now in the Louvre. The painter then made a
model, where he arranged dolls in costume.

233

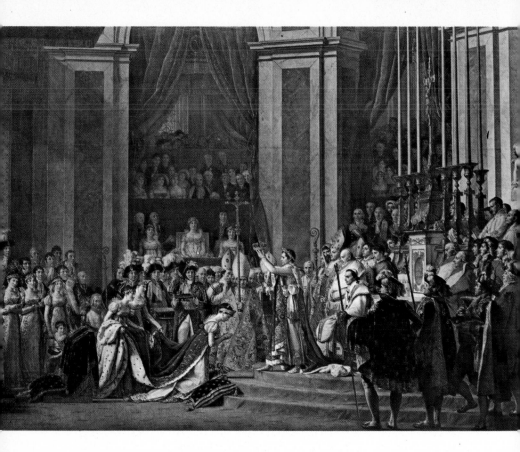

David had originally intended to portray the event faithfully, showing Napoleon crowning himself. The Emperor, remembering the quarrels between the Pope and the Holy Roman Empire, placed the crown on his own head to avoid giving a pledge of obedience of the temporal power to the Pontiff. But he evidently felt that it would not be desirable to perpetuate this somewhat disrespectful action in paint; so David painted the coronation of Josephine by Napoleon, with the Pope blessing the Empress.

Grouped round the altar, near Napoleon, are the chief dignitaries — Cambacérès, the Lord Chancellor, Marshal Berthier, Grand Veneur, Talleyrand, the Lord Chamberlain, and Lebrun, the Chief Treasurer. Madame de la Rochefoucauld carries the Empress's train; behind her are the Emperor's sisters, and his brothers Louis and Joseph. In front of the central stand are some of the marshals, and in it is Marie Laetitia, Madame Mère (the Emperor's mother), who was in fact not present at the ceremony.

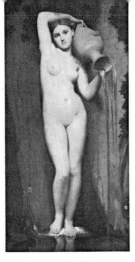

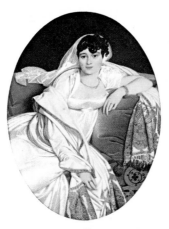

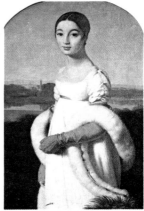

Ingres *La Source* Ingres *Mlle Rivière* Ingres *Madame Rivière*

INGRES, JEAN-AUGUSTE-DOMINIQUE, 1780–1867
The Turkish Bath
Canvas: Diameter 42½ in. (108 cm.) Inventory. R.F. 1934
Signed: J. Ingres Pinxit MDCCCLXII Aetatis LXXXII
(Reproduction p. 236)

Acquired at the end of the year 1859 by Prince Napoleon, who returned it to the artist. Bought by Khalel Bey, Turkish ambassador in Paris, for 20,000 francs. No. 34 in the Khalel Bay sale, 16–18 January 1868. Collections Henri Say, Amédée de Broglie. Bought in 1911 by the Société des Amis du Louvre.

As Jules Mommejà pointed out, Ingres derived the idea of these swarming nudes in the interior of a harem from Lady Mary Wortley Montague's letters (No. XXVI and XLII). She was the wife of the English ambassador to the Sublime Porte; in these two letters she describes baths in the Seraglio, which she was allowed to enter, and Ingres copied extracts from them into his notebook (No. IX), probably in about 1817.

Several of the figures in this canvas have been taken from earlier pictures; others are new. But as Hans Naef demonstrated in 1957 (in *L'Oeil*), Ingres had not a very ready imagination, and borrowed from both French and English prints of 'turqueries', going back to the eighteenth or even the sixteenth centuries. Copies of these are still to be seen in the archives of his studio in the Musée de Montauban.

This picture has existed in at least two forms. A first sketch, intended for Comte Demidoff, was executed in 1852, but not delivered; it was probably worked on again after this date, and at the end of 1859 it was bought by Prince Napoleon. The appearance of this picture, which at that time was

235

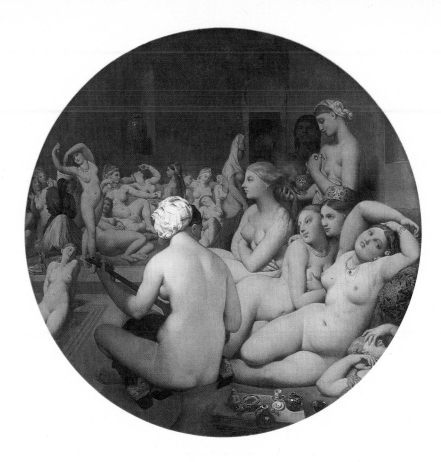

square, is known from a photograph dated 7 October 1859. On the interven-
tion of Princess Clotilde, scandalized by all those nudes, the Prince returned
it to Ingres; M. Reiset was entrusted with negotiating its exchange for a portrait
of the artist at the age of twenty-four (now in the Musée Condé, Chantilly).
Ingres kept the picture for several years, making various changes in it and
giving it its final circular form. He signed it in 1862, indicating with pride that it
was the work of a man of eighty-two.

GROS, JEAN-ANTOINE, 1771–1835
Napoleon at Eylau
Canvas: 295½ × 315 in. (533 × 800 cm.) Inventory: Inv. 5067
Signed at the left: Gros 1808

The battle of Eylau (8 February 1807) in Poland, in which the Russian army was defeated by the French during the fourth coalition, was an extremely bloody engagement, resulting in 25,000 dead and wounded. Napoleon wished to commemorate the victory, and had it made the subject of a competition; but he wanted his humanity to be emphasized, rather than his war-like qualities. The day after the battle, he had toured the battlefield, and was struck with pity at the sight of so much carnage. 'If all the kings on earth could see this sight', he said, 'they would be less greedy for wars and conquests.' This was the moment selected to appear on the official programme of the competition by Vivant-Denon, the Director of the Musée Napoléon. Gros, who only competed because he was pressed to do so by Vivant-Denon, was chosen in preference to twenty-five other painters. He received 16,000 francs for the picture, which was exhibited in the Salon of 1808.

The Emperor, advancing towards the right, is mounted on a light bay horse, and surrounded by his staff; the cloak and hat which he wore at Eylau were

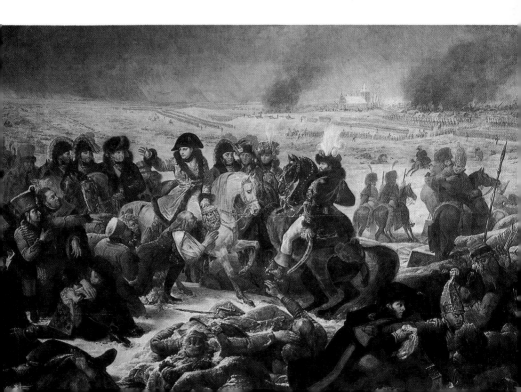

handed to Gros, who kept them till his death. Napoleon is speaking to a wounded Lithuanian, who is moved by the humanity of the victor, and is credited with saying: 'Caesar has granted me life; I will serve you faithfully, as I have served Alexander.' Opposite Napoleon, on a prancing charger, is Murat, whose epic charges transformed an undecided battle into victory; between Murat and Napoleon can be seen Marshal Berthier, Marshal Bessières and General Caulaincourt; the young Lithuanian soldier who stretches his arms towards Napoleon is supported by Baron Percy, Surgeon-in-Chief to the Grande Armée.

In this work, Gros has entirely forsaken classical composition; he has grouped his figures in masses and put striking close-ups of bleeding corpses in the foreground. Although he had never been far east, he has successfully rendered the melancholy of the great wintry plain, the sky leaden with smoke from the burning village.

GÉRICAULT, THÉODORE, 1791–1824
The Raft of the Méduse
Canvas: 193 × 282 in. (491 × 716 cm.) Inventory: Inv. 4884

For his Salon picture in 1819, Géricault chose a dramatic episode – the wreck of the frigate *Méduse*, which had set off with a French fleet on an expedition to Senegal, and had been lost in July 1816. The French admiralty was accused of having put an incompetent officer in charge of the expedition; he was the Comte de Chaumareix, a former émigré who had not commanded a vessel for twenty-five years. The picture was an enormous success, more on account of the scandal than because of an interest in the arts; but Géricault only received a gold medal, and his picture was not bought by the government. One wonders who it was suggested commissioning this painter of horror subjects to do a *Sacred Heart*.

Géricault was mortified, and decided to exhibit his picture in England, where a pamphlet had been published on the wreck of the *Méduse*. He entrusted the vast canvas to an eccentric character named Bullock (as Lethière had done with

238

his *Brutus Condemning his Sons*), and it was exhibited in London from 12 June to 31 December 1820, and in Dublin from 5 February to 31 March 1821. Géricault received a third of the takings, and the operation brought him in quite a large sum (probably 20,000 francs).

The painting was priced at 6,000 francs at the posthumous sale of the artist's possessions. It was bought by Dedreux-Dorcy, a friend of Géricault, for an additional five francs, and he sold it to the State for the same amount.

The most horrifying part of the shipwreck had been the drama of 149 wretches abandoned on a raft with only some casks of wine to live on, and the ensuing drunkenness and abominations. When the frigate *Argus* found the raft, after many days, she was only able to rescue fifteen survivors, of whom five died after being brought ashore. After some hesitation, Géricault chose this last episode — the sighting of the *Argus* by the survivors on the raft. With regard to the latter, he set himself to the task of carrying out an inquest as thoroughly as any examining magistrate. He rented a studio opposite the Beaujon hospital, so that he could make anatomical studies of the dying.

The picture was painted by Géricault in an extraordinary state of tension; 'the mere sound of a smile prevented him from painting'.

Delacroix *Self-Portrait*

Delacroix
The Death of Sardanapalus

Delacroix *The Massacre of Scio* Delacroix *Entry of the Crusaders into Constantinople*

DELACROIX, EUGÈNE, 1798–1863
Women of Algiers
Canvas: 70½ × 90½ in. (180 × 229 cm.) Inventory: Inv. 3824
Signed and dated: 1834
(Reproduction p. 242)

Exhibited at the Salon of 1834, where it was bought for the Musée du Luxembourg.

The capture of Algiers in 1830 had given France the Sultan of Morocco as a neighbour. Louis Philippe's government decided to send him an ambassador extraordinary, the Comte de Mornay; the latter wished to take an official artist with him and chose Eugène Delacroix. The mission left Toulon on 11 January 1832, landed at Tangiers on the 25 January, travelled through a part of Morocco, and returned via Oran and Algiers.

During his visit to this country, Delacroix witnessed spectacles belonging to a noble and primitive way of life which provided material for his art until he died; but he had not been allowed to enter the jealously guarded harems of the Moslems. It was the chief harbour engineer at Algiers who persuaded one of the port officials, a former *reis* or owner of privateers, to allow Delacroix into his own harem.

In these few hours Delacroix did several watercolour sketches, some of which are in the Louvre. Using them as a basis, he painted a large picture on his return, and exhibited it in the 1834 salon. He wanted to show the dark tones of flesh and the subdued colours in the warm half-light of the harem.

In 1849 he painted another smaller version of the same subject, now in the Musée de Montpellier. Here the colours are softer and the atmosphere more intimate; it has a note of nostalgia absent from the 1834 Salon picture, which is still full of his first impressions, and which already foreshadows Renoir. The latter artist was well aware of this relationship; in 1872 he painted a large picture inspired by Delacroix's canvas and called *Les Parisiennes habillées en Algériennes* (Tokyo Museum). He had already done an *Odalisque* and exhibited it in the 1870 Salon. (Chester Dale Collection, New York.)

DELACROIX. EUGÈNE, 1798–1863
Still-Life with Lobsters
Canvas: 31½ × 39½ in. (80 × 100 cm.) Inventory: R.F. 1661

Painted at Beffes for General Coetlosquet. Exhibited in the Salon of 1827; in the Moreau collection; Moreau-Nélaton donation, 1906.

This painting was one of the splendid collection of works which Delacroix sent to the Salon of 1827, and which included the *Death of Sardanapalus* as well as others from among his finest pictures. On 28 September·1827, Delacroix wrote to his friend Soulier: 'I have finished the General's animal picture, and I have dug up a rococo frame for it, which I have had regilded and which will do for it splendidly. It has already dazzled people at a gathering of amateurs, and I think it would be amusing to see it in the Salon.'

Of all Delacroix's paintings, the *Still-Life with Lobster* reveals most clearly the impression made on the young artist by English painting. The background with its red-coated huntsmen is reminiscent of landscapes by Constable; the dead game in the foreground, and the incongruous lobster, rival the finest details in the works of Jan Fyt.

Delacroix painted this picture when he returned from England; even before then, he was in close touch with English painters in Paris — Fielding and Boning-

ton amongst others. But it was at the Salon of 1824 that he discovered the revolution which Constable had brought about in English painting, when he saw the three landscapes which the latter was exhibiting there. He hastily repainted the background of the *Massacre of Scio* along much the same lines; when the state bought the picture from him for 6,000 francs (a considerable sum in those days) he lost no time in spending the money on a trip to England. This opened up a new world to him: the Parthenon marbles, the Gothic style, the paintings of Lawrence and Etty, the horses (his host was the horsedealer Elmore), sailing in a yacht—a sport he was able to indulge in with an aristocratic friend of Elmore's—and the plays of Shakespeare. English painting had attracted a whole colony of French artists to London; among them Eugène Isabey, Eugène Lami, and Henri Monnier. Delacroix also renewed contact with Bonington, and worked in company with him. He was in London when he heard of the heroic death of Lord Byron, to whom he pays tribute in his Journal.

Delacroix *Liberty at the Barricades*

Corot *The Cathedral of Chartres*

COROT, JEAN-BAPTISTE-CAMILLE, 1796–1875
View of Marissel
Canvas: $21\frac{5}{8} \times 16\frac{7}{8}$ in. (55 × 43 cm.) Inventory: R.F. 1642
Signed at bottom left
(Reproduction p. 246)

Painted in 1866 at Marissel, near Beauvais, and exhibited in the 1867 Salon.
Sold there by Corot to M. Laurent Richard, a tailor, for 4,000 francs (Corot's
letter of 30 June 1867). Moreau-Nélaton gift, 1906.

Corot became acquainted with the Beauvais region through M. Badin, the
Director of the Manufacture Nationale de Tapisseries, a painter whom he had
formerly known in Italy. He was at Beauvais in 1857, and visited it frequently
until his death; when M. Badin left the factory one of his friends, M. Wallet
of Voisinlieu, gave the artist hospitality. He explored the valley of a little
stream called the Thérain, looking for riverside subjects, of which he was par-
ticularly fond. It is this stream which flows in front of the hill on which stands
the village church of Marissel, near Voisinlieu.

Corot *View of Marissel*

Corot *The Coliseum seen from the Palatine*

Another smaller picture shows the same subject, seen closer up from the other side of the Thérain; it is painted in a rather freer technique, with somewhat heavy impasto. The latter was painted during a greater number of sessions, and is more deliberate; it is a subtle study of light, finely executed, which denotes patient observation. The light, which does not seem to have reached its full strength, is that of early morning; the trees are beginning to bear young shoots; the first hint of spring is in the air. Probably no other painter has expressed so well this uncertain moment of the changing seasons. A photograph of the same scene, taken beside Corot by M. Herbert of Beauvais, shows the slight changes the artist has made.

Nothing looks simpler, more 'ordinary', than Corot's subjects. But his painting is so subtle that one can guess the month, the time of day, and even the region. The landscapes done in the neighbourhood of Beauvais have a quality of verdure and light which makes them immediately recognizable to the practised eye.

COROT, JEAN-BAPTISTE-CAMILLE, 1796–1875
The Coliseum seen from the Farnese Gardens on the Palatine
Paper on canvas: 11 × 19 in. (28 × 48 cm.) Inventory: R.F. 154
Signed at the bottom, on the right: Corot Mars 1826

Painted direct from nature in Rome, March 1826. Exhibited in the Salon of 1849. Bequeathed to the Louvre by the artist (1874).

Although he had not attended the official studios, Corot, a pupil of the neo-classical landscape painters Michallon and Jean-Victor Bertin, followed French tradition in believing that only Italy could complete the education of a landscape artist. Leaving a portrait of himself with his parents, he left for Rome in the autumn of 1825, accompanied by Behr, a fellow-student from Bertin's studio. He found a whole group of artists studying neo-classical landscape; amongst them were Caruelle d'Aligny, from Lyons, and Edouard Bertin. He began by working in the Roman Campagna, then painted views in the city of Rome. His accuracy of vision, his sensitive freshness and, above all, his technical quality set him well above his companions, who were not slow to recognize his talent.

In March 1826, during the course of fifteen sessions on the top of the Palatine hill, he completed three studies: the present picture, the *Forum from the Palatine*, also in the Louvre, and the *View of the Farnese Gardens*, in the Phillips Memorial Gallery in Washington. Corot was always particularly fond of the first two pictures, recalling the most historic site in Rome; after his death, it was found that he had written on the stretcher of each of them 'pour le Muséum'.

Corot always referred to the Museum of the Louvre under its original title; he wished to be represented among the immortals by these two landscapes.

When he decided, in 1849, to submit to the Salon for the first time a painting done direct from nature (encouraged by the suppression of the jury), it was the *Coliseum* which he chose to send.

COURBET, GUSTAVE, 1819–1877
The Painter's Studio — A Real-life Allegory
Canvas: 141½ × 226 in. (359 × 598 cm.) Inventory: R.F. 2257

Painted at Ornans, from November 1854 to March 1855. Rejected by the Salon of 1855, and included in the exhibition of his works which Courbet held in the Avenue Montaigne, in the precincts of the Exposition Universelle, inside a hut which he had built for the purpose. Exhibited at the Société des Beaux-Arts, Bordeaux, in 1865. Carried off by Durand-Ruel in February 1873, with 57 other canvases also saved from the seizure of his goods with which Courbet was threatened. Exhibited in 1873 at the Cercle Artistique of Vienne, then sent back to Ornans. At the sale held by Juliette Courbet on 9 December 1881, was bought by the dealer Haro for 21,000 francs. Included in the Courbet exhibition at the École des Beaux-Arts in 1882. Withdrawn from the Haro

sale in 1892 for 100,000 francs. At the sale of the elder Haro in 1897, sold to Victor Desfossés for 26,500 francs; in 1899 bought back by his widow for 60,000 francs in competition with the Louvre, who raised the bidding to 57,000 francs. Used as a painted curtain at the Hôtel Desfossés. Sold by Mme Desfossés in 1919 to Barfazanges; bought by the Louvre with money raised with the help of the Amis du Louvre, various art-lovers and public subscription.

Courbet *The Burial at Ornans*

Courbet *Stream in a Ravine* Courbet *The Haunt of the Deer*

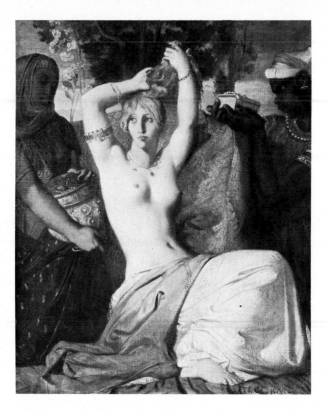

Chassériau, Théodore, 1819–1856
The Toilet of Esther
Canvas: 18½ × 14⅛ in. (45·5 × 35·5 cm.) Inventory: R.F. 3900
Signed bottom right: Th.ʳᵉ Chassériau 1841

Exhibited in the Salon of 1842 (No. 62) under the title *Esther preparing to appear before Ahasuerus*. Marcotte de Quivier collection. Part of Baron Arthur Chassériau's bequest to the Louvre in 1936.

The gloomy sensuality of Esther is reminiscent of Ingres' nudes. But another influence is also apparent here; the two slaves, one a negress, who wait on Esther recall Delacroix's harem interiors. From this period, Chassériau oscillates between these two contradictory influences, which divide his art; Delacroix's romanticism lures him away from the style of Ingres, which was his true vocation, and all too often inspires him to use heavy, vulgar colours. The present picture, however, is not yet affected by this tendency; it was painted while the career of the artist was still at the cross-roads.

250

MILLET, JEAN FRANÇOIS 1814–75
The Gleaners
Canvas: 33 × 44 in. (84 × 111 cm.) Inventory: R.F. 592
Signed: J. F. Millet

Exhibited in the Salon of 1857. Bought there by M. Binder, of L'Isle-Adam, for 3,000 francs; Bischoffsheim Collection; bought by the widowed Mme Pommery, of Rheims, at the Secrétan sale in 1889 for 300,000 francs; bequeathed to the State. It entered the Louvre on her death in 1890.

Burdened with a family and with financial worries, Millet worked at this picture with all the conscientiousness and intensity of his peasant nature. Millet realized that in working so hard over his pictures he tended to make the execution laboured and the inspiration sterile. In this case, however, it was not so; the landscape in the golden summer-light has preserved all its freshness of vision.

The picture was painted at Barbizon, where Millet settled in 1849; in the background is the wide plain of Chailly. The work was badly received when it appeared in the Salon. The authoritarianism of the Empire was at its height, and Millet's republican views were considered subversive.

Th. Rousseau *Storm Effect*

Th. Rousseau *The Oaks*

ROUSSEAU, THÉODORE

These two pictures show two very different aspects of the artist's work. *The Oaks*, which was bequeathed to the Louvre in 1902 with the Thomy-Thierry collection, is one of the highly elaborated, closely studied paintings in which he tried to express the very soul of nature. It was painted on the edge of the forest of Fontainebleau.

Storm effect on the Plain of Montmartre, on the other hand, painted in 1835, is a work of his youth; it has the free and spontaneous character of his earliest productions, before he tried to give his art a conscious direction.

DAUMIER, HONORÉ

The Washerwoman
This picture was bought by the Louvre at the Paul Bureau sale, 20 May 1927, for 701,000 francs — a very large sum for that time. It is one of Daumier's most powerful works. Living on the Île-Saint-Louis in Paris, he used to watch the washerwomen going to and fro on the Quai d'Anjou, coming up from the Seine, and expressed the lot of these working women of the city in a whole series of pictures, of which this is the finest.

LIST OF ILLUSTRATIONS

Figures in italics denote colour plates

253

256

260

INDEX

262